WRITING AND SPEAKING FROM THE HEART OF MY MIND

WRITING AND SPEAKING FROM THE HEART OF MY MIND

Selected Essays and Speeches

Mĩcere Gĩthae Mũgo

AFRICA WORLD PRESS

TRENTON | LONDON | CAPE TOWN | NAIROBI | ADDIS ABABA | ASMARA | IBADAN | NEW DELHI

AFRICA WORLD PRESS
541 West Ingham Avenue | Suite B
Trenton, New Jersey 08638

Copyright © 2012 Mīcere Gīthae Mūgo
First Printing 2012

Book and cover design: Saverance Publishing Services

Library of Congress Cataloging-in-Publication Data

Mugo, Micere Githae.
Writing and speaking from the heart of my mind : selected essays and speeches / Micere Githae Mugo.
 p. cm.
"The essays and speeches that appear in this book were originally presented as either keynote addresses, or conference papers, or interviews, while others were submitted for publication as book chapters on request."--Acknowlegments.
Includes bibliographical references and index.
ISBN-13: 978-1-59221-853-0 (hardcover)
ISBN-10: 1-59221-853-9 (hardcover)
ISBN-13: 978-1-59221-854-7 (softcover)
ISBN-10: 1-59221-854-7 (softcover)
 1. Mugo, Micere Githae. 2. Africa--Civilization--20th century. 3. Africa--Social conditions--1960- 4. Politics and literature--Africa--History--20th century. 5. Women--Africa--Social conditions--20th century. 6. Women intellectuals--Africa. I. Title.
 DT14.M78 2011
 960.32--dc22

 2011018120

For
My beloved nephew, the late Mbūrū Kīereinī, who had a razor-sharp mind, courage and spontaneous mischievous wit that ALS could not touch

And
My dearest friend, Hannah Njoki Tiagha, with a heart, mind and will too powerful for ALS to subdue

Also for
My mother, Grace Njeri Gīthae, whose mind remains needle-sharp even in her 90s

And
My late father, Richard Karuga Gīthae, who taught me to defy gendered boundaries

Certainly for
My beloved daughters, Mūmbi and Njeri, in celebration of their brilliance, agency of "voice", comeradeship and committed activism

Contents

Abbreviations

AIDS	Acquired Immune Deficiency Syndrome
AMREF	African Medical and Research Foundation
AAPS	Association of African Political Science
BBC	British Broadcasting Corporation
CODESRIA	Council for the Development of Social Science Research in Africa
CID	Criminal Investigation Department
CNN	Cable News Network
DRC	Democratic Republic of Congo
EAC	East African Commission
ECOWAS	Economic Community of West African States
EU	European Union
FESTAC	Festival of African Arts and Culture
GSU	General Service Unit
HIV	Human Immunodeficiency Virus
IMF	International Monetary Fund
JASPA	Jobs and Skills Program for Africa
KANU	Kenya African National Union
KBC	Kenya Broadcasting Corporation
NAFTA	North American Free Trade Agreement

NATO	North Atlantic Treaty Organization
OAU	Organization of African Unity
PANAFEST	Pan-African Historical Theater Festival
PAWLO	Pan-African Women's Liberation Movement
PAYM	Pan-African Youth Movement
PCI	Population Communications International
SADC	Southern African Development Community
SAPES	South African Political and Economic Series
UNESCO	United Nations Educational Scientific and Cultural Organization
UNICEF	United Nations Children's Fund
UNIFEM	United Nations Development Fund for Women

Acknowledgments

The essays and speeches that appear in this book were originally presented as either keynote addresses, or conference papers, or interviews, while others were submitted for publication as book chapters on request. I would, therefore, like to express sincere gratitude to all the individuals, organizations and institutions that invited me to participate in the intellectual exchanges that gave birth to the chapters in this book. The "introduction" indicates the forums where the original presentations were made and the publications in which they first appeared. Because most of the invitations allowed me the liberty to "do my own thing," as young people would say, I chose to abandon customary "academic jargon" and instead used dialogical discourse in keeping with a Gĩkũyũ adage that counsels, *kwaaria nĩ kwendana* – meaning "to hold dialogue is to love" – which I fervently believe in. For this license and freedom of choice, I am most appreciative.

Compiling a book of essays such as this one is a tedious and time-consuming task that involves a great deal of research in an effort to locate the various sources where the scattered pieces appear. This task would not have been possible had it not been for the efficient services rendered by a number of individuals who have worked with me as research assistants over the years: Amma Tanksley-West, Anthony Buisereth, Christiana Kaiser, Michael Onyango Orwa and Brempong Osei-Tutu. The other set of "research assistants" to whom I am deeply indebted for their ever ready assistance with a variety of tasks, including data collection, typing, editing, proofreading and even unraveling the occasional mysteries of a computer are my

beloved daughters, Mŭmbi and Njeri. My gratitude also goes to my youngest sister, Nancy Gĩthae, who aided with typing a huge chunk of the first draft of the manuscript at some point. The last lap of the journey is often the hardest and in this regard, over the last year or so Dr. Osei-Tutu has been instrumental in helping me get to the finishing line. He has brought into this project incredible skills in scanning some of the material from original publications, streamlining the footnotes, proofreading and editing the manuscript, formatting the final draft, as well as converting the hard copy into a CD for submission to the publisher.

The philosophy of *I am because you are and since we are, therefore I am,* which Dr. John Mbiti, my undergraduate Philosophy Professor at Makerere University in the early 1960s, expounds in *African Religions and Philosophy* has been a reality throughout my life. In Kiswahili we call this essence of being human and demonstrating communal solidarity, *utu* and in Sindebele or Zulu, it is known as *ubuntu.* My monograph, *African Orature and Human Rights,* defines this world view through the "Onion Structure Theory." Without the support of my family, extended family, friends and community supporters – too numerous to name individually – especially during the last couple of years, this work would not have materialized. All of these embracing circles of support and friendship involving beautiful people provided the re-enforcement I needed to defy multiple myeloma and move forward with this project. Indeed, I believe it was these solid circles of affirmation, plus ancestral, spiritual and divine intervention that hastened remission, making it possible for me to return to work sooner than I had imagined.

In this regard, I can never thank my amazing daughters, Mŭmbi and Njeri, enough for their comradeship, friendship, care and never failing love. No mother could ask for better daughters and I feel extremely fortunate to have these two young women in my life. Intellectually, they have contributed to my growth in very special ways, but particularly through thought-provoking discussions and lively, controversial debates – at times heated – especially over issues such as parental authoritarianism, ageism and the imperative of creating a safe democratic space in our home, where everyone has a voice. Mŭmbi and Njeri constantly remind me of the pivotal role

that young people, including students I have taught over the course of my career, have played in challenging me not to just think and theorize progressively, but to "walk the walk," as African American Black English would put it. By raising "awkward" issues such as sex, sexuality, homophobia, professorial power and privilege, ageism, patriarchal silencing of youth and so on, they have taught me to interrogate the evasiveness of an "ostrich with the head in the sand" mentality within me, replacing it with daring and courage to explore experiences that are different from, but enriching to, my own.

Other members of my family – immediate, extended and adopted – have also been incredibly supportive of my work all along and I wish to gratefully acknowledge them all, even though here I can only name selected "figure heads": my dearest mother, Grace Njeri Gĩthae and my beloved siblings, in order of seniority, going by their first names – Mũringo, Judi, the late Joyce, Mũtugi, Wambũi, the late Wanjirũ, the late Gĩthanda, Njerũ and Nancy; my cousins, alphabetically – Gathoni, Gĩthanda, Wambũi, Wangũ, Wanjirũ and Violet; my non-biological extended family members, in alphabetical order – Ama Ata, Chitepos, Chotos, Dithole, Joy, Judy, Kheli, Kwame, Leslye, Mabhenas, Marĩ, Moyanas, Karũri, Wangarĩ, Njoki, Odamttens, Otiekus, Pat, Tasneem, Tiaghas, Victor, Wambũi, Wangũi and many more.

Since leaving Kenya in 1982, originally under exile, many progressive scholars – most of them young; others not so young – have played a pivotal role in not just validating me, but by enriching my work. Some of them have produced engaging scholarship through either analyzing and commenting on my publications, or performing my work, including poetry; while others have compiled excellent biographical entries that have exposed me to a wide international audience. Yet others have extended me the honor of describing me as their mentor, even during my days of exile under the Daniel arap Moi's dictatorship when the actual mention of some of the people in exile was dangerous. To name just a few, in surname alphabetical order, these include: Adeleke Adeeko; Ama Ata Aidoo who has honored me with beautiful poetry dedications; Beth Maina Ahlberg; Miriam Chitiga; Wangui wa Goro; Naana Banyika Horne; Wanjiku Mukabi Kabira; Lillian Mabura; Wanjohi

wa Makokha; Robert Mushengu McLaren; Wambui wa Mwangi; Mshai Mwangola-Githongo; Chinyere Okafor; Eunice Njeri Sahle who recently dedicated her fine book, *World Orders, Development and Transformation*, with the generous tribute, "For Professor Micere Githae Mugo with love: thank you for making the power of ideas visible, and a life of ideas imaginable" and last but not least, Florence Wambugu, a renowned biotechnologist, who has often cited me as her mentor. To these and other progressive intellectuals, I say: please accept my deep appreciation for your interest in my work and just as importantly, for your insightful critical and creative perspectives that have added great depth to it.

Paul Muite, thank you for always standing by me, especially during the ugly era of the Moi-KANU dictatorship when your legal support was indispensable. Special thanks to you and to Makau Mutua for fighting so relentlessly to assist me in reclaiming my Kenya citizenship two years ago even as some government officials were blocking it using red-tape and legal technicalities to argue that I was a "foreigner" and no longer a Kenyan. As for Zimbabwe, my adopting motherland during exile, you will for ever be in my heart.

My publisher, Kassahun Checole, you have been amazing to work with.

Finally, this book acknowledges all those scholars who are committed to shattering the myth that knowledge is the monopoly of Western educated elites and who not only recognize ordinary people as producers of diverse "knowledges," but validate indigenous sites of knowledge as spaces for academic enquiry.

Introduction

During the last three years or so as I have been battling multiple myeloma, I have become keenly aware of the risks of procrastination. Indeed, as the struggle against this sneaky disease heightened in 2009, the reality of the hackneyed expression, "life is too short," suddenly hit home and from some complacent corner of my mind came gushing out reminders of all the tasks and projects I had put aside for "another day." The force with which this "unfinished business" erupted made me panic momentarily, but I soon recovered, for, luckily, I have learnt the important lesson that "releasing" the mind and being at peace are critical to the healing process. At the same time, I have come to accept a painful truth: when it comes to cancer and other incurable illnesses, one can never be too certain that there will be "another day," even when obstinate determination, positive thought, optimism and hope are staunch guiding mottos.

The urgency of this harsh reality has driven me to revisit a number of incomplete projects that have been sitting on the shelves of my life, including the compilation of the selected essays and speeches in this collection, which started several years ago. Originally, my grand plan was to polish up the pieces and submit them for publication during my sabbatical (2008-2009), but that was never to be as I ended up spending the leave undergoing medical treatment. Much as I would have liked to meticulously comb through each of the pieces ensuring that every footnote and reference detail is in place, therefore, I have decided that as they stand now, they constitute worthwhile reading.

The essays and speeches reflect not just an important portion of my intellectual output over the years, but tackle a significant variety of themes that traverse several fields of academic engagement. This cross-disciplinary approach not only reflects the intellectual diversity my work aims at, but the dialectical vision that informs it, both of which characterize African American Studies as a discipline. Most of the submissions have already been published internationally either as papers, or as journal articles, or as book chapters in publications representing a cross section of disciplines, including the arts and humanities, the social sciences and education. The primary purpose of this collection is to compile into a single volume pieces scattered here and there with a view to making my work more readily accessible to a diverse readership.

The book is divided into four parts under headings that roughly group them according to areas of study as well as thematic concerns. However, the grouping should not be viewed as an exercise in exclusionary partitioning of information, for, in my view, any attempt to compartmentalize knowledge is an exercise in futility. In this regard and to a very large extent, the partition is illusive. Both thematically and disciplinary-wise, a number of essays refuse to be contained in sections, insisting on crossing my artificial borders while making connections that defy the imposed demarcations. This tension will become clear as we briefly review the contents of each of the four parts below.

Another area of seeming awkwardness that requires an explanation is the repetition of information and material in some of the essays. As I read through the manuscript, I cannot help remembering examination paper instructions that I myself have often given that remind, or more accurately, *warn* candidates not to repeat material in responding to different questions. Lest I appear to be disregarding a warning I have so readily given to others, I hasten to explain that since the original papers from which the essays emanate were presented at different forums, the repetition is unavoidable. If anything, it should be viewed as a form of deliberate re-enforcement of ideas underlining the importance I attach to the repeated concerns or themes. Equally evident is repeated reference to statements by a number of particular authors, including: Chinua Achebe, Ama

Ata Aidoo, Amilcar Cabral, Aimé Césaire, Angela Davis, Frantz Fanon, Paulo Freire, John Mbiti, Okelo Oculi, Walter Rodney and others. Their evocation is a mark of how much they have impacted my theorizing and the extent to which they remain relevant to many areas of my intellectual endeavors.

The final challenge has to do with the frustration of being unable to communicate the urgency of the historical moment during which many of the papers and particularly the keynote addresses, were delivered. Indeed, what were "resounding themes" in the 1980s, 1990s and during the opening years of the 21st century when the bulk of the essays or speeches were composed may seem somewhat dated now. Of special mention is the recurring reference to socialism as an alternative to capitalism. In this day and age when socialism has almost become a "blip" word, I still dare posit that the debate remains more relevant than ever, considering how miserably capitalism as a system has failed the majority poor in global societies. Hopefully, too, most of the content still makes sense today and impacts with relevance as we continue to either encounter a re-enactment of some of the critical historical moments, years later, or recognize connectivity between the past and the present. In order to ensure a broad common point of departure in reading the chapters, however, I have sketched some brief background against which to contextualize each piece.

Part I is entitled "Autobiographical Touches using a Black Feminist Brush" and contains writing that deals with experiences that reveal who the author is while providing some of the contextual background that has shaped her intellectual and imaginative work. "The Role of African Intellectuals: Critical Reflections of a Female Scholar, University of Nairobi, 1973-82 and their Relevance to the US Academy" was originally written for a proposed book by Ibbo Mandaza, intended as part of a series by SAPES (South African Political and Economic Series), during the 1980s in Harare, Zimbabwe. I believe Ibbo Mandaza's primary objective was to provide space for a selected group of African intellectuals to share their journeys with a continental, as well as international readership, highlighting the challenges of academic production under a neo-colonial setting. A revised version of the essay is featured in a recent publication titled, *Academic*

Repression: Reflections from the Academic Industrial Complex, edited by A. Nocella II, S. Best and P. McLaren, published by AK Press. "The South End of a North-South Writers' Dialogue: Two Letters from a Post-Colonial Feminist," appears in a volume entitled, *Challenging Hierarchies: Issues and Themes in Post-Colonial African Literature*, edited by L.O. Podis and Y. Saaka, published by Peter Lang. The letters were originally composed for a UNIFEM (United Nations Development Fund for Women) project meant to engage a selected group of African and "Western" women writers in "conversation" by pairing them as pen pals. My correspondence with Birgitta Boucht, a minority Finnish-Swedish poet and novelist (1992-93), coincided with a period when I was in political exile during the Daniel arap Moi dictatorship in Kenya.

The essays in this first part of the book generally illustrate the truth of the argument that the worlds of scholarship and writing are highly contested terrains. Thus, under environments that are oppressive – physically, politically and psychologically – the progressive writer/scholar is engaged in a constant struggle of resistance against the invasion of her intellectual and imaginative spaces. This struggle heightens when the issue of gender comes into play, hence my use of a black feminist "brush" to paint the complex, gendered canvas against which the various contestations take place.

Part II, entitled *Orature, Literature and Creativity through a Black Feminist Lens,* groups together published pieces dealing with literature and orature. The opening chapter, "Women and Books," was originally presented as one of several keynote addresses during the 1985 International Book Fair in Harare, Zimbabwe, that focused on the theme: "Writing by Women and Development." Since then the paper has been published in several venues, including a book of essays edited by A. Adams and J. Mayes under the title, *Mapping Intersections: African Literature and Development.* The essay indicts literary elitism for creating "book apartheid" and in so doing, locking out the majority of ordinary African women (especially those working within the *orate* tradition) from "the world of books." The next chapter, "The Woman Artist in Africa Today: A Critical Commentary," was originally published in *Africa Development*, Vol. 19, No 1, 1994, by CODESRIA (Council for the

Development of Social Science Research in Africa), based in Dakar. Along with other papers it was meant to be a reflection, from the point view of an artist and scholar in the humanities, on the tasks and challenges that CODESRIA needed to address looking back to its inception in 1973. Over the years, the piece has appeared in several other publications, the most frequently cited being *Challenging Hierarchies: Issues and Themes in Post-Colonial African Literature*, edited by L.O. Podis and Y. Saaka. The intervention highlights creativity among "orate" women, who are depicted as being just as skillful as their literary counterparts. In the chapter that follows, "Popular Paradigms and Conceptions: Orature-based Community Theatre," attention turns to theater and drama, focusing on the community theater model. The piece demonstrates the extent to which community theater practice draws from the orature tradition as an alternative paradigm to existing Western models, resulting in the democratization of theater production and consumption. The essay appears as a chapter in a book edited by Michael West and Bill Martin, entitled, *Out of One, Many Africas: Reconstructing the Study and Meaning of Africa*. The book covers part of the proceedings of a symposium held at the Center for African Studies, University of Urbana-Champaign, Illinois in 1994, during which Africanist scholars interrogated dominant paradigms on the teaching of Africa. "Elitist Anti-Circumcision Discourse as Mutilating and Anti-Feminist" closes Part II. The chapter, originally published in the *Case Western Reserve Law Review*, Volume 47, No. 2, 1997, is a contribution to an ongoing debate on what is popularly referred to as FMG (female genital mutilation), to which the entire issue was dedicated. The lead article, titled "Bridges and Barricades: Rethinking Polemics and Intransigence in the Campaign Against Female Circumcision" was by Professor Leslye Obiora. Its general line of argument was that she found existing Western discourses on the subject culturally dismissive, condescending, "stigmatizing" and even criminalizing of African women who practiced circumcision, thus her objection to the term "genital mutilation." My particular intervention specifically addressed the role of literary texts in this regard, focusing on a review of Alice Walker's *Possessing the Secret of Joy* and its sequel, *Warrior Marks*, which Walker has co-authored

with Pratibha Parmer and produced as a documentary film. Theorizing from a black feminist perspective, the chapter criticizes female "circumcision" while denouncing the demonization of African women practitioners and operatives who, in my view, are but "victims" of ritual-centric indoctrination and patriarchal socialization that are primarily responsible for propagating the practice.

Essays in this second part of the book demonstrate my engagement with orature and literature as complementary art forms that deserve equal recognition and treatment even though, individually, they are uniquely different. Indeed, most African writers – especially those belonging to the older generations – are not just "students" and "products" of both traditions, but more of literary "converts" who were originally children and "disciples" of the orature tradition. The influence of orature on major literary figures such as Chinua Achebe, Ama Ata Aidoo, Okot p'Bitek, Flora Nwapa, Rebecca Njau, Ousmane Sembene, Wole Soyinka, Ngũgĩ wa Thiong'o and others, is indisputable. Consequently, the essays in Part II have attempted to bring both traditions at a round table to engage in conversation, while at the same time subjecting them to the scrutiny of a black feminist lens in an effort to unveil the gendered realities they encompass.

The chapters in Part III of the book fall under the title: "Culture, Class, Gender, Pan Africanism and Human Development." This section, consisting of essays mostly expounding the theme of culture, is an example of material repetition noted earlier. The opening essay, "Culture in Africa and Imperialism," published in a special issue of *Third World in Perspective – An Interdisciplinary Journal*, Volume 1, No. 2, 1994, is the final version of a paper presented at a number of previous forums. It is an attempt to broadly define culture focusing on Africa for illustrations while at the same time linking it to the larger project of imperialism. The second one, "Gender, Ethnicity, Class and Culture" is published in a book entitled, *Culture and Conflict: the Role of Culture in the Prevention and Resolution of Conflict in Africa*, edited by A. Datta, *et al.*, consisting of proceedings from a UNESCO symposium on "The Role of Culture in the Prevention and Resolution of Conflict in Africa," held at the National Institute of Development Research and Documentation in Gaborone,

Botswana, 1995. The essay examines points of connection as well as intersection – even tension and conflict – between culture and the construction of social identities such as gender, ethnicity and class, all of which play a major role in the prevention and resolution of conflict. The final essay in this section, "Re-envisioning Pan Africanism: What are the Roles of Gender, Youth and the Masses?" broadens the focus from Africa to address the larger political-cultural scene of Pan-Africanism. The central argument in this essay is that without participation from women, youth and the masses, Pan-Africanism will never be a global mass movement. The two groups are viewed as critical constituencies and forces for revamping Pan-Africanism. A re-envisioning of the Pan-Africanist project is, thus, viewed as urgent and as needing to dispense with outdated notions and conceptualizations of Pan-Africanism, replacing them with radical, revolutionary and engendered paradigms. Although a direct connection between this final essay and the rest in the section might not be obvious at a glance, it is nonetheless there in that Pan-Africanism has a clear cultural and political base, as do the social constructions of gender, youth and the masses.

Part IV of the book entitled, *Democracy, Empowerment and Construction of New Sites of Knowledge* features essays and speeches that point to possibilities, suggest alternatives and propose the way forward in tackling situations that stand in the way of genuine human development. "Advocacy for Empowering the Masses – Translating Rhetoric into Action" appears as a book chapter in *Democracy on Whose Terms?* edited by M. Melin and published by Scandbook, Falun, Uppsala, in 1995. Like some of the other chapters in this book, the original version was a panel presentation at a conference. The essay explores the meaning and construction of democracy in Africa, unpacking the problem of power relations while recognizing the imperative of agency among ordinary citizens. The essay that follows, "Meeting Point Between Basic, Subsidiary and People's Rights: Lessons from African Orature," published in the *Syracuse Journal of International Law and Commerce*, Volume 26, Spring 1999, was also originally part of a panel presentation at a Human Rights Symposium. The topic of the panel was, "How does the Universal Declaration of Human Rights Guarantee Social Economic

Rights for African Men and Women?" My basic argument was that if we are serious about seeking possible answers to problems that affect African masses, we must, among other imperatives, engage their indigenous knowledge systems as sources of knowledge. The chapter thus posits African Orature as an important indigenous site of knowledge that is rich with lessons on values and ethics pertaining to human rights. My evocation of African Orature in human rights debates and other discourses, especially those taking place in the academy, is intended as contestation against not just the colonial negation of Africa as a backward site that is altogether devoid of human values, but an interrogation of a supremacist epistemological mind-set that perceives the West as having the monopoly of knowledge. The debate is pursued further in the next essay, "Transcending Colonial and Neo-colonial Pathological Hangovers to Unleash Creativity," published in a book edited by Kimani Njogu: *Culture, Entertainment and Health Promotion in Africa*, Twaweza Communications, 2005, consisting of proceedings from a conference around that theme. Originally delivered as a keynote address, the talk was supposed to be inspirational, but at the same time provocative, challenging the participants to come up with new visions for Africa, especially in film and media. The basic argument of the essay is that to unleash creativity and emerge with authentic alternatives, progressive African cultural workers must first cure themselves of colonial and neo-colonial brainwashing, claiming the agency to re-define themselves anew. "Burying the Kasuku Syndrome: Constructing Inventive Sites of Knowledge" pushes the same debate even further, provocatively urging higher education practitioners to bury the *kasuku* (parrot) culture of imitation and become inventors of alternative sites of knowledge. This too was originally delivered as a keynote address at a Ford Foundation conference on the theme of "African Higher Education Initiative" held in Nairobi, Kenya, 2004. It was later published as a part of the conference proceedings under the title, *Innovations in African Higher Education*. Once again, I had been asked to deliver an inspirational address that was daring and provocative to the audience – most of them senior higher educational professionals, administrators and university professors – challenging them to become innovators. Using an African Orature

style of composition and mode of presentation, the piece aims at providing a practical example and model paradigm that offers an inventive, alternative way of communicating intellectual, academic ideas. In general, it challenges members of the intelligentsia to invent diverse, alternative sites of knowledge in the various areas of their specialization and expertise.

Most of the essays in this collection highlight women as indispensable resources in society, constituting a major driving force in every aspect of human development. The essays thus advocate more than just women's inclusion in this historical process, reiterating the absolute need for their full participation, representation and empowerment in all areas of life. By insisting on locating women at the heart of historical action, the essays are underlining the fact that their marginalization, silencing, impoverishment and disempowerment are major barriers standing in the path of potential human development, globally, but more so in Africa, which represents the most oppressed of global humanity.

In titling the collection, *Writing and Speaking from the Heart of my Mind: Essays and Speeches,* I seek to address another concern that has been my favorite theme for quite sometime now. Indeed, the concern comes up in some of the essays in this book. Namely, that mainstream academy has come to perceive respectable academic work as that which is defined by a set of facts, processed by an "abstract" mind that produces what is sometimes viewed as "objective" and/or "neutral" knowledge. Under this definition, any scholarly discourse that registers feeling and or passion is dismissed as non-academic. Yet, as we are all aware, nobody thinks, reasons, analyzes, writes or speaks from an idea-free space that can be described as "neutral." Scholars and thinkers are products of a human environment that shapes their thinking through socialization, culturalization, education and other processes. To complicate the matter even further, the processes are in themselves operative tools of systems and institutions that are laden with values and ideological "meaning." Furthermore, factors such as race, ethnicity, class, gender, religion, age, differences in ability and other "locators" in life influence our view of reality in very concrete ways. They define the context as well as viewpoint from which all individuals – including

scholars – think, speak, write and practice. Given this understanding, I offer no apologies whatsoever for insisting on making a linkage between the heart and the mind as interconnected complementary spaces from where intellectual thought is processed. Indeed, I seriously believe that any scholarship or knowledge claiming to be devoid of feeling is in essence pretending to be "extra" human and if unchecked this kind of arrogance can lead to alienating, if not annihilating, elitism. It seems important to me that the mind should have a "heart" if what it produces is intended to enhance human growth. Equally clear is the fact that to enhance true human growth, academic discourses and theories must translate into concrete, practical action among the communities around us, as well as within the larger global community, through their application to real life situations. In so doing, scholarship will become an agent for social transformation, building the world into a happy "home" for all human beings and not just the privileged.

Drawing their beat from "the heart of my mind," these essays and speeches seek to be conversational, aiming at dialogue with the reader. They deliberately avoid using alienating "post-modernist" jargon, which has come to be viewed as the standard mode of communication and mark of academic achievement. At the risk of self-repetition, I offer no apology in embracing the notion that my mind has a heart. This is because I am persuaded that the challenge of the 21st century is not to flaunt knowledge, but rather to humanize it by using it to "name" injustices, seek agency and then map out alternatives for the collective advancement of all global societies, especially the powerless. In doing this, we shall have created new possibilities for all humankind. As we speak of this century being the age of information explosion and unprecedented technological advancement, therefore, let us also vow to turn the era into a new historical chapter that will propel individuals and collective groups to the heights of their human potential. This is the challenge posed by *Writing and Speaking from the Heart of my Mind: Essays and Speeches.*

Mĩcere Gĩthae Mũgo
Syracuse, New York

Part I

AUTOBIOGRAPHICAL TOUCHES USING A BLACK FEMINIST BRUSH

Chapter 1

THE ROLE OF AFRICAN INTELLECTUALS: CRITICAL REFLECTIONS OF A FEMALE SCHOLAR, UNIVERSITY OF NAIROBI, 1973-82 AND THEIR RELEVANCE TO THE US ACADEMY

In the spring of 1994, I attended the New York African Studies Association annual conference, hosted by the Africana Studies and Research Center at Cornell University as an invited guest. During one of the panel discussions, Joseph Okpaku, a longstanding publisher, launched a scathing critique of a colleague whose paper was so overburdened with the exposition of other scholars' theories that, according to Okpaku, there was little of his own reflections. Okpaku challenged him to compile a manuscript without a single footnote and he would publish it without conditions. The practice under challenge here is that elitist academic culture regards a publication as unscholarly unless it is loaded with quotations and footnotes from established academic *gurus*. Okpaku's critique goes even further to identify this practice as a problem that could enslave and paralyze emerging scholarship, especially in Africana Studies.

Taking heed of Okpaku's intervention, this chapter will be mainly based on my reflections. However, an attempt will be made to relate the recapitulated debates to theoretical formulations and ideological

frameworks that help elucidate as well as contextualize them. The coverage will highlight the years 1973-82, the period I spent at the University of Nairobi, Kenya, East Africa, highlighting the plight of women intellectuals. The focus on women is pertinent because in spite of the milestones made by women's movements globally – especially during the United Nations' Women's Decade culminating in the Beijing conference and the years after – the woman's narrative still remains largely silenced under patriarchal domination.

But having taught in the United States of America for a total period of about 20 years now, I also make a connection between the 1973-82 intellectual Kenyan scene and academic repression in America, often covert but at times blatant, especially over the last few decades. One key common factor is that like Kenya, America's systemic injustices and repressive practices reproduce themselves within academia, directly or indirectly, and in turn, repression in academic institutions inevitably leads to more repression through society as a whole. This is because very often, the theories that the academy produces filter out into the larger society as "truths" and as "policy" guidelines. I will ground this proposition in the conclusion by showing the similarities between Kenyan and American encounters with academic repression. But we can see other parallels as well, such as the stigmatization of critical thinkers as "communists" and the vilification of intellectuals who engage in activism as "unscholarly," labeling that often affects their tenure.

The chapter will be in two main parts. The first will deal with a definition of African intellectuals, placing them in three broad categories, followed by an analysis of the general characteristics typifying each. The second part will be a re-visitation of the Kenyan intellectual scene in 1973-82 with a focus on the plight of women intellectuals, highlighting a personal detail. However, as intimated, the debates I describe within the Kenyan context are just as relevant in a US context, seeing that historically, progressive thinkers in societies that suffer from domination and repression share similar experiences.

The Historical Context

In defining intellectuals from the African world and their role in society, one cannot avoid making a historical connection between

them and the colonial or neo-colonial classrooms that intellectually fashioned them, as well as the econo-political systems to which molding spaces are answerable. This linkage is important because there is a growing tendency to view scholarship and intellectual endeavors as zones of "neutrality," "objectivity," and non-partisanship. The notion is propelled by the fact that intellectuals in Africa (and elsewhere) have always occupied a very privileged position in society, often being referred to as "the brains" of their societies, "the cream" of their nations and the "think-tanks" of their worlds. Moreover, they are designated the prerogative of leadership – whether they have demonstrated leadership qualities or not. With years of hindsight, we realize that this may be a part of what is wrong with Africa's leadership, which is dominated by intellectuals from the colonial and neo-colonial eras. Okello Oculi, a leading African Political Scientist, once described African intellectuals as spoilt children who pout when nobody pays attention to them. *Wananchi* (Kiswahili term for ordinary people) look upon them with awe, referring to them by their titles rather than by name. Many of them suffer from what I call "the first one ever," "the only one" and "the one and only one" syndromes.

In the case of Kenya, the majority of intellectuals would have received their education from legendary former colonial institutions that had the agenda of training an elite leadership reflecting the image and ideas of colonizing powers. The hidden agenda was that these elites would become collaborators aiding with the domination of their own people. That some of them rebelled and became matriots/patriots and revolutionary leaders was, as far as the imperialist powers are concerned, tragic. Clearly, in Africa, what W.E.B. Du Bois described as members of "the talented tenth" were groomed to become not just monopoly owners of intellectual production, but to act as deities and fixed points of reference in relating to *wananchi.*

Kenyan intellectuals fall within the three major categories: the assimilated or conservative, the liberal or co-opted and the rebel or revolutionary. This classification becomes extremely important as it leads to a clearer understanding of the various zones of demarcation and contestation we shall encounter in revisiting the selected academic debates highlighted in this chapter.

Assimilated/Conservative Intellectuals

The first type is best dealt with by Frantz Fanon in his classic works, *The Wretched of the Earth*[1] and *Black Skin White Masks*.[2] In the preface to the former book, Fanon observes:

> The European elite undertook to manufacture a native elite. They picked out promising adolescents; they branded them, as with a red-hot iron, with the principles of Western culture; they stuffed their mouths full with high-sounding phrases, grand glutinous words that stuck to the teeth. After a short stay in the mother country they were sent home, whitewashed. These walking lies had nothing left to say to their brothers; they only echoed.[3]

Okot p' Bitek has provided the most dramatic representation of this type through the character of Ocol in *Song of Lawino*.[4] Indeed, African Orature and the literatures of Anglophone, Francophone and Lusophone Africa are teeming with these characters. Generally, they are seen as traitors, mimics and extensions of the pertaining political regime, either willingly or through coercion. Often they constitute the conservative intelligentsia that crafts the rationale and agenda used by the state to justify the repressive system. Some play the role of the "court poet," writing flattering books in praise of heads of state, including dictators.

Many of these intellectuals are so alienated from the people that the latter's suffering does not touch them. They live differently, dress differently, think differently and speak differently. As indicated, they have mostly been reared in an academic environment patterned along foreign cultural paradigms. Some of them refer to themselves as cultural "high breeds," not so much in the sense of Mũgo wa Gatheru's *Child of Two Worlds*, [5] but in a spirit of distancing themselves from Africa. In their self-alienation they sometimes imagine they have become the people whose ideas they imitate. They are perfect examples of "victims of invasion" described by Paulo Freire in *Pedagogy of the Oppressed*: "The more invasion is accentuated and those invaded are alienated from the spirit of their

own culture and from themselves, the more the latter want to be like the invaders: to walk like them, to dress like them, talk like them.[6]

The largest section of the conservative camp of intellectuals consisted of an older group of scholars, pioneers of traditional colonial mission and government institutions. Many of them were the first to wear Makerere University gowns when this was the university in East Africa, perceived as an academic paradise or Mecca by any ambitious student on an intellectual pilgrimage. These were the men and women described earlier on as suffering from "the first one ever," "the only one" and "the one and only one" syndromes. This group of academic veterans would invoke African traditions to legitimize behavior that benefited them whenever patriarchal structures accorded them privilege, power and domination as "leaders," "elders," and "chiefs." This would happen whenever questions from the youth and other underprivileged groups such as women and workers challenged their positions. They would tell heroic stories of how they had made it to where they were, how the trying journey had called for patience and tolerance, how lucky those asking awkward questions were to have appeared on the scene later when life was supposedly a lot easier, etc.

In summary, conservative intellectuals in Kenya at the period under discussion more than fulfilled their role as defenders of mainstream ideas, however reactionary, including state terrorism, yet justifying this as "rational," "professional" and "intellectual." Many of them were patronizing, condescending and even tyrannical towards students, treating them as irritating nuisances especially when the students dared to criticize the government. They would scold the youth, accusing them of biting the hand that fed them while threatening them with serious reprisals, including grade "burial." They played the role of "Overseer" for the repressive regime very effectively. Similar types are to be found in the US academy where they operate as conservative agents for the preservation of the status quo.

Co-opted/Liberal Intellectuals

The main characteristic of this group of intellectuals – the liberals – is that they view themselves and their ideas as ideology-free.

They argue that academic and intellectual discourses should be "neutral" and "objective," neglecting to factor in the role of class as well as ideological interests. By and large, their elitist theorization and abstraction of ideas tend to limit and confine debates within the walls of the classrooms. Some of their discourses are so enigmatic that trying to follow the arguments becomes an exercise in frustration, futility and disempowerment.

The liberals have internalized the ethos of dominating education and are, at best, only prepared to criticize it from within its institutionalized structures and frameworks. They are fascinated with ideas and emphasize academic excellence in the liberal tradition, but they basically look upon knowledge as theory. The kind of practice and problem-solving approaches that would translate knowledge into transformative action are never urgent or high on their agenda. Using abstract notions of "academic freedom" and "freedom of expression," they argue that the role of the academy is to generate knowledge for its own sake, rather than for practical application to social problems. Many liberal intellectuals make good academic bureaucrats, often occupying departmental chairs, deanship positions and other hierarchies of the university's administrative structures. A number of them get appointed in senior government positions within the Civil Service, becoming the political system's policy makers and enforcement agents. What Isa Shivji has called the ideology of "enterism" is popular practice with this group who really have no serious quarrel with the status quo so long as the system leaves enough cracks for them to squeeze through. Their historic mission, as Fanon puts it, is "that of the intermediary."[7] Their posture in political debates is often accommodationist and at best reformist. It is no wonder their critics have depicted them as fence sitters on the boundaries of ideological discourse.

Most of the intellectuals at the University of Nairobi during the period under investigation belonged to this group. A lot of them had benefited from education in Kenya's leading schools and had then proceeded to the universities of Makerere, Nairobi and Dar es Salaam, or other institutions abroad. They had been tutored in the best of the liberal academic tradition demanding excellence and high competition, but a moderate worldview, sometimes tempered with

religious allegiance. Many of them espoused "academic freedom" and "freedom of expression," but when it came to confronting the system that repressed these rights, the majority would retreat. More importantly, when it came to linking struggles on the campuses to those being waged in the communities, they distanced themselves especially where the working class and the peasantry were involved. Clearly, there was a dichotomy between their articulated theories, espoused principles and praxis. There was a lot of talk punctuated by ambiguity, yawning gaps, silences, retreats and even abdication in the face of crises. These intellectuals were anxious not to be viewed as agitators, seeking to remain "reasonable" and "rational" people who stuck to their books and did not cause trouble to the system. Above all, even when they questioned aspects of human rights abuses, they were eager to explain that they were not "communists" – a phobia to which we shall return.

In *The West and the Rest of Us*, Chinweizu summarizes the role played by African liberal elite intellectuals in protecting and perpetuating the neocolonial status quo as follows:

> African liberals, as agents of an international liberal imperialism, have a special job: to spread the liberal ideology in Africa... Though they advertise themselves as serving Africa, they operate in an environment, with a mentality and under conditioned attitudes and direct advice that all tend to yield policies that primarily serve the neocolonial powers, policies that often are in direct opposition to the genuine interests of the African peoples. Conditioned by a pro-Western miseducation, they see their class interests as tied to those of their imperialist masters, and they readily abandon the interest of their people to protect those of their class.[8]

Basically, this group believes in the system and will not endanger possibilities of self-advancement such as job promotion or nomination to executive positions. They dare not risk slowing down the race towards the acquisition of the good things of life, away from the poverty of academic existence: residential mansions, posh cars, gifts of land and national titles from the government in exchange for silence and or co-operation, and so on. Only a small percentage has

demonstrated enough principles and courage to withstand these coercive maneuvers from the powers that be. In the US, this type is all too typical, consisting of careerists who mainly use knowledge for abstract projects and self-advancement.

Rebels/Revolutionary Intellectuals

The third category of intellectuals is constituted by rebels. Like their conservative and liberal counterparts, many radicals were educated in either mission schools, or colonial/neo-colonial government schools or in foreign countries. However, at some point they identified the classrooms that taught them the ABC's of dominating cultures as factories for churning out false consciousness. Africa is full of examples of this category of intellectuals, including state figures such as Kwame Nkrumah, Amilcar Cabral, Agostino Neto, Eduardo Mondlane, Julius Nyerere, Patrice Lumumba and others. In a classroom situation, those who belong to this category see themselves as positioned at the battlefront of contending ideas and clashing frontiers of knowledge. To them scholarship, research and learning are not neutral processes, but rather parts of a deliberate agenda specifically designed by the system in power to support its economic base, as well as propagate its controlling ideas. They view themselves as advocates for the rights of ordinary people. Whether or not all of them live up to this self-appointed responsibility is another issue.

Many of them have been influenced by Marxism-Leninism as an ideological framework of reference and within this context see themselves as "the vanguard" for revolutionary change. Again, whether most of them have stood or will stand the test of time over prolonged struggles, or fall on the wayside is an important issue, especially in this era of renewed fights for democratic change. Whether they will act differently once in positions of power remains a crucial test in the continuing struggles for genuine change. What has become clear over a period of time is that generally, this group has also tended to be characterized by loud talking and exhibiting paralysis when it comes to effecting revolutionary change. They have tended to treat revolutionary consciousness as an intellectual game. They will even go as far as cultivating personalities and lifestyles

that define what they perceive to be "revolutionary." A number have been known to intimidate those around them with their arrogance and alienating elitism while parading as the saviors of their worlds. Moreover, in academic discourse some intellectuals from this camp have tended to theorize so much that the knowledge and experience articulated has often failed to touch real living individuals, remaining the abstract monopoly of the learned. This gap between theory and practice becomes very important when we examine the impact of this category of intellectuals on Kenya during the 1970s and 1980s in particular.

With time it became clear that for as long as the rebels just made noise among themselves on the campuses and other academic venues, the government remained unperturbed. The problem arose when the group started organizing around and outside the campus, crossing the academic fence in order to reach out to the community for dialogue and action. This turned into a threat against the status quo and harassment became the order of the day. The group was seen as crossing boundaries beyond which the government had not allowed or granted permits. They were undermining the controlling principle of "divide and rule," which was unacceptable in the eyes of the authorities. As Paulo Freire observes, in education for domination, the elites are taught to "think without the people" while selectively 'thinking *about* them' for the ulterior motives of domination and control:

> They do not permit themselves the luxury of failing to think *about* the people in order to know them better and thus dominate them more efficiently. Consequently, any apparent dialogue or communication between the masses is really the depositing of communiqués, whose contents are intended to exercise a domesticating influence.[9]

Realizing the dangers inherent in this posture, waking up to the understanding that the people and the students they taught were their "constituent matrix, not mere objects thought of,"[10] the action-oriented category of progressive intellectuals went all out to demystify their ivory tower status. They decoded their language so that there was communication and dialogue with the students and

members of their constituent communities. They organized out-reach symposia in schools and colleges. They initiated community projects and devised research methodologies that ensured the participation and the empowerment of the people. They became rebels. Important as these developments were, however, what these people often overlooked was the urgency of identifying tactics that would help them dodge the now widening net of repression, denial of academic freedom and abuse of human rights. Naively, they exposed themselves unnecessarily, especially given the climate of censorship and terror unleashed by the state machinery. An unsympathetic right-winger once scolded me asking: "What did you people expect? You were all over, creating rabble as if daring the police to come for you!"[11]

Except for the unfortunate assumption in this statement that freedom of speech is a privilege rather than a right, this vicious attack contains an important lesson. Progressive intellectuals needed to learn guerilla warfare tactics to avoid self-exposure. The heightened persecution of progressive academicians and gross violations of human rights eventually taught the rebels that they were dealing with a tyrannical system and needed new tactics. To use an analogy from Achebe: "Eneke the bird says that since men have learned to shoot without missing, he [she] has learned to fly without perching."[12] Under repressive neocolonial conditions it is necessary for the class of progressive intelligentsia to become what Walter Rodney once described as the "guerilla intellectual." Although Rodney was advising the left on teaching in the capitalist classroom of the United States of America, his advice is just as relevant when analyzing the Kenyan neo-colonial university classroom:

> I use the term "guerilla intellectual" to come to grips with the initial imbalance of power in the context of academic learning. Going beyond the symbolism of the building, I'm thinking also of the books, the references, the theoretical assumptions, the entire ideological underpinnings of what we have to learn in every single discipline. Once you understand the power that all this represents, then you have to recognize that your struggle must be based on an honest awareness of the initial disparity. And that's how

> the guerilla operates. The guerilla starts out by saying, the enemy has all and we have nothing in terms of weapons, but we have a lot of other things. We start to make and invent what we actually have, and use that strength to transform the actual logistical position over a period of time into one where we call the tune and ultimately carry the battle to the enemy. This is the symbolism, if you like, behind the use of the term "guerilla intellectual."[13]

In closing this section it is important to acknowledge that over time Kenya has witnessed a significant presence of progressive intellectuals with true revolutionary consciousness. A number served terms in preventive detention and prisons on trumped-up charges while others managed to escape the net and go into exile. Many lived for long periods under police terror and constant harassment. A number of those incarcerated returned home to join ranks of the unemployed even though they possessed skills that the country was in dire need of. The government blocked their employment as a way of punishing them and coercing them to become collaborators. Their partners, children and family members became targets of this harassment. Sheer will to survive became an act of heroism on their part.

It was partly to the credit of the rebel group that Kenya's neo-colonial government came to be exposed to the international community as repressive. The sacrifices these intellectuals, their students and the masses of Kenya made – especially during the 1970s and 1980s when rebellion was not fashionable – have greatly contributed to the minimal democratic space that Kenyan people have managed to negotiate during the last few decades. Similarly, US progressive intellectuals have historically played a vital role in the assertion of civil and academic rights, but ironically, the struggle grows tougher with the consolidation of American imperialism.

The University of Nairobi and the Kenyan Scene

Broadly speaking, the above three groups were the major contenders on the Kenyan intellectual scene in the seventies and one can safely argue that the categories apply to this day. However, during President Daniel arap Moi's dictatorship (1978-2002) the

ranks of the progressives had shrunk while those of the liberals and the conservatives had grown. This was largely due to the dictatorship's tactics of coercion and bribery in an effort to isolate the progressives. During the 1992 national elections many conservative university professors served as KANU (Kenya Africa National Union) "youth wingers," never mind that some of them were in their 40s, 50s and 60s! Even more ironic was the fact that some who once belonged to the revolutionary class had not only abandoned the ranks of progressives but joined the "Youth 92" movement. Undoubtedly, the notion of intellectuals as revolutionary leaders' calls for serious interrogation given their opportunism, shifting loyalties and dubious alliances at critical moments in history. In this regard Frantz Fanon's analysis in "The Pitfalls of National Consciousness"[14] remains prophetic.

In the 70s and early 80s, the University of Nairobi campuses were beehives of academic activity all year round. Students, professors, and even the communities around the campuses seemed hungry for debate and intellectual exchange. A professor who went into the classroom ill prepared regretted it. Students would go into the library, read about the latest debate and walk into the classroom armed with information, ready to test the professor's knowledge. Walking between the classroom and one's office made a long journey, for, students would stop one every few yards to "disagree," or "partly agree" or "fully agree" with what one had said in the classroom. These extended debates outside the classrooms were the most exciting aspects of intellectual dialogue on the campus.

Then there were public lectures and seminars, featuring local, national and international speakers. On such occasions, the audience would sometimes arrive up to an hour ahead of time to secure seats. At times lecture halls would be so full that students would sit on windowsills and debates often continued late into the night. Indeed, a few well-attended public lectures around the open quad witnessed agile students climb nearby trees to listen to the speaker(s) on the public speaking system. All over the country hunger for intellectual exchange was incredible. I recall speaking once at Chanzu Teacher Training College outside Mombasa in 1978. Although the public lecture was not compulsory, nearly the whole college turned out to

hear me on a Saturday evening when they could have been out in the town's nightclubs. The sea of bodies in front of me inspired me. These were exciting times: historical moments for believers in the power of knowledge and its agency in creating true (as opposed to false) consciousness.

Seminars, symposia and workshops were usually packed and the discussions would be so animated that the notion of being on the "hot seat" was no joke. The audience would actively punctuate the presentations with remarks of approval or disapproval, but without becoming unruly. Following the discussions even the harshest of the critics would treat the presenter to a friendly cup of tea or coffee. There the debate would continue, sometimes till the small hours of the morning in the case of a night event.

The years between 1973 and 1982 were bursting with critical issues, both on the campuses and around the nation. The biggest projects were: overhauling the up to then colonial secondary school curricula, promoting drama and theater in schools and colleges, expanding public lecture series for schools and colleges, increasing outreach to the communities outside the campus, applying individual and collective research to practical community needs, and so on. A lot of professors also served on national panels, boards, councils, organizations and so forth. The Department of Literature (where I taught) sent out a free traveling theater around the country every long vacation. Other than the grading of public examinations, which was paid for, all these activities were voluntary community service. Undoubtedly, intellectuals on the campus were busier than they are given credit for in their service to the nation. It is important to make this point because politicians in Kenya have often dubbed university campuses idle places.

As intimated, in the mid-70s critical national debates saturated the classrooms and corridors of academia as they did the entire country. They resulted from disillusionment with national independence and those who took over power on the eve of *uhuru*. More than a decade of independence had not registered serious efforts to address the concerns that Kenya's liberation had placed on the table. Instead, a capitalist, neo-colonial economy had taken root; active promotion of foreign investment had become an official eco-

nomic policy; the crisis of landlessness had remained unresolved; poverty had increased; rampant corruption and the amassing of wealth by the rich were the order of the day; continuing bans on workers' strikes were crippling the unions, and so on. What Fanon had observed at the inception of African independence was true two decades after the words were uttered:

> There exists inside the new regime... an inequality in the acquisition of wealth and in monopolization. Some have a double source of income and demonstrate that they are specializing in opportunism. Privileges multiply and corruption triumphs, while the morality declines. Today the vultures are too numerous and too voracious in proportion to the lean spoils of the national wealth.[15]

Among the legislators who spoke up against these ills was the then member of parliament for Nyandarua North and former Mau Mau detainee, Honorable Josiah Mwangi Kariuki. Though a millionaire, Kariuki recognized the poor's grievances and advocated a systemic redistribution of wealth, including his own. He was extremely popular all over Kenya and was referred to as the poor people's advocate. Following a prolonged period of government harassment, including a trumped-up bankruptcy suit, Kariuki was assassinated in the most brutal manner. There was a national crisis with demonstrations virtually bringing everything to a standstill. For several weeks the people of Kenya claimed freedom of speech and set up *kamukunjis*[16] led by Nairobi university students. For once, the majority of Kenya's population was with the progressive university community in their denunciation of and demonstrations against the assassination. A lot of liberals joined in and even a section of the conservative camp agreed that things had gone too far.

Following Kariuki's burial, the government mounted a vicious purge chiefly aimed at the campus. Progressive outspoken student leaders were arrested, harassed and ultimately expelled from the university. Many of the lecturers were similarly harassed and kept under fierce surveillance. During the following few years, every aspect of US-style McCarthyism informed the Kenya government's dealings with progressive academicians. KANU party hawks

warned Kenyans against imagined "communists" on the university campuses who threatened the security of the nation. One semi-literate KANU hawk got so carried away with castigating the imagined band of communists that he vehemently urged Kenyans to demonstrate sufficient patriotism by going to the Nairobi campus in order to capture Karl Marx for whom he advocated immediate deportation. In the hope of capturing Karl Marx, the police intensified their spy network on the campuses including posting paid informers in the classrooms. Progressive faculty and students were rounded up for interrogation. The questions asked clearly pointed to the presence of spies in the classrooms where alleged "seditious" utterances were made. With the communist phobia there emerged sharp divisions among the various intellectual groupings described earlier. With time some of the conservatives joined in the fray of McCarthyism and witch hunting. A few of these honorable academics were suspected to be paid police informers. Most of the liberals either observed silence or condemned what was happening in whispers behind closed doors. The hunt for the rebels was on.

With aggressive foreign investment and installation of US military bases in the country, the situation worsened. The government took to issuing frantic bulletins ensuring foreign investors that the climate was secure for investment. Kenyans were being continuously reminded, *Hakuna cha bure!* (Nothing is for free). Regarding the redistribution of land and wealth, the government preached: "willing buyer; willing seller." Property was viciously protected and robbery with violence accorded the death sentence. Police mounted harassment against street hawkers, open market traders, road kiosk owners, *jua kali* artisans and other petty business owners. They chased street children, known in Kenya as "parking meter boys" (there were some girls as well) and homeless people, sweeping them from the streets especially when international conferences were about to take place. On the Kenyan coast, the beaches were packed with foreign tourists and "child prostitutes" (boys and girls) were becoming a part of Kenya's catalogue of growing problems. In the meantime, the government was becoming even more repressive on the university campuses and all over the country. More than three

people having a gathering had to secure an official permit or the meeting could be deemed illegal.

In the heat of these tensions, two calamities directly related to foreign ownership and the presence of US military bases rocked the nation. At Thika, a town forty or so miles from Nairobi, a guard at a Del Monte pineapple plantation unleashed dogs on an adolescent school girl named Waithera as she was passing by on her way home from school. The animals mauled Waithera to death. The court set the offending guard free and imposed an insignificant fine on Del Monte company. There was a national outcry. Meanwhile, in Mombasa on the coast, an American sailor, Sandstrom, who was in a contingent of sailors on a US Navy mission, had gone to a night club and met a sex worker, Monica Njeri, and arranged to go to her apartment. When Sandstrom violated a verbal contractual agreement, a quarrel arose. He split Monica's stomach with a knife, ripped her guts out, and sprawled them on her apartment's floor. A high court judge – English by origin, as were most judges at the time – fined Sandstrom 500 Kenya Shillings (approximately US $10 or less during the 1970s) and bonded him to be of good behavior for five years. The "honorable" judge described Sandstrom as a young man of good behavior, with a strong Christian background, who had been enticed by a "prostitute."

Coming as they did on top other grievances, these incidents caused an outrage across Kenya. Progressive students and faculty organized public lectures, seminars, symposia and *kamukunjis* to denounce the atrocities. I was a part of these protests. There was country-wide solidarity with our efforts including some progressive religious groups. The liberals and even some conservatives partici-pated in the public discourses. As expected the government stepped in. Forces of the paramilitary police, known as the GSU (the General Service Unit) and troops of the regular police force were unleashed on the campus and whenever they invaded these spaces, they came with a vengeance, violently attacking students indiscrimi-nately – whether they were a part of the protests or not. The theme of police brutalities on the campuses would require another essay altogether. One detail that cannot be omitted, however, was the use of rape as a weapon by the invading state repressive forces, which

has happened across imperialist histories of invasion, repression, war and conquest. Pools of blood and blood-soaked underwear in the classrooms, dormitories, the library and other spaces told most tragic stories of bestiality, violation of women and patriarchal assertion of sexual power. The offenders were never apprehended, let alone brought to justice and this remains a terrible stain on Kenya's historical canvas – a serious testimony to repression.

By the end of the 70s, it had become clear to the progressive wing of intellectuals that the most effective form of change would only come with the involvement of the Kenyan people. The panic the Kamĩrĩĩthũ theater project[17] had caused within the ranks of Kenya's ruling class had demonstrated this. Correctively, intellectual activists began to structure their research projects to include participation from the people. The university academic staff union made more deliberate linkages with workers unions and the Students' Union, with which a lot of informal networking was already in process. It engaged in an intensive recruitment campaign and emphasized networking among the various campuses, which created a sense of power whenever the union raised its voice. As campus activism heightened, the government announced more stringent measures to curb academic freedom, and one Saturday afternoon, an announcement on government-controlled media reported that during a speech he had made congratulating a wedding couple, President Moi had banned the University of Nairobi's academic union. This is the arbitrariness with which national policy was often determined and announced in Kenya under Moi's dictatorship. The nation was perceived as the personal and private monopoly of the president, who had declared himself as constitutionally above the law.

The Fight against Patriarchy

On the campus itself, it was becoming increasingly obvious that the state's efforts to co-opt administrators and academicians in positions of power within the university structure were succeeding in enforcing repression. Most senior positions were occupied by men and many of them tended to be just as autocratic as their government partners. They were generally ruthless with the students and condescending towards their colleagues, especially the "juniors."

Some deans and department chairs were known to threaten outspoken colleagues, telling them that they would never get promotion unless they shut up. Students would be threatened with failure if they refused to be submissive. Some of these so-called male leaders were downright sexist towards their female counterparts. There were episodes of sexual harassment but most victims would be threatened into silence. The campus was, undoubtedly, becoming a microcosm of the neo-colonial world. At the time I was an active official of the Kenyan Writers' Union, an outspoken member of the University of Nairobi Academic Union and an activist in several groups and organizations organizing against repression and abuse of human rights underground.

Progressive intellectuals and activists were in agreement that Moi's repressive regime and its collaborators should be taken to task in spite of the inherent dangers. We constituted a strong caucus of faculty and featured prominently on intellectual fora around the campus. We decided to start with changing the academic leadership on campus. In the Faculty of Arts (comprising the arts, humanities and social sciences) deanship elections were due at the beginning of 1980 and we unanimously agreed to field a woman candidate. The choice of a woman candidate was a deliberate statement in recognition of women intellectuals who were a tiny minority in the faculty, most of them "juniors." I believe I was the only female senior lecturer in the Faculty of Arts then. When I was nominated as the deanship candidate, all hell broke loose. I was plagued with all forms of intimidation, including stalking and life-threatening anonymous telephone calls. Still, I won the deanship with an overwhelming majority vote against a male candidate who was a conservative full professor and the administration's preference. We were given to understand that the government ordered the University Registrar to nullify the elections immediately, which he did even though he had been the election's returning officer and had publicly announced my victory. He issued an official bulletin announcing that he had appointed the defeated candidate to serve as Acting Dean until further notice. The activists issued a counter statement, with my consent, asserting that I was the elected dean and would not step down.

The CID (Criminal Investigation Department) police swung into action and threatened me with arrest if I did not step down. At times they would coax me to resign advising me that my activism was not befitting of a respectable woman. When it became apparent that neither the activists nor I would give in, and that campus protests (referred to as "riots" by the government) were about to break up, the decision was reversed and I was "allowed" to assume the deanship.

At the gender level, that election campaign brought to the fore very important lessons, one of them being discrimination against women, especially if they happened to be progressive. As soon as the conservatives knew that a woman candidate was being fielded for the deanship, the patriarchy in them emerged and they went on the offensive. Some of the attacks were general, maintaining that women were not capable of leading while others were personal and vicious. At the personal level I was declared unfit for executive leadership because I was suing for divorce and in their eyes this was scandalous. Those who did not want to beat about the bush simply declared they had no intention of being led by a woman. The cowardly sent threatening, abusive and sexually graphic messages anonymously via telephone: "Stay home and look after your children and husband like other women"... "if you don't withdraw your candidacy, we will teach you an unforgettable lesson to remind you that you are a woman" (read physical abuse and possible rape)...; "your husband should give you a few slaps to discipline you"...; "it is no wonder you are abandoning your husband..." etc., etc. Crude versions would degenerate into graphic, pornographic insults. It was unreal... The point of reference had suddenly ceased to be my academic competence or tested leadership qualities, the sole criterion now becoming my gender.

Witnessing so much hysteria stirred by a woman's candidacy for the deanship was instructive of how viciously guarded the monopoly of male power and custodianship of knowledge had become in the academy. The conservatives regarded the protection of this monopoly as a matter of life and death. For them, allowing a woman to become dean was like standing by watching coup-makers overthrow them and their fiefdoms: niches of power they had inherited from

colonialism which was patriarchal itself and that they regarded as god-given. By seeking to dismantle patriarchal control and domination, the rebels were committing sacrilege and hence agents of state coercion would have to be brought in to stop the move. Concerned friends tried to persuade me to withdraw my candidacy. However, unwilling to abandon the activists' collective agenda, I became all the more adamant to face the challenge. Solidarity between progressive colleagues and student activists was so solid that there was no looking back.

Another instructive aspect in this deanship race was the close connection between the university dons and government. Long before the elections, during a police interrogation episode, the interrogators had leveled sexist insults at me that were very similar to the ones cited above. They had accused me of trying to be a man and failing to be a "proper woman" through my activism, advising me that politics were the prerogative of men. The interrogation session turned into a sexist harangue:

> "Remember this is not the university where you talk as you like. You are in front of men now. So, watch out... We can beat you senseless and so don't try your sharp tongue here... As for your husband: does he live with you in the same house? ... Hey, God is strange indeed. How did he give you children? ... Poor kids! They might as well not have a mother... You think you are a man, don't you? ... If you play with us we will strip you and check you out!"[18]

These patriarchs were clearly offended by the idea of not just having to deal with a woman intellectual, but with one associated with struggles against neo-colonial injustices. Manifestations of this resentment had been witnessed over time in the form of mass student rapes by the police and the general service unit whenever unleashed on the campus to stop demonstrations. As mentioned before, following the invasions, classroom floors would be littered with women's underwear and blood splattered all over the place, narrating the sad story behind the visible mess. This antagonism against women rebels is so socialized by patriarchal upbringing that the police have come to use it as a weapon especially in repressing

rebellious women. The other reason behind gendered violence is the need to create fear in order to silence women, for, rebellion is the first step towards liberation. When women suffer silently and accept domestication, they are, in essence, assisting their captors to police their own oppression and enslavement. Those who exercise control love this because this way they do not even have to enforce subjugation. Conversely, they panic when they hear their victims articulate the source of their exploitation because once the oppressed have named their oppression, the next sure step is likely to be a search for avenues of escape.

Clearly, it only requires a crisis to awaken the beast lying dormant in human beings. This is what happened when patriarchs and sexist bigots saw a woman stand for election to become a faculty dean. The same men, who will sentimentally proclaim how great their mothers are when it suits them, were hounding another woman for exercising her rights. One wonders whether beyond sentimentalizing these patriarchs truly perceive their own mothers, sisters and wives as full human beings. My suspicion is that in reality, the only condition on which patriarchal males accept women is when the latter accept imposed servitude, for, under sexist socialization, to dare transcend or diverge from the traditional women's roles of wives and mothers is a form of transgression.

Between struggling against state repression and patriarchal oppression the academic environment at the University of Nairobi was no rose garden for women academicians. Even when opposition was not openly articulated, the atmosphere was often hostile and alienating. Indeed, being in the minority around so many male colleagues served to make it appear as if the few women scholars who were around were academic gate crushers. But I must emphasize that the patriarchal mindset and violent misogyny described above did not apply to all male colleagues. There were many exceptions, mostly among the progressives. For instance, progressive male colleagues were behind my nomination for the deanship and not only campaigned vigorously for my election, but constituted the opposition that overturned the nullification. I was also fortunate enough to be in the Department of Literature where most men were

advocates for gender equality, which is not to claim that they were altogether liberated from socialized and internalized sexism.

Conclusion

In concluding, I would like to go back to the question I asked at the beginning: what relevance does the foregoing have to the social-academic situation in the US? I would argue that there are direct and indirect applications. Direct applications involve the role of the state, especially after 9/11, to use "national security risk" as an excuse to violate people's freedoms and human rights, including those in academia. Both Africa and the US have used "Red Scares" to demonize opponents as "communists," and now the very same tactics, more so in the US, are being used to vilify intellectuals and opponents to government as "terrorists," which then grants the state the presumed right to harass, repress or imprison them.

Indirectly, it is critical to remind ourselves that repression does not have to necessarily use guns, weapons, torture or terror to be effective in undermining academic freedom, for institutionalized racism, surveillance, profiling, policing of "proper" disciplinary and discursive boundaries, and such other practices can be just as repressive.

And whereas, unlike in Kenya, I personally have not experienced the police knocking at my door in Syracuse to take me away for security interrogation, I know fully well that many US citizens have been subjected to police brutality and state harassment, and many have been imprisoned for exercising their constitutional rights. A taste of what they go through once behind bars has been evident several times when I have been taken to a room for a body search at an airport security point. The "barking" and aggression by some of the officers is so crass that describing the experience as humiliating is an understatement. The same can be said about some police encounters, even when they are for "routine" purposes. As for my experience with frequent airport security checks that I am told are based on "random" computer picks, what can I say? How does one accuse computers of profiling? What I have witnessed even more regularly in the US, however, is institutionalized racism, gender inequities, disability marginalization, disciplinary discrimi-

nation, and many other practices that make a mockery of the claim that the US is the world's beacon of freedom and democracy. Similarly, although I have not been told what I can or cannot write and teach, nor punished for political involvement on campus or outside the university, I know that assaults on academic freedom take many forms, from the overt command to the subtle threat or reprisal. These have become routine and systematic in US universities. Very few institutions are as lucky as we are at Syracuse University where we currently have a Chancellor, Professor Nancy Cantor, who has deliberately created an academic environment that not only challenges institutionalized racism, but one that enhances progressive intellectual work under her vision of "Scholarship in Action" which emphasizes application of theory, transformative community projects and networking between the campus and the outside world.

Thus, while we must be careful not to undermine or dismiss the impact of physical terror as it existed in Kenya during the 1970s and 1980s under a repressive state dictatorship, we must also recognize the seriousness of mental, intellectual and psychological terror – so common in post-9/11 America. This is just as damaging since it affects the academy and the larger world. For, once critical thinking is chased out of the places where it flourishes most, there is no telling how severe an impact this could have in killing off what little intellectual culture there is in the US. Such censorship would not only greatly exacerbate an already existing crisis in education whereby citizens are poorly equipped to challenge their oppressors, but lead to resignation and failure to recognize that oppression exists.

Chapter 2

THE SOUTH END OF A NORTH-SOUTH WRITERS' DIALOGUE: TWO LETTERS FROM A POST-COLONIAL FEMINIST

❧

222 Sapsucker Woods Rd., Apt. 2A,
Ithaca, NY 14850
November 3, 1992

Birgitta Bouch
Mechelingatan 4 B 60 00100 Helsingfors
FINLAND

Dear Birgitta,

I am giving myself the liberty of addressing you by your first name, hoping that you do not mind and also that this will influence you to drop the Mũgo part of my name when addressing me next time. And now, how are you doing at the many fronts of struggle that characterize a woman's life? For, like me, you seem to be all persons in one: head (or is it one of the heads?) of household; mother (and wife); professional; writer; political activist; private and public figure. Well, the Gĩkũyũ language has a proverb that says: *"njogu ndiremagwo nĩ mĩguongo yayo"* (an elephant does not give up carry-

ing its tusks), but, frankly, I must admit that my tusks have proven too heavy over the last two years. However, my usual spirit of "never give up!" continues to be one of my anchors. I will explain what I mean by all this in a moment.

For now, let me ask you to please accept my most sincere apologies for the regretted and unintended role I have played in causing the delay of the North/South women's dialogue. More personally, let me apologize for keeping you under suspense during this past year as my partner in correspondence. Believe me, I find this letter very difficult to write because the long gap that stares at me between June 29, 1991 (when you wrote the launching letter), and today, November 3, 1992, is more than embarrassing – making my task most awkward, to say the least. The irony of it all is that under normal circumstances I am such an avowed keeper of promises and strict observer of deadlines that I am sometimes accused of being "neurotic" where honoring these matters is concerned. Furthermore, my political activism has come to convince me that collective efforts are so "sacred" that not even personal problems should be allowed to sabotage them. Yet, here I am, having allowed just that to happen. I feel awful and wish that I had been more firm about withdrawing from the project at the time I had suggested I should last year. Anyhow, it is too late to regret this now and I do want to thank you for your patience as well as insistence that I go on. I will do my best not to break the contact this time.

Having tendered my apologies let me now take time to explain what went wrong – why I am writing from America and not Zimbabwe. Later on I will have to answer your questions as to why you were writing to me in Zimbabwe and not Kenya. Oh, the stories of my life! Where do I begin now? Oh yes. I think that the last time I communicated with you was when I was in London last year, on my way to the Edinburgh Women's Writing Conference where I was due to give a keynote address. At that time, I had hoped that come the end of December I would have responded to your communicative one of several months earlier. I had clearly underestimated what it would take to wind up seven years of active living and working in Zimbabwe, which I needed to do because I was going to be away on sabbatical leave for the entire year in 1992. The whole of December

was a nightmare. I needed 48-hour-long days to do all that had to be done. And of course, being a single parent, mother of two "minors" by law (in real life they are two very mature and tough women combatants!) amounted to winding up for three people where official business was concerned.

By the end of December, the idea of correspondence had become a dream. The reality was that my fatigue became extreme to the point where I was involuntarily making a public joke of myself. Quite a number of times I found myself driving through red lights, unaware that this was the case and at other times I would be reminded by impatient hooting drivers that I had stopped at a green light – obviously waiting for it to go red in order to move, eh? Dangerous stuff, I tell you! In connection with this, let me encourage you to keep up the tradition you seem to have made a part of your routine: taking off to the countryside during the summer and stealing off to Sweden or some place for a short vacation. If we laboring women do not learn to take time off, cool out and just regroup – emotionally, intellectually, socially, physically, etc., etc. – the responsibilities around us will ensure that our body systems unwind on us, not to mention the possibility of their winding up on us! I am, of course, preaching about the desired ideal. The reality is that most of the time, in order for some of us (and for our children to live), we are forced to remain human bees. When I think how much worse it is for our sisters who are members of the oppressed masses of the world, I become absolutely persuaded that if our feminist struggle does not place the agenda for economic justice at the forefront of the rights we must fight for as women, we will have started the battle from the rear and not the front. If other feminist struggles can afford to do this, those of African women and sisters from the so-called "Third World" will have betrayed the struggle for basic human rights, which the majority of their kind are faced with on a day-to-day basis. They will have assumed a simplistic civil rights approach in addressing the problems that deny life itself to the overwhelming lot of womankind in our stifling econo-socio-political systems today... But let me continue with my narrative.

By the morning of my departure (I had to be at Harare airport around 4 a.m. on Sunday, January 5, for a six o'clock take off), I had

not had even a wink of sleep for two full days and nights. Up to four hours before travel, I honestly did not know that I was going to ever make it to the flight. And I was on the type of ticket that could not be changed in any way. Let me tell you, I only managed to catch that plane due to the love and generosity of some close friends and members of my extended family in Zimbabwe. (My daughters had left two weeks earlier to go through Kenya in order to reconnect with our family, as well as relink with their motherland, following almost a decade of separation). These wonderful people took control of a situation that would have been impossible for me to face alone. They packed up my bags, rescued all the vital documents that I needed for travel from piles of engulfing paperwork, made sure that one of them drove me to the airport and absolutely insisted that what they were doing was only natural! Imagine it being natural to have to go back to my flat the following day (and a few more after that!) to sort out the upside down state of things there! What would we do without friendship and love? Take it from me; some of these people have been sorting out my unfinished personal business up to the present. One of them, Irene Wairimū Sando, a chemist, has had to shoulder all this work for me on top of running her business and mothering her two young children. You know, Birgitta, self-sufficient as I try to be as a general rule, there are times in my life when I know that I would never survive, let alone manage, without collective networking and group support. My departure from Zimbabwe was clearly one of those situations.

Making a stop in Addis Ababa, Ethiopia, for several days, I visited with a very close friend, Hannah Njoki Tiagha, who was working with the UN. The next stop in London reunited me with my daughters, Mūmbi and Njeri, who had flown there from Nairobi. There we spent a healing weekend with a beloved elder sister, Judi Mūthoni Gilmore and her family. Njoki's home in Addis and Judi's in London gave me what I could not find in my own home: sleep, peace and rest. I cannot tell you how much I needed what these two homes gave me as replenishment in order to undertake the final lap of my journey to the United States of America where I was going to spend my sabbatical leave with my daughters, at the Africana Studies Center of Cornell University.

We arrived in Ithaca, New York, in mid-January, under incredible temperatures of around 60 degrees – very odd for north country winter weather. Six hours later there was a mean storm that deposited piles of snow, making the story that was circulating about a green Christmas only some weeks before a bit difficult to buy. The Mũgo family decided to make a joke of this whole drama by boasting that they had taken Ithaca by storm! However, the joke did not last us very long because barely a month later I was taken by storm myself by the unexpected diagnosis of an illness that landed me in a local hospital for an operation. Before I had time to recover from the shock – physically and psychologically – I was hit by a vicious virus attack that almost wiped me out and I mean just that. I had never known that a virus attack could be so dramatic and fateful. It was a frightening experience and it left me a wiser survivor. However, up to now I have not quite recovered from the follow-up "expenses" that these hospitalizations occasioned, at the health and financial levels.

Before my hospitalization here, I knew that under capitalism being poor is a "crime," but now I know that given the unaffordable cost of medical treatment, it is an added "crime" for a person with light pockets to be sick in this United States of America. I have had to take up a full teaching load at Cornell University – which I was fortunate enough to secure – in order to pay up my health bills. Since I essentially came here to finish up the compilation of some manuscripts that I wanted to hand in to a publisher early next year, this has meant an enforced double load of work. Once again, my correspondence has had to be shelved and you are one of the unfortunate victims. But, even though I am under siege, especially in so far as unfulfilled deadlines are concerned, I feel sufficiently strong and defiant of the odds before me to promise that I will do my best not to break the process of dialogue that we have set in motion and that needs to continue.

Now let me turn to some of the questions that you asked in your letter.

First of all, congratulations on having hit the half-century mark a little ahead of me. I am going to be 50 this year. So, other than the roles that we seem to have in common, here is something else that brings us together – the age circle. By the way, being members of the

same generation is quite a big, uniting experience in my indigenous Kenyan culture and in Zimbabwe, my new home. Age-mates enjoy a special bond.

On the question of gender, unlike you, I have never wanted to be male even as a child. In fact, I have always embraced my female-ness. Part of this self-affirmation came from my parents' attitude towards patriarchal values. Both of them, well-known educationists during the 30s, 40s and 50s in our part of Kenya, fought relentlessly for the rights of women – including the then controversial issue of girls' education. There were seven "girls" and three "boys" in the family before the death of one of my younger sisters, just several years ago. We were all brought up as equals and there was never any demarcation line between what patriarchal society considers work for males and work for females. My father used to do household tasks defined by sexism as "women's work" and also encouraged us girls to cross the artificial boundary line mystifying certain tasks as male and "unfeminine." My parents taught us the discipline of productively engaging in manual labor – using our own hands to take care of our personal business and working around the farm/ home – even though there were a lot of domestic and farmhands employed by them. The other influence had to do with my mother's family background. She came from a family of extremely liber-ated women, led by her mother, Nzisa. My maternal grandmother, whom I still remember with unceasing admiration, was petite, beau-tiful, extraordinarily intelligent, articulate, forceful, fearless and also one of the most compassionate of human beings that walked this earth. *Guuka* (grandfather), her husband and a famous teacher, also a pastor in the Anglican Church, was gentle, wise and charming. He too believed in women being equal achievers with men. This is difficult to believe, isn't it? More so when one remembers that my grandparents would have been born in the 1880s or 1890s. Anyway, with this kind of pro-female family background, one always felt good about being a woman. Ironically, I never traced any contradic-tion in a statement that my father used repeatedly, addressing the "girls" in my immediate family. He would tell us: "Always remember that you are my boys!" Now that I think about it, I never heard him

refer to my brothers as his girls. He must have been loudly debating with the world out there and its hang-ups about female children. Perhaps I should tell you a little bit about my place of birth. I was born at a place called Baricho in the Kirinyaga district of Central Kenya, on the slopes of Kirinyaga, that legendary and mythical/ mythological mountain, poetized by matriots, patriots, historians, geographers, mountaineers, beauty lovers and the like. My mother's farm still sits under the majestic grandeur of that awesome mountain with its famed three snow covered peaks: Lenana, Nelion and Batian. So, we are quite privileged to be a part of a natural beauty spot that people travel from great distances to see. It is also important to point out that it was in the forests of this historic mountain (among other places), that the Mau Mau combatants waged the armed struggle against British colonialism. Field Marshall Dedan Kĩmathi operated between Nyandarwa and Kirinyaga mountains, but one of his deputies, later, Field Marshall Mũthoni wa Kĩrĩma, whom I call my *chimurenga* mother (liberation war mother), had Kirinyaga forests as her regular base. From all this you can see that my life seems to have been surrounded by a series of historic and historical struggles since childhood. I am, to a large extent, a child, a product and an extension of these struggles – a note on which I should now turn to the question of why I am in Zimbabwe and not Kenya, my home of birth.

This is another one of my long stories, which I will try and summarize. On the other hand, because the story defines my plight as a woman political activist, struggling against imperialism in a neo-colonial situation, a position which consequently unravels the condition of many other women in Kenya under the same conflicts – women whose stories are not in the international press – I will also have to be careful not to mutilate the account; otherwise I will smother its essence. Let me be quite direct and say that I have been in exile from Kenya since August 1982. When I went into exile, I had just won a divorce suit that I had initiated some years earlier and had been given custody of my two daughters, Mũmbi and Njeri. Mũmbi was just about turning eight and Njeri had just turned six. For the first two years of our exile, we lived in Canton, upstate New York, where I was a visiting professor at St. Lawrence University.

Being the first-ever Africana member of the academic staff at that very fine, wealthy and overwhelmingly white institution, I dedicated my time and energy to the agitation of concerns such as: the hiring of progressive people of color on the faculty, the incorporation of Africana Studies in the curriculum, the strengthening of Africana associations on campus – including the Black Studies' Union – and so on. I was also involved in voluntary community work around the Canton area. I designed and launched a program for African American prisoners at a nearby jail, Ogdensburg maximum-security prison, in which I taught Kiswahili, African History from antiquity to the present and held workshops in creative writing. In between my campus and community activities, I jetted back and forth around North America, campaigning for the release of political prisoners in Kenya and conscientizing my audiences on the abuse of human rights by the neo-colonial ruling classes in our motherland. Take it from me, it was quite an uphill battle then, given the conspiracy of establishment-controlled media in the West, determined to depict Kenya as the epitome of democracy since the regime was capitalist and anti-"communism." As far as the American government was concerned, of course, its military bases superseded the interests of the Kenyan people, and so in its eyes, the police state that neo-colonial Kenya was remained a democracy and the world was actively and deliberately so misinformed. It was a difficult time for us.

During our stay at St. Lawrence University – ideological differences between me and a lot of my colleagues notwithstanding – my daughters and I were really made to feel a part of the campus family life. We experienced hospitality, support, solidarity and love from many people that I need not mention by name since you do not know them. The most moving support came from a community of East African women students, especially a core of Kenyans, led by two particular ones who literally parented Njeri and Mūmbi while I concentrated on political activism. I would not have survived without the support of these young sisters. They were constant and tireless in their solidarity. Students and colleagues at St. Lawrence were also very supportive in signing petitions for the release of political prisoners and in helping with their distribution. The community played quite a significant role in assisting us to expose

the hypocrisy and criminality of the Kenya police state. My courses were always fully subscribed and since St. Lawrence University had a Kenya program, contact with the students who might be a part of this journey provided a very important meeting point. So, St. Lawrence became our first home in exile.

However, much as the St. Lawrence University community, in itself, made us feel a part of it, my daughters and I were not happy living in America. The girls had a harder time than me. They became targets for attack by some of the children they went to school with and were treated to the worst racism that they could have imagined possible, by children like themselves. However, the most distasteful aspect of it was that the oppression came from bullies who were years older than they were. Their class teachers – both of them tremendous, professional people – did everything they could to protect my daughters in the classroom; but life outside the classroom, especially on the bus and the playing fields, was a perpetual battlefront for them. Not even the headmistress, another wonderful individual and professional, could control that. It is to the credit of the girls that their strength, fighting spirit and love for each other saw them through all this. But the experience left emotional and psychological scars that have taken time to fade. In fact, it is not possible for these kinds of dents to go away altogether.

Concern over the development of the children thus became the instigating reason behind my decision to return to Africa after two years of exile; but there were other very serious underlying needs for this return. In America I felt very alienated, geographically, historically and spiritually, from the heart of the political struggle that my comatriots and compatriots were waging at home. I needed to get back to some closer position. Physical removal from the scene of action can become a seriously alienating factor. One stands in danger of losing hold of the heartbeats that dictate the rhythm and pace of the action on the primary ground. Furthermore, I could not deal with the self-whipping that I constantly put myself through every time I stood up in front of my American students, struck by the guilt of the realization that my skills and services were much more desperately needed by our mother continent than by America. These considerations aside, my daughters were losing both of their

indigenous tongues rather fast and I felt that another African locale would at least give them a compensating African language to work with, not to mention a better chance to retain their Kiswahili and Kikuyu, which they had spoken fluently before our departure from Kenya. So, two years following our arrival in Canton we set out for Africa.

The University of Zambia had offered me a position as Chairperson and Professor of the English Department, an offer I had accepted immediately. On our way to Zambia, my daughters and I stopped over in London and while there, we received notification from the University of Zambia that the Moi regime had contacted the government of Zambia at state level objecting to my presence there. That was the end of my intended journey to Zambia. I was stranded in London, without a job or home for a few months. This was another stage in life when the support, generosity, and love of friends and caring relations helped me live through a most destabilizing experience. Another generous act – this time from the Government of Zimbabwe – brought about a solution to the crisis. They invited me to go and make Zimbabwe my home. When way back in 1970 I had become an active member in solidarity work with – among other struggles – the Zimbabwean liberation struggle, an engagement that I had continued with until Zimbabwe's independence, little did I know that this involvement would end up providing me with a home at a desperate moment. That great African country whose ancient history is a symbolic reminder of the continent's contribution to global civilization has been our second home since November 1984. My base has been the English Unit in the Department of Curriculum and Arts Education, at the University of Zimbabwe.

And now another short story to answer a question that I can already read in your mind: why did I have to go into exile?

At the time I left Kenya in 1982, I was serving a second term as the elected Dean of the Faculty of Arts – then the biggest faculty at the University of Nairobi, comprising departments in the Arts, Humanities and the Social Sciences. Interestingly, the faculty was predominantly male, but a good section of my male colleagues had no hang-ups about my academic leadership as a woman and I had

a most productive working relationship with the majority of them. The faculty must have been happy with what we had collectively achieved during my first two-year term of deanship as well because after it, they had unanimously elected me for a second term – unopposed. Among some of the needs we had tried to address was the challenge of relating theory to practice, beginning with the use of our skills and knowledge to serve the masses of Kenya whom we perceived as victims of extremely oppressive socio-econo-political structures under the pro-imperialism, neo-colonial dictatorship of the day. I also belonged to the Kenya Writer's Association, the executive committee of which I was a member. The progressive wing of this association shared the above vision and was challenging writers to use the art of writing and composition in the struggle for economic and social justice, raising an uncompromising voice against the abuse of people's rights at all levels of existence. I was a member of the University Academic Union as well. Among a whole long agenda of the human rights we were fighting for were: the removal of American bases from our country, an end to organized state violence at all levels, and an end to detention and imprisonment of political activists on account of their views, freedom of expression, etc., etc. These and many other activities that helped me contextualize the struggle that needed to be engaged in if women and other oppressed people in our country were to achieve their liberation became a part of my daily life. Inevitably, I found myself in the circle of people targeted by the police for harassment, arrest, habitual investigation and torturous interrogations anytime that the police felt like rounding its victims up. But we survived, through sheer obstinacy and a vision of what we saw as the inevitable end of the oppressive regime on the one hand and the sure victory of the people on the other, however long the struggle might take.

Following the attempted coup in August 1982, there were massive arrests all over the country. I was confidentially tipped that I was to be included in a swoop that was meant to net colleagues and students on the university campus. I immediately left with my two daughters, but under a firm promise to myself and the comrades who helped me escape that I would use all the time and energy possible to internationalize the Kenya struggle. Up to now this is

my mission and I will never look back, for, what has happened to awaken the international community to the plight of the Kenyan people, ultimately stripping the lies that this community has been told about imagined democracy under neo-colonial capitalism, is important if global struggles are to be linked. With the solidarity of other international struggles, the Kenya masses have pushed the Moi dictatorship into a corner and forced the discredited regime to bow to the democratic political process. Unfortunately, even as I compose this communication, the emerging opposition leadership is busy enacting predictable betrayal of this mass-based collective achievement. The big fish are preoccupied with squabbling over who is to be the president of the country, instead of pushing forward the issues on the people's agenda for real socio-econopolitical liberation. It is sad. Still, I have faith in the people of Kenya and if nothing else happens, the experience will have left us more politically mobilized, will have created some space for us to debate a little more freely and will have taught us that true leadership will ultimately have to evolve from the masses themselves, being defined by the form that the struggle takes. The history of elitist leadership, however progressive its claim, will need very systematic proof to correct its betrayals of our history of collective struggle.

You asked about my books. When I published my first three titles: *Daughter of My People, Sing!* (poetry), *The Long Illness of Ex-Chief Kiti and Other Plays* and *Visions of Africa* (literary criticism), I deliberately chose a local publisher, in the spirit of promoting our local publishing houses. In this particular case, I was dealing with the East African Literature Bureau, a child of the East African Community, which I believed needed to be nurtured as an experiment in regional co-operation. Many of us were saddened by its break-up. With that demise emerged the Kenya Literature Bureau, as a part of the Ministry of Education. Its distribution of books has been very poor, especially internationally. Compound that problem with the fact that according to the government I am a "dissident" and you have a major part of the statement of my problem as far as the books go! Well, I have to do something about getting them re-issued by another publisher. In the meantime, I will try and get some copies for you even though this may take quite some time. By the way, has

the copy of *The Trial of Dedan Kĩmathi* that you were looking for resurfaced? It is the kind of work that should be readily available on inter-library loan, and so I hope that you have managed to secure another copy.

I would very much like to read what you have written as well. You said that *This World Is Ours,* the work you have coauthored with Carita Nystrom, is in English. For some reason, it is not in our library here and I wonder whether you would be kind enough to send me a copy of it at some point, or to give me details about the publisher so that I can do the ordering myself. I would appreciate that. You see, I am engaged in discourse touching on women's liberation and consequently, I have a deep interest in examining aspects of feminist theory and praxis. In fact, right now I am teaching a course on African and African American women's biographical and autobiographical sketches in which I use feminist theories. So, I would very much like to hear what you and your colleague have to say about these matters.

I was quite fascinated by your language status as a member of the Swedish-speaking minority in Finland. What is the political history behind this? Artificial boundaries? Conflicts resulting in dispersion? Migration? I need some education on this as my knowledge of your part of the world is rather limited – thanks to the British concept of global education that taught its products so little outside its empire! Believe me, I have spent the better part of my life re-educating myself in response to the miseducation that denied us a true knowledge of ourselves, our history, and our culture, while also leaving us rather ignorant of anything that was not British or British-made, as it were. So you see, I need your help and solidarity in this process of self-education.

And while you are at it, please tell me: are you considered a Swedish writer by the Swedes or are the geographical boundaries so firm that you can only be a Finnish writer working in Swedish? I have a feeling that I may seem to be asking the obvious, but I am deliberately provoking the nationalist debate in an effort to suggest that we need to do a remapping of a lot of these boundaries that artificially separate people all over the world. The African case and the frightening carving job of the continent that was done in Berlin

during the so-called scramble for Africa by Western imperialist powers, who really proved to be professional civilization butchers, is of course a tragic demonstration of this. Last semester, a Nigerian colleague who was a visiting scholar here told me of an outrageous case in which a boundary between two West African nations cuts through a family farm. Can you imagine the kind of administrative problems this must create?

The other issue in your letter that intrigued me was the statement that you like being a member of a minority group because it sharpens your sensitivity in viewing details that the majority tends to take for granted. Strangely, in terms of logical connections, your argument took me to South Africa (and to the historical contexts under which the tragic drama of colonial and imperialist domination has been enacted by ridiculously small minorities, using the power of the gun, or money) and I simply had to conclude that sensitivity must be completely alien to these invaders' constitutions! Look at the terrorism they have used and continue to use, not only to try and make the overwhelming majority invisible and immaterial, but to condemn them to eternal servitude! But then, we are not really dealing with normal human beings, are we? For, if they had a claim to this they would realize that the act of being human is in the affirmation of others' humanity. Without this we are a mockery of the human essence.

Lastly, let me answer the question you asked regarding my language situation. I speak Gĩkũyũ, Kiswahili, English and rather inarticulate Chishona. The last is a Zimbabwean language that I need to polish up so that I can learn another major tongue there, known as Sindebele. I am probably being a bit ambitious, but there is no harm in creative ambition! Other than these, I speak and write very poor French, which I used to be quite good at. I have done some short unpublished pieces in Gĩkũyũ and Kiswahili that I need to channel into publication at some point. My other ambition, as far as the language of creative composition goes, is to write and publish in Kiswahili, which I have had to teach myself mostly as it was not on my colonial high school curriculum. The reason for this future agenda is that Kiswahili cuts across the more than 52 language groups that exist in Kenya and has become the medium of commu-

nication among the workers as well as across the rural communities in the country. I am convinced that one of the reasons why Tanzania has been able to define itself as more of a nation (in terms of ethnic non-antagonism) than Kenya has, for instance, is because in its planning and policy-making, the government has given Kiswahili a true national status, allowing it to serve as an important communication link between the various Tanzanian nation groups. But, more on language another time.

For now, let me end here, hoping to hear from you soon if this lengthy and political letter of mine does not put you off altogether. Whatever you do or do not do, please tell me how you spent this summer. Your description of the Finnish summer in last year's letter was so poetic that I look forward to some more of that. And what is the fall or autumn like there? In this part of America, it is beautiful. Some trees have leaves that come out in stunning colors. As for the winter, to be quite honest, the cold tends to freeze my vitality. In fact, I would need an overdose of inspiration to ever do a repeat performance of something that I did in 1969 during my first winter in Canada. I actually poetized snow! Amazing!

Stay well!

Warm regards,

Mīcere Gīthae Mūgo

P.S. I started this letter two weeks ago and had promised to send it early last week, but I became extremely busy just before going to the women's conference in Toronto and could not complete it. Today, November 19, I am off to yet another conference. By the way, the Toronto event is a success story that I must relate to you in detail sometime. Do not let me forget to do this, please, because it is very important.

Very finally, should there be too many errors in this letter, please understand. I am working on it late at night to make sure that I post it before traveling later on today.

Thank you and stay well.

222 Sapsucker Woods Road, #2A
Ithaca, NY 14850
May 28, 1993

Dear Birgitta,

Thank you very much for your letter of March 23, 1993, and for the beautiful card that you sent along with it. I was very sorry to learn that the flu had calculated its unwelcome visit in your direction even as history was ushering in the New Year. I do hope that you are feeling better by now because the flu bug can last a long time.

Your question: "Why are we doing this?" made me laugh, not out of insensitivity, but because you posed it in such an agonized way. Your obvious irritation (I apologize if I misread you) itched through each one of your words with such drama! Let me, by the way, confess that I fully share these feelings with you. There is no doubt that pressure that you and I could have well done without has been created by the need to meet the publisher's deadline which by now, most regrettably, must be more than dead. I think that if there is anything to be learnt from all this, it is that the processes of creativity and dialogue cannot and should not be manipulated; however well-meaning this manipulation is. I also have a feeling that beyond this and, outside the tightness of our individual schedules, the delays in getting back to one another have been due to the fact that we are conscious we are somehow engaged in an abstract exercise. I mean, we are communicating with each other as agents of a publication project rather than as voluntary correspondents. Do you see what I mean? This creates some form of awkwardness and even, to an extent, artificiality in dialogue. For, as you say, complete strangers who have virtually nothing in common (except their human beingness and womanhood) do not all of a sudden begin holding intimate debates with each other out of the blue.

For me, quite frankly, the basic incentive has had to do with a need that I have been feeling for quite some time now, to bridge the big gap between me and my last published creative writing effort. Closely tied to this is the reason I gave in my earlier letter: that I

have always been a firm believer in dialogue. Again, especially given the poor distribution of my East African publications abroad, I have looked upon this as an opening for me to address an audience that may not know of my work. Thirdly, I really do believe that the world should be made aware of the way women of African origin view their own gender struggles – which is not to say that there is any homogeneity or consensus based on women's geographical or cultural locations, for, in the final analysis, it is each individual's worldview that illuminates these engagements. The point is that too much speaking has been done on our behalf. I am attracted by the possibility that this exchange will provide a small part of the global platform, and is it not true that all of us seek for this as writers? So, there you are, as far as my reasons for having lasted this far go.

By the time this letter reaches you, you will have started your summer holiday. Well, have a restful time, whatever you do. And, frankly, I am glad that your extended family challenges the construct of "Villa Garbo!" It is true that we need and must create space to be alone, but it is also true that the force of the larger group provides a wonderful validation of our essential selves, and this, too, is something we must seek.

The seriousness and intensity with which you addressed the challenge before all of us to rise and live above mere proclamations spoke to me very clearly. However, unlike you, I do believe in truth – meaning, at the most basic, the historical, materialist reality that confronts us whether we want to acknowledge it or not. This reality either affirms our humanity, or denies it. Because of this, I also feel that it is a human responsibility to make clear proclamations when negation diminishes the human being in any one of us. You may not agree with this, but I believe that refusal to make a proclamation in the face of injustice and oppression of other human beings is evasion of a human responsibility. However, the greater truth is that mere proclamation without concrete action to change the reality under question is another form of irresponsibility too. In this connection, may the practical work you have been engaged in and continue to perform find fruition, however long this takes.

This point reminds me to tell you a little bit about the women's conference in Toronto last year. The occasion brought together

such a formidable group of women (mostly from cultures which have been victims of colonization, imperialism and dictatorship), which the sheer experience of their multitudinous presence became empowering. There must have been at least three thousand at the opening ceremony. I have never had this kind of experience all my life! The other moving thing about the opening and closing sessions in particular was the amount of space and prominence given to first-nations women who have been historically relegated to the background in their own land of origin and birth since the invasion of North America by Christopher Columbus. The opening main speaker was a first nations woman as was the closing speaker, Rigoberta Menchú Tum, the 1992 Nobel Prize winner. Then there was a group of first-nations women singers whose songs were full of fighting spirit and creativity. Similarly, most of the panels featured very strong women's voices that shared living experiences of their struggles for their rights, for the rights of their children and those of their communities. The conference deliberated on the creation of links that would bring women's struggles together in solidarity. The umbrella theme was "creating and making links." As with every conference, there was a lot of talking, but it was the kind of talk that is absolutely necessary if women are to emerge out of the isolation that they often tend to live in as an oppressed community of human beings. In other words, women shared real experiences from their lives, some of them most grueling. The experiences of women living in North America made it quite clear that racism remains a way of life in the so-called "developed" "first world." I participated on a panel that was discussing "women under political repression and torture" and also read poetry at an open evening session.

The Toronto women's conference was one of the few where I have seen a conscious attempt made to place practical knowledge before theory and academia. I heard ordinary women speak to me with such power and sincerity that I suddenly felt as if there was something fake about the university environment that I was returning to at Cornell. I think there should be more of those kinds of forums.

I am winding up here at Cornell to go to Kenya and Zimbabwe for the summer. I now have a leave of absence from the University of

Zimbabwe and will be based at the Department of African American Studies at Syracuse University as of September when I return from home. Right now, I do not know how I am going to emotionally handle the return to Kenya, following a period of nearly eleven years of exile. I have walked through the motions of my arrival in my mind, but I know that the heart, the feelings and the being in me will do their own live walking. Well, all I can say is that it will be wonderful touching home again. Unfortunately, there is also anxiety in my heart because in dealing with the hawks in neo-colonial power at home, one cannot ignore the fact that one is before a ruthless bunch of unprincipled people who thrive on the political harassment of others. Moi's KANU (Kenya Africa National Union) regime is still very angry with those of us who have used their exile experience to expose its abuse of human rights and corrupt squandering of the economy, for, this has all along reinforced the internal struggles by the ordinary people of Kenya. The combined efforts finally brought the government to its knees last year in accepting multiparty politics, a possibility it had not only rejected but dismissed before then. So, I hope that I will be safe.

Winding down at Cornell has ended up being more of a task than I had anticipated. I got involved in a poetry drama production, which I was directing, using the community theater method. The production was a practical component of a course that I was teaching on African theater and drama. The poetry drama had as its theme: Mother Africa and her children and was actually entitled, "Mother Afrika's Children." I thought it important to focus on the plight of Africa's children and the agony of the mothers who see these little ones die in their arms, even as they are struggling to prevent it. My latest collection of poetry, which is with a publisher right now, focuses quite a bit on this tragic situation, linking it to imperialism and neo-colonialism. We performed to a Cornell audience and then took the show to the community in Ithaca. The community performance was a wonderful experience. The audience was so moved by the effort that the students had put into the acting, singing, and dancing that some of them were in tears.

The other activity that has come to mean a lot to me is some voluntary work that I have been doing in a maximum security

prison at a place called Elmira, forty-five or so minutes from Ithaca. It is a very large prison, with over two thousand men locked up in there, but guess who constitute the overwhelming majority? Men of African American origin – a sizable percentage of them under twenty-five! The next biggest groups are Latinos and Hispanics. So, the American system obviously has ways of criminalizing the poor and powerless in their society, unless we are to assume, of course, that certain groups of people are born criminals! What is most painful about it is that the men in there have some of the sharpest minds that I have ever dealt with. I had the exact same experience ten years ago, when I did voluntary work at Ogdensburg maximum-security prison from St. Lawrence University, which I wrote about in my last letter. I am reminded of what George Jackson once said at the height of the black Power struggle in this country: that the best minds among African American men are wasting in jails. What I have tried to do is to contribute towards keeping those minds alive by visiting the men and taking some students with me on the visits. I think it is important for Cornell students to confront this reality. Cornell is a very rich and privileged institution, and living here can create all kinds of illusions for people of African origin, when it does not enforce alienation, that is. The men identify topics that are of relevance to their lives and then the students and I facilitate discussion. However, they (the men) do most of the talking and what they have to say is worth all the listening that one can do. So we engage in discussion sessions, debates, dialogue, poetry readings, etc., etc. I plan to continue with this work from Syracuse, which is only an hour and a half or so away from Elmira.

Lastly, I had a wonderful experience reading through examination scripts from students at the end of this semester. The set of answers that I enjoyed reading most were related to a question through which I was trying to elicit their practical, personal experience so as to encourage them to apply knowledge to real life situations. The question read something like, "Discuss the content of three works studied in this course, demonstrating their relevance to your special experience and reality." The course itself was on African women writers, studying artists such as: Ama Ata Aidoo, Nawal El Saadawi, Flora Nwapa, Mariama Ba, Tsitsi Dangarembga, Ellen

Kuzwayo and others. Oh, you should have read the responses! They were the most articulate, the most genuine, the most powerful statements I have ever heard from those students. Some of the stories and experiences related were at one level frightening. It hurt to read about what some of these young people have been through. At another level, however, it became a celebration of the strength and unmolested beauty of some of this community of the youth that I had taken so much for granted in the classroom. All through the semester, one or two of the male students in the class had expressed discomfort with the fact that most of the books we had read had depicted men in what they saw as a negative light. In fact, two of them insisted that women writers were involved in "male bashing." For me, the stories told through the answers that I am referring to closed this strange debate on "male bashing" once and for all. The narrators had relived concrete experiences, which were anything but fictional. Each story was a painful indictment of the oppressive systems that humankind has constructed (mainly at the invention of patriarchal males), to institutionalize women's oppression, which is linked to the oppression of the poor and powerless in the world. And on that note I leave my teaching and research experience at Cornell as I move on to new pastures.

I really have to stop now as I have a whole lot of other business to take care of before I travel in another week. But before I put a full stop to this communication, let me say that in the final analysis, I am glad this dialogue ended up taking place. It is my hope that we will meet before too long. Perhaps we can ask the publishers of these women's debates to find a way of bringing the debaters together when the book is out. For the time being, stay well and experience productivity in whatever you undertake.

Sincerely,

Mĩcere Gĩthae Mũgo

Part II

ORATURE, LITERATURE AND CREATIVITY THROUGH A BLACK FEMINIST LENS

Chapter 3
WOMEN AND BOOKS

Between 1979 and 1982, I experimented with a small voluntary literacy campaign project, involving women from Kibera, one of Nairobi's huge slums. One day, my best student, a beautiful mother of six, turned up at my house (where I held the classes) with a swollen face and badly damaged nose. Her husband had come home and had been infuriated to find her reading a book. Describing the activity as a reflection of idleness and a sign of unwomanly conduct, the angry man warned his wife that she was never to be caught, at any time of day or night, reading a book. This was the kind of thing done by school children and not grown married women, he said. He had beaten her up thoroughly – just to drive the message home. In fact, with the exception of two women in that class of ten, all the other students attended these private classes under strict secrecy. The enforced secrecy made the work even juicier for all of us. It made those struggling working class "housewives" all the more thirsty for knowledge.

In 1977, when the Kenyan government banned the drama activities of Kamĩrĩĩthũ Community Center, near Limuru, where Ngũgĩ wa Thiong'o and Ngũgĩ wa Mĩriĩ had founded a people's theater, a similar form of gendered censorship took place. After the government had sadistically razed to the ground the structures of the open-air theater that the workers and peasants had built, the Kiambu District Commissioner gave a speech in which he specifically singled out women for admonition. He ridiculed them for

having participated in the drama productions, deriding them for spending time idling and jumping around on stage, like children, instead of working in their homes and cultivating their shambas, as all "respectable" married and old mothers do.

Even though definitely crudely extreme, these two cases reveal attitudes that would appear to look upon the world of books, literature and theater as being quite antithetical to the aspirations of women. They are painted as undignified and idle for daring to penetrate this world. But beyond this, the registered attitudes have a class bias. Women from the working and peasantry classes are shown as having no business – nay, right – to associate with books. The book world, then, becomes a special realm for the elite classes and of course, for school children – the future educational elite in the making.

In this chapter I would like to address this problem of creating book apartheid against working class and peasant class women, for they constitute at least 80 per cent of the female population in most African countries. I would like us to examine the problems that they specifically face in their attempt to relate to the world of books and academic knowledge. As writers, publishers and critics, we need to find ways of combating the negative attitudes and conditions that would make women and books strangers, or that would intimidate this very important majority part of our audience and potential artists. We need to be quite clear whether our celebration of literary achievement here truly embraces these beautiful people, who were definitely born a long time ago, with all due respect to Ayi Kwei Armah. For, whereas as members of the elitist class of women we may have considerable achievement to celebrate at this forum, with our underprivileged sisters out there, this Book Fair may also need to express a lot of anger, for, on the whole, they have been unaccommodated by the world of books and written ideas. The basic blame, of course, lies squarely on the oppressive economic conditions and socio-political environments that they live under and which we must seek to destroy. This is the challenge that this chapter poses to this distinguished community of women and men of books.

Like the nurse who forewarns her target before giving an injection, let me confess to you that the facts in front of us today are

both gloomy and tragic. I share them with you, not for the purpose of dampening your spirits, especially as some of you have come here to celebrate achievement, but to agitate you into urgent action. Let us first of all look at the overall continental scene on the question of illiteracy. We find that out of the 156 million illiterate people of Africa aged 15 and above – nearly two out of three or 83 per cent are women. Among the males, the figure scales down to 63 percent.[1] Although these facts are from a 1979 source, one can boldly assert that except for improvements in a few African countries that have made incredible strides to combat illiteracy in the last few years (Tanzania and Zimbabwe being special cases that deserve mention[2]) the situation has hardly changed. Yet, even in Zimbabwe where the situation is certainly brightening up, 66 percent of the 2.5 million illiterate people are women.[3] Needless to say, the majority of these are peasants in the rural areas and the rest mainly working class urban. The overall continental reality on illiteracy is by the way, most ironic, considering the fact that writing as an art was invented by Africans of the Nile Valley Civilization, way back in antiquity and centuries before Europe knew that is was possible for human beings to communicate in this manner (Diop 1974; Sertima 1985; Williams 1987).

The gloomy picture of illiteracy aside, the working class and peasant woman leads an existence that quite militates against her membership into the world of books. UNICEF'S (United Nations Children's Fund) *News of Africa*, published in 1985, cites the normal daily routine of a typical rural peasant woman as stretching from 4:45 a.m. to 9:30 p.m. I would argue that the second time estimate is very much on the early side. Many rural village mothers do not finally hit the sack before 11:00 p.m. Between these hours the woman is engaged in very draining activities, physically and emotionally. For instance, taking care of infants and pre-school children; doing all the domestic work including cooking, washing, cleaning the home and compound; grinding cereals; mending and washing clothes, fetching wood and water – activities which might involve miles of walking; working in the gardens; building; ferrying goods to the market; looking after cows and goats, in the absence of herds-boys; breeding chickens; attending to family rituals; attending to demand-

ing husbands, relatives and extended relatives, etc. Beyond these handicaps, it is this woman who knows what it is to eke out a living from economically raped Mother Africa whose breasts have been milked dry. Africa is a continent of extremes: deserts, stone, drought, floods, swamps and, of course, a few farming and arable lands out of which we cannot yet produce enough to feed ourselves, most of us. So, given this situation, how does the rural woman sit down to read a book after 11:00 p.m., with a few hours to go before starting the mad race of existence for the following day all over again? What does she use for light? The wicker lamp? The fire at the hearth?

For poor women in the cities, the picture is not any better. Most of the so-called unemployed women from the working class lead a backbreaking life as well. Even when they may have tap water, unlike their rural sisters, for them to get a bucket of this water the urban poor sometimes have to line up in a non-ending queue for hours. Emotionally and psychologically, this woman has to put up with a lot of pressures, arising from capitalist alienation in an industrialized setting. Divorced from the solidarity of the extended family circle, she often has to deal, single-handedly, with most problems created by her suffocating economic existence. There are other women lower down this ladder of poverty: for instance, the petty trader, the street woman and the rest of the lumpen. Swallowed up by this nihilistic background, this woman has nothing like direct connection with books. She lives in a "hole" and has no reading facilities. Thus, even if she were to miraculously work out leisure reading time, the conditions she lives under would all together rule out the world of books as a goal to aspire to.

There are other problems. Even at the global level, except in socialist states where the cost of books and publishing are subsidized, books have become so expensive that they remain out of reach for a person with light pockets. Soon, accessibility to books in the open market will become the prerogative of the economically affluent classes. For most of the time, women workers and peasants are so busy working out the arithmetic of basic survival that even when they are literate and can spare the time to read, they have no purchasing power to get to the books in order to fulfill their intellectual needs – the right of every human being. Yet another pro-

hibitive factor is the size of most books that make good imaginative reading. The average struggling reader from the masses neither has the time nor the atmosphere, nor the intellectual energy – let alone the supporting reading skills – to handle a book that is more than a hundred pages in length. Fifty pages alone can be overwhelming and forbidding for most readers just on the literacy line.

Then, of course, there is the language problem. It is no exaggeration to say that 99.5 percent of our good, creative African output is in foreign tongues – most of it addressed to a foreign audience and the elite class at the domestic level. This automatically excludes, as part of our readership/audience, the majority of peasants and workers. Even when literate, they operate around our mother tongues. And, as Frantz Fanon says, to speak a language is "above all to assume a culture, to support the weight of a civilization."[4] Thus, beyond the problem of language, we also have to deal with a literature that is full of alienating elitist images and visions of Africa as far as the masses are concerned. Indeed, some of it goes out to embrace values that are so Western and bourgeois that it makes us begin to appreciate how intellectually enslaving the a b c of the colonialist classroom is. The visions range from nationalistic ones to those that are not only condescending towards and dismissive of the masses, but also unrepresentative and negative that their images of the poor and their world become nihilistic. How do the worker and peasant relate to such an oppressive alienating literature?

The underprivileged position of the peasants and workers produces yet another problem that is even more tragic, the attitude of self-debasement. It further alienates the oppressed from the world of books. Let us elaborate: Following years of exploitation, domination, and degradation by the enemy, the deprived masses are conditioned not only to look upon the oppressor as being superior, but to be self-demeaning before him/her. Paulo Freire articulates this position very eloquently in *Pedagogy of the Oppressed*.

"Self-depreciation is another characteristic of the oppressed, which derives from their internalization of the opinion the oppressors' hold of them. So often they hear that they are good for nothing, know nothing and are incapable of learning anything – that they

are sick, lazy and unproductive – that in the end they become convinced of their own unfitness."[5]

A lot of peasants and workers often look upon the world of books and ideas as the prerogative – nay, the natural, unique, private monopoly – of the dominating classes. They are almost apologetic about their intellectual ambitions. Because of this, many shy away from books and writing.

In her moving autobiography entitled *The Diary of Maria de Jesus*, published under the title, *Child of the Dark* in 1960, a black Brazilian woman, Carolina Maria de Jesus (whom Marxist-Leninists would categorize as a member of the lumpen proletariat) tells us of the verbal persecution that she had to live with, for daring to write a book. The sad contradiction is that the taunts and insults mainly came from members of her own class, especially her oppressed sisters – all living under dehumanizing, abject poverty. Thanks to her sense of self-confidence, convictions, determination and daring, coupled with the crying urge to expose the dehumanizing conditions that threatened her and the lives of her children, the world today has one of the strongest testimonies against the evils of capitalism, from the mouth of a first hand victim. Maria de Jesus was barely literate, by the way. The significance of her most straightforward, lucid account of human suffering and degradation lies in the fact that it is the oppressed person who identifies, names and articulates her oppressive reality. Unfortunately, this insistence on penetrating the world of books and ideas by a member of the lumpen proletariat is rare, especially in a "Third World" context.

In *Let Me Speak*, Domitila Barrios de Chungura, another Latin American woman – this time from the Bolivian working class – has placed into the hands of the reading world a dynamite that clearly illustrates the creative potential among the oppressed classes. This work, in ordinary layperson's language, has a penetrating class view of the oppressed as seen from a worker's perspective. It destroys the myth that workers and peasants cannot produce imaginative or academic books.

Creative efforts by African working class and peasant class women surely remain lying, crushed and buried, under the mountains of problems already discussed! The African elitist classes even

deliberately mystify books and knowledge as a means of preserving their prestige. I remember how when I was small I witnessed peasants suffer humiliation at the hands of a primary school teacher. Illiterate, they used to go to him to have letters written or read. The short man would absolutely delight in seeing these men and women – some of them elderly – bow before him, acknowledging his superiority. He would take all the time there was in the world to attend to them. He would strut and stride across his compound, whistle away, straighten his collar, drink his tea... you name it, just to create suspense and mystery as well as a feeling of dependency in the waiting peasants. Meanwhile, they would have brought him eggs, chickens, fruits and other delicacies. The primary school teacher was a feudal lord in his little intellectual kingdom. Quite a joke, if the whole thing were not so sad. Now I wonder how accurately this mischievous letter-expert cared to articulate these people's problems, pains, sorrows or joys.

This said, one moves on to pay respects to the oppressed African woman for her determination, industriousness and optimism, reflected in her uncompromising struggles to break through the walls of illiteracy that imprison her and chain her mind. The majority of adult literacy students on the continent as we speak now are women. Zimbabwean figures, for instance show that the number of adults enrolled in these classes since July 1983 register at the 200,000 figure. 71 percent of these students are women. Today, of the 350,000 adults attending literacy classes, three out of four are women. Defying age, enslaving customs, oppressive political institutions, the crippling exploitative economic system, these mothers and sisters are marching ahead resolutely, determined to explode the negative silence imposed upon them by illiteracy; insistent on naming the world for themselves. Needless to say, they will only ultimately overcome following this country's complete transition into socialism, which will create an economic system in which dictatorship is in the hands of the proletariat, supported by the masses at large. At that stage the world of books and ideas will not only become a reality, but a basic human right.

In the meantime, what happens? Who will create literature on and with these staggering multitudes? Or, shall we leave them condemned in a literacy desert?

An orature tale tells us that once upon a time, a fed-up fictional female recipient of bad news from the proverbial owl one day dried her eyes and resolved to pronounce a curse on the "bringer" of the sad tales. "May you never stop weeping so long as you live!" she told the owl. And so, up to this day, the owl has not stopped weeping. Now, I categorically refuse to remain a professional life-mourner, like the owl. In the rest of the chapter, I wish to suggest alternatives that we will need to discuss among ourselves as members of the book-world, lest we stand guilty of playing the flute while African masses are burning.

Writers and publishers for women are today faced with a formidable, but most challenging task: either to make literature "part of the common cause of the proletariat,"[6] as Lenin has counseled; or to turn it into a continuing monopoly for the elites. As far as some women are concerned, the luxury of the option does not really even exist. We have the limitations behind our privileged class position and stand persuaded by Freire when he asserts: "Revolutionary praxis must stand opposed to the dominant elites, for they are by nature antithetical."[7] If we are to undertake the production of the books for the oppressed masses, therefore, we must begin by identifying with their class interests. Now in my opinion, the only kind of writing that will address this assumed position is liberation literature. In creating the *authentic* or *true* work as Freire would put it, we will be providing the oppressed with just this. Liberation will become "an instrument that makes dialogue possible,"[8] leading to reflection and revolutionary action, which will, in turn, ultimately transform the oppressive reality, Freire correctly argues:

> Human existence cannot be silent, nor can it be nourished by false works, but only by true works, with which men transform the world. To exist, humanly, is to *name* the world, to change it. Once named, the world in its turn reappears to the namers as a problem and requires of them a new *naming*. Men are not built in silence, but in word, in work, in action-reflection.[9]

Only, however, hard as we may try, as members of a specific privileged social class – for most of us the elitist petty bourgeoisie – it will be impossible to completely transcend our class contradictions and produce authentic mass literature. It is important that we realize this, lest we become cultural invaders, like the colonizer who penetrates that world of the conquered in complete "disrespect of the latter's potentialities," thus imposing his own worldview on them and inhibiting "the creativity of the invaded by curbing their expression."[10] The danger of invading the world of female peasants and workers is not imagined, but very real indeed – especially in this epoch of radical feminism.

I will illustrate the point I am making. Towards the end of last year, I attended a seminar that was deliberating upon the legal rights of women in an African country that will remain nameless. During one of the plenary sessions, I was hit by a contradiction that seemed too glaringly serious to be left unchallenged. The entire panel of rapporteurs consisted of seven males and one woman. Of the complete panel, there was not one African woman. Further, the seminar delegates were exclusively drawn from elitist and petty bourgeois circles. I repeat: there were no working class or peasantry class women at a seminar that was deliberating on women's legal rights. Considering that at least 80 percent of the women whose problems were being discussed came from these two classes, I sought to know from the gathering how authentically representative of mass interests it considered itself to be. I was promptly and most rudely silenced by a tyrannical chairman whose action was endorsed by a number of angry petty bourgeois "researchers" and self-appointed oppressed women's representatives, who claimed the authority and right to speak for the masses because they had done a lot of research on them. One of the delegates actually said this. I could not absorb the whole farcical drama. I could not believe that such audacious paternalism and condescension were possible. All I could say was: there are definitely, simply, far too many self-appointed petty bourgeois messiahs around Africa. This on top of foreign ones too!

I ask this gathering of writers, critics and publishers: who are we to speak *for* the masses? They have their own mouths, you know. Surely we can only speak in solidarity *with* them, not *for* them. Where

are they, for instance, at this Book Fair? Women are so prominent as artists in the orature tradition that their absence at a forum like this one registers very negative silence. I have honestly reached a point where I feel so strongly about the need to incorporate peasants and workers at intellectual forums that I think governments that have chosen the socialist path should make their inclusion compulsory. It does not matter how much time or money we spend dealing with the problems of translation. So, to those of us who have endorsed the masses' revolution, fighting alongside with them as ideological allies, let me implore humility. Our task is to work with them as friends and comrades and not as their intellectual bosses. Let us join Paulo Freire, yet again, in seeking to explode "the myth that the dominant elites, 'recognizing their duties,' promote the advance-ment of the people, so that the people, in a gesture of gratitude, should accept the words of the elites and be conformed to them..."[11] Let us not kid ourselves, fellow writers, critics and publishers. Only the oppressed can, in the final analysis, liberate themselves. Only they can transform the oppressive reality before them through their labor. Only they can create new conditions under which to live as free people. For this reason, we must consider, as our ultimate goal, the creation – from among the masses – of an audience that also participates in composing, criticizing and publishing the works of art that it consumes. That way we shall aim at creating creative producers and not consumers only. This will set authentic dialogue into motion, which is what we require at the initial phase of the liberation process. Indeed, "dialogue, as the encounter among men to 'name' the world, is a fundamental precondition for their true humanization."[12] And, lest we undermine the urgency of this liber-ating literature, let us look south and see what is happening in South Africa, in Namibia. Let us look around Africa and see what is going on. All over the continent, the masses are engaged in a life and death struggle to break the chains and throw off the fetters of oppression that deny them their being. What reality can be more urgent to address than this? Unless we face the challenge, the existing oppres-sive economic structures will remain unchanged and under them, the oppressed can neither produce nor consume the world of books. Conversely, the notion on women and books can only be relevant to

the economically dominating social classes of Africa. I would hate to think this is what we are saying at this time.

Finally, men and women of books must face the challenge of producing, together with the workers and peasants, literary modes and expressions that will capture the true rhythms of life, speech and thought, associated with the masses' struggle. This dynamic and dialectical approach should liberate books from the confines of glass shelves and bring them down to earth – where they belong – turning the messages the covers encase into beehives of liberating activity. Poetry and drama – active genres that ultimately demand verbal articulation and actual performance – may well be some of these dynamic modes, suited to the masses' participation. As part of this essential struggle, too, we will need to address the orature tradition and its aesthetics, revolutionizing them sufficiently to articulate the contradictions that define the class nature of our socio-economic African relationships. For, lest we forget, more than 80 percent of the workers and peasants of Africa are consumers of orature.

If I sound prescribing, it is because I do not wish to raise dust and then run away, leaving you buried in its clouds. It is because I believe that there are women writers, critics and publishers here today, who, in the struggle to break through into a male dominated world, will see it as logical to espouse the cause of the most oppressed in our societies. It is because all of us, men and women, need to address the problem of women and books within its context – the class struggle.

Chapter 4

THE WOMAN ARTIST IN AFRICA TODAY: A CRITICAL COMMENTARY

ᴥଣ

A Definitive Introductory Anecdote

Once upon a time, when I was about ten years old, a paternal uncle came to our home one early evening. My father and a teacher colleague of his who was visiting us had gone out. My mother and a paternal aunt, a great friend of hers, were in the house. A group of us children were outside playing. After greeting the children and the women, my uncle proceeded to ask: *Hĩ! Kaĩ andũ matarĩ kuo gũũkũ ũmũũthĩ*? Literal translation: "I say! Are people not here today?"

A telling pause followed the question and then, in a matter-of-fact fashion, mother answered, *Moimĩĩte kũ? To ng'ombe na mbũri ici ũroona*! Translation: "Where would they (people) come from? There are only the goats and cows that you see."

Not permitted to laugh at grown-ups, we the children simply took to our heels and ran to the back of the house where we rolled on the grass and giggled ourselves silly. We missed the rest of the drama.

This story introduces the underlying concern behind this chapter's focus on the woman artist in Africa. The discussion is both a statement, as well as a restatement of a problem that women continue to pose even as we speak now: Why is it that criticism has paid

such scanty attention to our women's artistic productivity? Why the imposed invisibility, in the face of so much harvest all around us?

Intention and Scope

Given the forbidding size of the African continent, the particularity of detail will have to suffer under broad generalizations, even though these should apply without falsifying the former. Similarly, under the constraints of time and space, the myriad of rainbows of artistic expressions produced by African women will have to wait while we narrow ourselves to the concerns of orature and literature.

The chapter opens with a reiteration of the question already posed and comes in the form of articulations by a selected group of women artists and critics. The articulations are followed by a review of critics, mostly concerned with the written tradition, who have addressed African women's creativity. The discussion then proceeds to examine women artists creating in the orature tradition. Following this, the chapter examines statements by African women writers, revealing how they view their art and its role in society. Finally, the conclusion attempts to link some of the issues raised in the chapter to reflections on the tasks and challenges that face CODESRIA (Council for the Development of Social Science Research in Africa) since its inception in 1973.

Gender Discrimination and Women's Artistic Creativity

A number of critical commentaries on African women's writing have identified gender discrimination as the primary problem affecting women's creativity and the nature of discourse surrounding it.

Jessie Sagawa of Malawi argues as follows:

> The discussion of African Literature usually centers on the male writer and character. If the critic is concerned with women, it is mostly her significance to the style of the author that interests him. Rarely has the role of the women in fiction been of serious interest to the critic of African Literature. And the female writer finds herself in similar circumstances. While most of the male African

writers have received wide coverage, the female writer has,
until recently, tended to be neglected (Sagawa 1984:164).

Sagawa goes on to argue that the woman critic has not, on the
whole, done much more than her male counterpart to redress the
imbalance, pointing to sexist indoctrination as the problem behind
the marginalization of and bias against women writers and female
depiction in African literature as a whole. She provides overwhelm-
ing evidence to support the case she is making and one so often
made by other women before as well as after her.

Similarly, discussing problems faced by women artists, a paper
entitled "Women Writers" (Mugo 1984:162-205) explores the
question of female writing and publishing, posing a related ques-
tion: "Why is it that the written tradition appears to have pushed
the African woman to the backwaters of literary achievement?" To
answer the question, the discussion takes us back to the history of
writing in the West, where patriarchal tendencies had led to the
appropriation of the art by males to the extent that certain women
writers were forced to assume masculine names in order to be
published at all. The paper then traces African women's creativity
through colonization and colonial education to the current oppres-
sive neo-colonial realities. All these environments are shown as not
only promoting patriarchal subjugation of the African woman, but
as actively militating against her potential artistic productivity,
while she struggles to remain at the center of the creative process.

Penina Mlama comments on the discriminatory treatment of
women artists in Tanzania, further reinforcing the arguments under
discussion and thus demonstrating the universality of the experi-
ences encountered by members of her gender. She observes:

> I think there are very good women artists. If you look at
> the traditional performances, the women are some of the
> best performers. But when it comes to writing, it is the
> men who are given prominence. If you look at the village,
> who are the best storytellers? It is the women. Who are
> the dancers? It is the women. So I think that, on the one
> hand, there is a deliberate attempt not to give prominence
> to women writers. I don't think this trend is confined to

Africa alone, because I think this happened in Europe in the past. In the many cases men do not like challenge from women (Mlama 1990:86).

Ama Ata Aidoo pushes the debate further. In characteristic articulateness, she denounces a whole line of male critics, both African and Western, for negligence, discrimination, and callous condescension toward African women writers, punctuating her extended argument with classic illustrations, including what she terms, "a personal detail." The "personal detail" reveals how Robert Fraser once went as far as accusing her of borrowing the title *No Sweetness Here* from Ayi Kwei Armah's *Two Thousand Seasons*, published in 1973, whereas her short story "No Sweetness Here" had come out as early as 1962, and her collection of stories bearing that title in 1970. Having further detailed the "abuse" of other African women writers by a world of literary criticism dominated by men, Aidoo observes:

> In fact, the whole question of what attention has been paid or not paid to African women is so tragic, sometimes one wonders what desperation keeps us writing. Because for sure, no one cares. To have blundered our way into one more exclusively male sphere of activity can be forgiven. After all, clumsiness is a human failing. We all make mistakes. What is almost pathetic is to have persisted in staying there in the face of such resistance and sometimes resentment. Some of us believe that for writers and other creative persons any critical attention is better than none at all (Aidoo, unpublished source, 117)

There are other problems beyond the question of negligence. Molara Ogundipe-Leslie, for instance, finds men as critics of women's writing "usually patronizing and legislative," further arguing that "many feel the concerns of women are not serious enough since they are about the area of emotions and the private life." She wonders "how we got the idea in colonized societies that only political themes are respectable" and argues that, in fact, "great literature has always been about emotions and the actions which

spring from them," citing from Soviet literature to illustrate the case she is making (Ogundipe-Leslie 1990:71-72).

Under interrogation here is the authenticity of gender-biased criticism that assesses women's writing using patriarchal values, standards and paradigms. Indeed, Adeola James's book, *In Their Own Voices*, where Ogundipe-Leslie makes these observations, is full of statements like those expressed above. The writers interviewed include: Asenath Odaga, Buchi Emecheta, Flora Nwapa, Penina Mlama, Rebeka Njau and others. Historically then, African women writers have been sidelined not only by the application of patriarchal measurements of what is success and what is failure, but through downright sabotage, viewed by women as a ploy to ensure male domination. Adeola James summarizes the debate as follows:

> To say that the creative contribution of African women writers has not always been recognized is to put the case mildly. In fact, the woman's voice is generally subsumed under the massive humming and bustling of her male counterpart, who has been brought up to take women for granted (1990:1-2).

In *The Collector of Treasures*, Bessie Head blames this male superiority syndrome on erring ancestors:

> The ancestors made so many errors and one of the bitter-making things was that they relegated to men a superior position in the tribe, while women were regarded, in a congenital sense as being an inferior form of human life. To this day, women still suffer from all the calamities that befall an inferior form of human life (see James 1990:5).

Clearly, Bessie Head identifies one of the root causes of our problems as being situated in patriarchal false consciousness. In this respect, we do well to remind ourselves that even as we respond to Amilcar Cabral's (1973) call and "return to the source," our journey must be one of search: a critical retracing of ancestral footsteps, avoiding those that would lead to pitfalls instead of to a celebration of self-knowledge. In other words, the perpetuation of patriarchal values that undermine women's creativity must be addressed with

uncompromising frankness. Unless this is done we will be condoning oppressive cultural practices designed for the purposes of creating islands of power in the midst of oceans of powerlessness. One is arguing that societies should nurture creative beings and not slaves of fettering traditions. With this understanding in mind, critics at whose hands women artists suffer should be perceived as undesirable intellectual power brokers whose empires and monopoly enclaves must be challenged. The structures that negate women's creativity are indeed a version of those found at the macro-societal level. Ama Ata Aidoo makes a graphic representation of this reality when she observes:

> Women writers are just receiving the writer's version of the general neglect and disregard that woman [sic] in the larger society receive... You know that the assessment of a writer's work is in the hands of critics and it is the critics who put people on the pedestals or sweep them under the carpet, or put them in a cupboard, lock the door and throw the key away. I feel that, wittingly or unwittingly, people may be doing this to African women writers (1990:11-12).

Of course the whole of the foregoing debate would be incomplete unless contextualized within the societal, cultural, political, and economic formations against which the contradictions highlighted take place. For it is these that shape the consciousness, or false consciousness, that are in a clash as we observe the interplay between the various subjects engaged in the conflict. Indeed, it needs to be argued that the seeming line between males and females, lumped in two generalized opposing camps, cannot stand the rigors of a pointed analysis. Socialization, indoctrination and internalization of the kind of sexist, patriarchal values that deny the female artist her proper place/role and status in society, often cut across this assumed line. The systems and institutions that breed the unjust conditions, as well as the "myths" and "lies" that reinforce the false constructions under challenge apply to both men and women, even though to men more so than to their sisters. In this respect, of course, African women writers are not the only victims. We hear other women, particularly those from the southern hemisphere, and

other oppressed groups complain about similar marginalization and belittlement. Demonstrative cases in point are highlighted in such works as: *Caribbean Women Writers* (Selwyn-Cudjoe); *The Sexual Mountain and Black Women Writers* (Hernton); *Black Feminist Criticism: Perspectives on Black Women Writers* (Christian); *Black Women Writers* (Evans); and others.

Cult of the Giants and Celebrities

Another patriarchal construction that has adversely affected women's writing is what might be described as the "cult of the giants and the celebrities." There is a tendency in literary criticism to exclusively focus on the works of already well-established authors (read male writers). Why this "cult of the giants and celebrities"? Can these literary heavyweights be so fascinating that we can see nothing in other writers? Could it be a need on the part of the critics to remain on safe grounds, beaten as these might be? Is it fear of the unknown, the unfamiliar and the unsung? Is it the kind of laziness that shies away from innovation? Is it loyalties to personal friendships, ethnic connections, nationalist bonds, and ideological camaraderie? Is it careerist calculations that dictate patronage to celebrities so that they can bring us closer to the limelight in which they bask? Or could it be that we are afraid of touching women writers because of the sensitive gender issues raised by their works? The questions need to be wrestled with, for better or for worse. A celebration of giants is okay, but fascination with them to the point of fixation is wrong. Mesmerization can only lead to a freezing of possible extended action.

One is saying that African literary critics need to immunize themselves from the personality worship syndrome, which is one of the problems in Africa's larger democratization project. In the same way, if the works of women writers are to compete in the book market, as they should, the publishers and their distributors have to rise above the "big buck" syndrome. More than this, the academicians need to convince us that they are more than professional merchants who are only interested in promoting big names for what they can get out of them professionally. This may well be too much to ask in these days of IMF- and World Bank-maladjusted economics.

Worse off under this unfortunate contest of the big and the small, the powerful and the powerless, is the plight of women artists working within the orature tradition. Whereas women writers are correct in demanding the critics' attention and calling "foul" at the way the sexist game is played in criticism, looking at the orature tradition, the class factor becomes just as problematic as the power equation. Women working in this tradition have altogether been ignored as individual artists, being lumped under broad generalizations encompassing orature composers. Of individual talent and creativity, little has been really said. Generally, then, the written word boasts weightier currency than the spoken, and, under this equation, the woman writer becomes a "giant" while her sister remains a nonentity.

A Broad Categorization of Critics

At this juncture, it is imperative that we focus briefly on the character of critics, because their response to literature can influence creativity either positively or negatively. More than this, they often shape the direction that creativity assumes. Critics also play a major part in molding the consciousness of the audience at whom creative writing is aimed. Taking into account the debate generated in the previous sections, the first question that we need to ask here is: are all critics of African women writers as negligent, biased, arrogant, condescending, and sexist as they have been made out to be? Second, are female critics of women writers free of these blind spots? The answer to these questions is obvious. Male or female, critics are not a homogeneous fellowship of identicals. They come in all types, shapes, shades, voices and class positions. At the risk of generalizing, it might be useful to place them in three broad categories, similar to a classification I have made of intellectuals elsewhere, namely: conservative, liberal and progressive. These categories are neither static nor sealed from interference by all forms of social dynamics and dialectics. The point under discussion, however, is that in assessing the role of critics and their influence on women's writing, we need to move beyond lumping them together if we are to pinpoint the source of the problem before us. In other words, conservative critics are likely to do more damage to women's creativity than liberal

critics, for instance. Some people may disagree here, as liberals can be treacherous and elusive. On the other hand, if women writers were to call a roundtable conference to discuss the dismemberment of their creative products and imaginative integrity, they would be making the most progress sitting down with the third category of critics. These distinctions are important in differentiating between creative and destructive criticism.

A Review of Selected Criticism

We now move back to a question raised earlier, namely: has criticism on African women writers been as drastic as articulated? Whereas in the last ten years there have been efforts, some of them more than determined, to address the existing dry land of commentaries, sporting thorn bushes and shriveled shrubs, the situation still leaves a lot to be desired. A condensed survey of the literary scene will have to suffice. What follows is really an abridged review and update of the discourse initiated by Ama Ata Aidoo's paper, "To Be a Woman Writer – An Overview and a Detail," delivered at the Harare International Book Fair in 1985.

Up until the 1980s, criticism on African women artists appeared by way of book reviews, conference papers, journal articles and book chapters. Perhaps the most consistent of the journals in soliciting submissions on women's work has been *African Literature Today*, originally edited by Professor Eldred Jones of Fourah Bay College and later co-produced by him with Professor Eustace Palmer and Marjorie Jones as associate editors. *OKIKE*, edited by Chinua Achebe, has had a similar policy and has featured women both as critics and as writers. Hans Zell's *A New Readers Guide to African Literature* and *Présence Africaine* (Paris) series have included coverage on women as well. There are also a number of undergraduate and graduate theses out there, inside and outside Africa, a few of which I have personally supervised, devoted to women writers and writing. Indeed, individual critics, both male and female, have been persistent in their insistence that African women's creativity be brought to the fore for serious, extensive discussion.

It was not until the 1980s, however, that full-scale published studies on women's writing started to emerge. In 1984, Oladele Taiwo published the first volume of work devoted to African women writers, under the title *Female Novelists of Modern Africa*. In 1985 the Zimbabwe International Book Fair focused on "Women and Books" and devoted the workshop to discourse on women, creativity, publication and related issues. The proceedings, including presentations by outstanding African women artists such as Ama Ata Aidoo, Nawal El Saadawi, Flora Nwapa, Barbara Makhalisa Nkala and others, were a unique experience. The year 1987 saw the publication of a whole issue of *African Literature Today* devoted to African women writers. In the meantime, Adeola James was busy compiling her research, embracing 15 African women writers discussing literature, criticism and their own creativity. The work came out in 1990 under the title *In Their Own Voices*. Vincent Odamtten (1994) has done a full-scale review of Ama Ata Aidoo's works. There is, of course, a lot more going on. Still, other than Odamtten's book on Ama Ata Aidoo, we are generally speaking of "small-scale," not "intensive" or "large-scale" criticism.

Hence, dissatisfaction still remains with what is obviously such a tiny drop in the sea of creative productivity on the continent. Perhaps the greater challenge is on women intellectuals themselves to get on with the task of generating criticism, in the interest of self-representation. For, other than Adeola James's *In Their Own Voices* and Rudo Gaidzanwa's *Images of Women in Zimbabwean Literature*, the thinness of women's own publication record of full-blown volumes of criticism is apparent.

This challenge is real and urgent, considering the fact those women writers are obviously not amused by some of the voices of their male critics. For instance, this is what Ama Ata Aidoo (1985) had to say about Oladele Taiwo's work in the paper referred to above, delivered at the Harare International Book Fair on "Women and Books:"

> In 1984, Oladele Taiwo published *Female Novelists of Modern Africa*, a book whose publishers blurbed it [sic] "as an important study" and for which the author himself claimed in the preface that it is a "celebration" of the liter-

ary activities of female novelists in modern Africa. For any
writing woman, reading that "important study" should
be a fairly sobering experience... He virtually treats those
African women writers whose novels he discusses (and
short stories when the spirit moves him) as though they
were his co-wives to whom he dishes out his whimsical
favors. He constantly remarks on their intelligence or sto-
rytelling capabilities in the best "dancing dog" tradition, or
as if they were a bunch of precocious six year olds who had
demonstrated some special abilities to the head teacher.

The angered writer leaves Taiwo there, to rest in pieces!

Women Artists in the Orature Tradition

First of all, why orature and not oral literature? During the
last three decades, some areas of the African Academy have dem-
onstrated a very productive response to Amilcar Cabral's call for
African societies to "return to the source" as part of the agenda
for cultural emancipation, which this intellectual freedom fighter
rightly perceived as a necessary revolutionary act in the struggle
for economic and political independence. Scholarship in African
Orature has been one such area, the term orature itself being an
innovative coinage on the part of the East African School, best
articulated by Austin Bukenya and the late Pio Zirimu. The coinage
liberated the heritage from the begging posture that the term "oral
literature" tends to subject it to as scholars debate whether or not
the African creative tradition can be taken as serious "literature."
Orature has achieved much needed independence as a result of this
coinage, standing as a defined heritage on its own terms.

So, How Do We Define Orature?

African Orature is an art form that uses language to create artis-
tic verbal compositions. The verbal art culminates in dramatized
utterance, oration, recitation and performance. It has its distinct
set of ethics, aesthetics, values, and philosophy that distinguish it
as a unique heritage that has existed in the African world since time
immemorial and that is still appreciated by the majority of Africa's

population up to this day. In this respect, it should be understood that African orature continues to be created and consumed, even as we speak now. It also continues to influence creativity in written drama, poetry, fiction, music, song and other forms of artistic expression. As Africa's indigenous popular art form, it is dynamic and still evolving, continuing to define itself alongside current trends in economic and political development and "underdevelopment."

There is, for instance, a difference between the ways orature is generated in a rural setting as opposed to an urban setting. There is also a difference in the way the various social classes preserve, attend to and generate the art, with the affluent hardly having any use for it, except for "decorative" and expedient purposes, while the masses use it on an active basis. Further, it is possible to distinguish between progressive orature and reactionary orature. Orature that celebrates patriarchal values of domination – all forms of injustice and the silencing of the powerless in any society – is negative. On the other hand, orature that affirms life, growth, self-realization, human rights and self-determination, is progressive.

Women Orature Artists

African women have always dominated the African Orature tradition as cultural workers, storytellers, singers, dancers, riddle posers, dramatists and so on. As creators, educators, guidance counselors, family historians (which is a common arrangement in horizontal social formations), women artists become, so to speak, the collective memory and stream of consciousness that links a specific social unit from one generation to the other. The woman artist combines this role with those of mother, aunt, grandmother and, at times, big sister. The woman artist sits at the heart of a community's well-being and fans the fire at the hearth of its imaginative furnaces, especially those of its youth. But, let us not fall into the trap of either idealizing or generalizing, for, as intimated, like all other artists and culturalists, women creators in orature have never constituted a uniform group.

It is nonetheless safe to generalize and say that, of their own free will and given a choice, most women artists will belong to a

positive orature tradition. Political coercion and enforcement under neo-colonial military and so-called civilian governments have, however, exploited the negative aspects of orature to notorious levels, abusing the powerlessness and vulnerability of women as performing artists in the worst possible manner. Witness the arrival of African dictators at airports, often following trips during which they have either squandered national resources through extravagant shopping sprees abroad, or brought back foreign-aid packages with all kinds of strings attached (once, ironically, mistakenly referred to as "AIDS" by a peasant woman). On such occasions, women are rounded up, often in the thousands, to dance and ululate for the returning "heroes."

Wearing prints overwhelmed by humongous images of these ugly neo-colonial rulers on their backs, on their stomachs, across their chests and upon their heads, these poor women carry weighty symbols of Africa's betrayal and oppression. Roasting in the sun, dancing themselves lame, they sing praise poetry and ululate to these dictators as they swell with flattery, the lies caressing their ears. This coerced *waheshimiwa* orature is part of what I have described elsewhere as neo-colonial "ululation culture" and not people's authentic orature.

At a non-aligned movement's conference in Harare during the late 1980s, a crowd of such "ululation culture" artists actually referred to a senile octogenarian dictator as "a man in his prime, full of youth, vitality and virility!" The subject of praise waved back his fly whisk in self-appreciation. Some days following this praise song, it became evident that the subject of the song was far too old to even climb down an insignificant flight of stairs. When he tried to do so, the results were disastrous. He went plunging down, causing commotion in a packed conference center.

Another notorious dictator under whom children and youth have been so impoverished that their plights will leave a telling scar on the future of the land to which they belong due to the extent of their dispossession, thrives as a national father figure. Even after years of economic mismanagement, repressive rule and sheer police terrorism, coerced teams of "ululation culture" artists continue to poetize him in song as *baba wa taifa* (father of the nation) and

particularly, father of the children. Imagine these economically exploited and socially deprived mothers referring to this man as the father of their children! The creative imagination of Africa's orature tradition is under serious abuse and the result is what East Africans call a *kasuku* (parrot) culture in Kiswahili. The appropriation of orature through state patronage is a very serious cultural coup in the hands of today's African ruling classes.

Luckily, alongside this *waheshimiwa* orature, the resistance tradition of what I have termed *mapinduzi* orature is being created in the mines, the factories, the *matatus*, on the farms, in homes and other arenas of productive democratic praxis. In this connection, it needs to be noted that it is during people's historical struggles that human beings have created positive orature in volumes. In this undertaking a lot of African women combatants and "sheroes" have been active creators. Slave narratives, dramas, protest poetry, and songs were composed as much by men as by women across the middle passage and in the lands of enslavement. These creations conscientized, uplifted, and spurred victims of unspoken atrocities and dehumanization not only to defy oppression but also to overthrow it. *Mapinduzi* orature inspired liberation struggles in Algeria, Angola, Guinea Bissau, Kenya, Mozambique, Namibia, Zimbabwe and other places, producing a body of creative compositions that continue to influence the direction of art in these countries up to this day. *Mapinduzi* orature artists have nurtured the collective memories of their communities. They have exposed and decried the abuse of human rights and have been active participants, mobilizing for democratic change. They have played the role of articulators of the people's collective vision, even as the collective group searches for more humane alternatives of defining who they are. They have created an orature that affirms not only the resiliency of the human being, but one that asserts people's humanity and capacity to defy oppression, while lifting heads high, in order to show the true face of humanity.

It is no wonder that dictatorships have panicked whenever *mapinduzi* orature has mushroomed amidst oppressed groups in our societies. The panic has worsened when the creators and participants have happened to be women. The example of Kamīrīīthū,

near Limuru in Kenya, which I have referred to in another chapter, demonstrates this. The illustration is worth recapitulating. In 1977, after the government had closed the theater and then demolished it, the Kiambu District Commissioner publicly chastised women for their participation in the work of the theater, accusing them of neglecting their domestic duties in favor of frivolous dramatic activities. Clearly, *mapinduzi* orature women artists are a threat to neo-colonial dictatorships where *kasuku* and "ululation culture" producers are used not only to ensure the validation of the dictators, but also to promote escapism, tourist entertainment and false conscientization. As Laura A. Finke argues, "we must understand utterance as an ideological construct produced through conflict and struggle within a specific historical and social context" (Finke 1992:3). Utterance by women orature artists, who are a part of the oppressed world, becomes an "ideological construct" that interrogates the agents of enslaving systems and structures, which negate their existence, and this is threatening to the status quo.

Paulo Freire (1983) argues that utterance of the "authentic word" is a liberating act. This is so because true utterance leads to reflection and possible action. Meaningful action impacts on structures of oppression and threatens to change them. Thus for as long as *Mapinduzi* orature women artists continue to struggle to transform the stifling reality around them, they remain a threat to the systems that create the injustice they fight. Consequently, they become agents of development. One does not need to be a soothsayer to predict that this kind of people-based, people-generated orature will far outlive neo-colonial "ululation culture," composed in praise of *waheshimiwa*, their fly whisks, *fimbos* and guns.

Women Writers Speaking for Themselves

Self-articulation and self-definition are very important processes on the journey of attempted self-determination, which then enables an individual to become a full participant in collective social human development. For this reason, it is crucial to listen to women writers sharing and analyzing their experiences in creativity. As we have seen in previous sections of this chapter, most writers are not in the least bit satisfied with what the world of criticism has done with their cre-

ativity. In this concluding section, pronouncements by some of the writers will be commented and elaborated upon, in an attempt to show their relevance to African and human development.

So, what do African women writers have to say about their writing? What do they write about? Why do they write? And how do they write?

The August 1985 Zimbabwe International Book Fair, as noted earlier, had as its theme, "Women and Books." Among the women writers gathered at the event were Ama Ata Aidoo, Asenath Odaga, Barbara Nkala, Bertha Musora, Christine Rungano, Flora Nwapa, Freedom Nyamumbaya, Nawal El Saadawi, myself and others. Bessie Head could not attend, at the last moment. In the keynote address, "Women and Books," since then published in a number of sources including Adams and Mayes' (1998) *Mapping Intersections,* I highlighted the concern that "book apartheid" had tended to exclude women from among the masses as creators. Later on in the workshop a hushed audience listened to a sad story from a Zimbabwean primary school teacher who had labored on a manuscript for years and then had suffered the pain of seeing her husband shred it into bits before throwing it into the fire. Reliving a part of the hurt, she had remarked something to this effect: "He had torn up so many years of my life and set them on fire!" At the same forum, Nawal El Saadawi and Flora Nwapa described writing as a part of themselves, arguing that those who shared their lives would have to accept "the writer" in them as a vital part of "the person" to whom they were united. Buchi Emecheta once referred to her books as her children, and she too has a sad tale about another shredded manuscript. Tsitsi Dangarembga has stated, "I write to save myself... I really believe that's the only valid reason for writing." (Wilkinson 1990:193) What sobering pronouncements!

These writers are speaking about what is obviously a very shared need by women in the profession. Writing and creativity are lifelines, as far as African women writers are concerned. They are means of achieving what Okelo Oculi once described as "explosion of silences," a neat poetic conception which I have since expanded on to read, "explosion of negative silences," seeing that silence can be positive or negative. Negative silence is imposed: positive

silence is self-willed. Women are indeed sinking under the weight of mountains of negative silences that need to be exploded. Some of the stories over which the woman writer has to explode silence defy narration. The torture that Bessie Head (1974) narrates in *A Question of Power* is not just a work of imagination: the harrowing nightmares there are real. Ellen Kuzwayo (1980), similarly, tells of the years of pain and suffering that she carried as heavy baggage until she sat down to write *Call Me Woman*.

In a lot of societies, African women are socialized to believe that suffering in silence is a virtue. Among the Gikuyu of Kenya, a married woman is, in fact, known as *mūtumia*, literally meaning, the one who keeps her mouth shut. At marriage ceremonies, almost every woman is reminded that one of the ways of ensuring a lasting marriage is to shut up, to be a *mūtumia*. It is a real wonder that mental asylums are not bursting with women! The tragic storyline of silences that need to be exploded stretches between here and the beginnings of history, under all kinds of terrorizing experiences: patriarchal oppression, slavery, colonization, imperialism, war, etc. Women writers are attempting to break some of these silences. But as Molara Ogundipe-Leslie has argued in her essay, "The Female Writer and Her Commitment" (see Jones et. al 1987:13), these explosions will have to occur outside the present conventional structures and means of naming women's oppression. Women will have to "reinvent themselves," as Maya Angelou argues in a short documentary entitled *Black Women Writers* where she and others, including Angela Davis, Alice Walker, Michelle Wallace and Ntozake Shange make powerful statements. Only such self-reinventions will release stories and tragedies of rape, abuse, enforced self-bashing, and others that women have been coerced to bury in their subconscious minds. Women will have to "remember" and "articulate." Luckily, such stories have had beginnings in works such as El Saadawi's *Woman At Point Zero*, Kuzwayo's *Call Me Woman*, Ken Bugul's *The Abandoned Baobab* (its ideologically problematic areas notwithstanding) and others. The shame of humiliation will need to give way to the "utterance of the liberating word" (Finke 1992). In this respect, it is relevant to point out that biographical and autobiographical writing will provide key sources in helping us understand

the strength, spirit and imagination that keep women going in the face of a rejecting world. In this respect, too, it is absolutely essential that African women network with other women of African origin in sharing the proposed forms of action that African women have to turn to in order to ensure a lasting explosion of silences. This is one of the forms of commitment that Ogundipe-Leslie discusses in "The Female Writer and Her Commitment." "The Transformation of Silence into Language and Action," which the late Audre Lorde (1980:18–23) so articulately discussed in an article under that title, is of utmost importance here.

Another discovery that emerges from most of the 15 women writers interviewed by Adeola James is that creative writing is empowering. In fact, this is perhaps the answer to the rhetorical question raised by Ama Ata Aidoo, in a quotation cited earlier, where she wonders what kind of insistence it is that had kept women writing under the trying circumstances that she outlines. The need for empowerment partly explains why a lot of women writers not only insist on writing in spite of the great odds that face them; but more than this, the reason why they have created such strong women characters in their writing, an issue that clearly emerges in Adeola James's interviews. Ama Ata Aidoo says at one point:

> If I write about strong women, it means I see them around. People have always assumed that to be feminine is to be silly and to be sweet. But I disagree. I hope that in being a woman writer, I have been faithful to the image of women as I see them around, strong women, women who are viable in their own right (1990:12).

This compelling need on the part of the woman writer to empower not just herself but other women symbolized by the female fictional characters in her writing, comes out clearly in Ellen Kuzwayo's (1980) *Call Me Woman*, which is more than a personal autobiography: it is the life story of a whole line of South African sheroes. She says:

> I was challenged by the lives of so many, many women, who have made such tremendous contributions to the

development and growth of our country, in particular to
the development of the black woman... In fact, when the
publishing process of the book was coming to an end, I
noticed that the publishers had edited so many women
out. I had to tell them to push me out of my book and put
the women in because those were the people who inspired
me to write (Kuzwayo 1980:53).

Empowerment must be a key issue here, or we would not be dealing
with the kind of violent reactions to women's creativity earlier
discussed: the shredding of manuscripts, the imposition of "book
apartheid" on women from the masses and the ridiculing of under-
privileged women when they participated in artistic creations/
productions. Indeed, *In Their Own Voices* reports their status both
within the family and in society at large. A number of the writers
interviewed, for instance, say that their children express special
pride in them as writers, over and above everything else that their
motherhoods symbolize.

Indeed, on the question of empowerment, Buchi Emecheta
makes it categorically clear that to her, writing is power. Describing
her young days in the village, she says:

Some women will sit for hours just peeling egusi (melon
seed) or tying the edge of cloth or plaiting hair. Some will
be telling stories, and not to young children. I saw it and I
used to sit with them. I liked the power these women com-
manded as storytellers. Since then, I thought I would like
to be a storyteller myself (Emecheta 1990:37).

This leads us to the third point consistently made by women
writers: the fact that they have been influenced by the mothers,
aunts, grandmothers or older sisters who told them orature stories
(interestingly, none of them claims to have been influenced by male
orature artists). There is, therefore, a bond between many women
writers and the orature on which they were nurtured. There is no
doubt that part of the strength in the voice of the female writer
draws from the attributes of what I have earlier identified as posi-
tive orature, including the following: the conception of "my story"
as "our story": collective s/heroism; refraining from enigmatism;

redefinitions of notions such as strength, courage, and achievement; preoccupations with human rights for the powerless; and so on. The concern with human rights is of special relevance, as is the fate of the African child, and many other concerns that this chapter cannot even begin looking at. In *African Orature and Human Rights* (1991), I tried to touch on some of the ways in which connections with orature might provide us with a set of ethics and aesthetics that we have come to either disregard or belittle, centered as we are in Euro-ethics. The woman writer has an important role to play in all this. Indeed, a lot of women writers are creating their works, drawing from positive orature frameworks of reference.

Another woman writer who defines orature as a major influence upon her and her writing is Tsitsi Dangarembga. She observes:

> Another very significant experience was in fact the 1990 [Zimbabwean] independence celebrations. I heard the most beautiful poem I've ever heard being recited, and of course it was a Shona. It brought back to me that we have an oral language here. It isn't written, it's oral, and when it is reproduced in the medium in which it is meant to be, it is absolutely astounding (see Wilkinson 1990:195).

Brief as it is, this discussion on the bonding between orature and women writers would be incomplete without a look at the work of Penina Mlama, a playwright who has: (i) created all her ten-plus works in Kiswahili; (ii) deliberately written in Kiswahili in order to address her local audience; (iii) consciously researched in the ethics and creative forms of orature in order to explore her themes, as well as evolve her aesthetics; and (iv) spent a good part of her theater career operating in the community theater mode, as a means of applying her art to the reality that her works address. She is a true popular artist in the Brechtian sense of the term, as well as literally being extremely popular and admired in Tanzania. How many people have heard of this artist in the conferences that discuss language, community theater and popular culture? What about this as an illustrative case of the "giants-celebrities" syndrome? In the following, Mlama eloquently states her views:

> I have been using the Tanzanian traditional forms like songs and storytelling, dance and recitation, so as to come up with plays, which will appeal to the Tanzanian cultural identity... We use theatre as a means through which people can discuss and analyze their problems, put them into a theatrical performance, show it to the audience and then discuss what the solution should be. When we first started working on the popular theatre movement, we did not design it deliberately to engage "the woman issue" as such. But as soon as we started working, the woman issue always came up whichever problem we dealt with at the village level (1990:77, 83).

Above, Penina Mlama demonstrates the way the type of community theater she engaged in has tapped orature creativity using performance to provide a people's platform for naming the problems facing their communities and then dramatizing them, in an effort to find solutions. She also shows how, over time, these performances have provided space for addressing sexism and the woman question in society. On the issue of women as performing artists, she observes:

> In the area of drama, it is even more serious because many people still feel that women should not be performers. It is seen as a profession, which is despised, therefore respectable women should not be performing on the stage. This is a big contradiction because in a society like Tanzania, if you go to the village, our mothers are the dancers and the storytellers. Why is it that when you come to the city and a woman stands on the stage performing she becomes cheap? There are all these contradictions which really don't make sense and they have all contributed towards making the woman writer remain unrecognized compared to the man (Mlama 1990:86).

Mlama's statement takes us back to the debate on the censorship of women as creators, artists and performers. She demonstrated that in Tanzania, community theater is an area of contention for women artists – a regrettable fact, in light of the potential that performance offers, combining, as it does, orature and the written tradition. We are once more reminded that women artists are continuously

being stifled by patriarchal constrictions and prejudice even as they struggle to remain creative.

It is not possible to exhaust the discussion on what women see themselves as contributing to society through their art in the limited space of this chapter. As intimated, the subject has been quite extensively covered by the sources cited at the beginning of this section and in particular by Ama Ata Aidoo (1990) and Omolara Ogundipe-Leslie (1990) in their interviews with Adeola James. The chapter's objective was to facilitate access to more voices and to highlight some of the concerns seen as being key to the promotion or negation of women's creativity.

In conclusion, let us summarize the issues raised by this chapter in a poetic statement that is both an elaboration of the role of the African woman artist in society and a celebration of her undaunted determination to remain at the center of history and human development:

Prosaic Poem

In commemoration of those moments
when we make prosaic statements
that end up sounding poetic and then
we are reminded that ordinary human
dialogue is often punctuated with poetry

Refrain: One Day!

One day, we shall rescue our lives from peripheral hanging on and assume the center of historical action. We shall explore every avenue that runs through our lives and create life roads that know no dead ends, extending them to the limits of human destination. We shall put an angry full stop to the negation of our human rights.

One Day!

One day, we shall undertake a second journey along the bushy path of denied human development, chasing away

the wild beasts that prowl the route of our narrow survival lest they make a complete jungle of our already bestialized lives. We shall then cultivate a huge global garden and plant it with the seed of true humanity.

One Day!

One day, we shall emerge from the wings and occupy the center stage in full visibility, refusing to be observers and understudies who wait behind the curtain of living drama. We shall liberate the word and become its utterers, no longer cheer crowds or ululators who spur on and applaud the molesters of our affirmative speech.

One Day!

One day, we shall explode the negative silences and paralyzing terror imposed upon us by the tyranny of dominating cultures and their languages of conquest. We shall discover the authentic voices of our self-naming and renaming, reclaiming our role as composers, speaking for ourselves, because we too have tongues, you know!

One Day!

One day, we shall make a bonfire of currently dismantling and maladjusting economic structural adjustment programs, then engage in the restructuring process, producing coherence around our scattered daily existence till it is full to bursting. We shall stop at nothing short of holding the sun to a standstill until the job is complete.

One Day!

One day, we shall move the sun of our existence so that it truly rises from the east of our lives, reaching its noon at the center of our needs. We shall then release it to set in the west of our perverted and dominated history, never to rise again until it learns to shine upon the masses of global being, not only islands of pirated living.

One Day!

One day, we shall exterminate the short distance between
the kitchen and bedroom of our lives, storm out of the
suffocating space between the factory and the overseer of
our exploited creative labor, paving a path that leads to the
buried mines of our suppressed human potential. We shall
walk it if it stretches unto eternity.

One Day!

One day, we shall celebrate this earth as our home, stand-
ing tall and short, boasting of the abundance and multi-
fariousness of our fulfilled human visions. We shall not
look to the sky waiting for unfulfilled prophecies. We shall
upturn the very rocks of our enforced stony existence, con-
verting them into fluvial banks of life sustenance.

One Day!

(Mugo 1994:83–85).

Chapter 5
POPULAR PARADIGMS AND CONCEPTIONS: ORATURE-BASED COMMUNITY THEATER

Any serious project on the reconstruction of the study and meaning of Africa must place cultural discourse at the center of its dialogue, for cultural studies bring us face to face with the history of a people, their self-definition and an understanding of the dialectics that shape their destiny – together with all these processes' inherent contradictions. It is with this understanding that this chapter posits orature-based community theater as an important option in the quest for alternative paradigms that will take African studies in the arts beyond colonial and neo-colonial formulations. In its attempt to depart from traditional Western bourgeois and liberal theater traditions, orature-based community theater may be regarded as an example of what Carol Boyce Davies terms an "uprising discourse" (1994:80-112). It is among other things, a response to colonial and neo-colonial cultural expressions of domination. Drawing as it does on African orature forms, genres, and aesthetics that inform and shape the artistic production process, community theater is created with the broad masses of the people as the primary intended audience. I will return to this point later, but first I must elaborate on the reasons for the focus on orature and community theater.

The key argument here is that African orature and the performing arts constitute the core of the authentic art forms that bring us closest to the heart of African people's self-expression and practice.

They expose us to the type of indigenous knowledge that we should be scrutinizing as seriously as possible. This is especially critical given the crisis in what I call *invasion* by dominating paradigms, which are often veiled under the guise of status quo-controlled and status quo-programmed multicultural study packages, often run by paternalistic "specialists" who operate as agents of systems of domination. As has often been argued, even those who claim to be the best friends of Africa and Africans exhibit a consuming appetite for control when it comes to the question of intellectual output and authority on Africa. Personally, I have encountered Africanists who are not just condescending and dismissive of African perspectives and paradigms that contradict their own, but altogether hostile to them.[1] In this intellectual wrestling match, there is particular resistance to ideas centered on mass-based foundations of knowledge, a variation of colonialism's violent refusal to accept Africans as co-producers of intellectual knowledge, a case made eloquently long ago by Aimé Césaire (1955).

It has become all the more urgent that African scholars unearth people's paradigms that have the capacity to withstand conceptions imposed from outside by those who control the production of knowledge. The more successfully this is done, the better positioned African scholars will be in bringing to conference rooms their people's contribution to knowledge rather than recycled versions of Western scholarship. The focus on home-grown theories and practices will also contribute to the task of weeding out armchair-cum-tourist African Studies specialists who have appropriated the study of Africa, analyzed it from a calculated distance, and taken advantage of the current gloomy status of African academic conditions.

This is not, of course, an argument for fencing off non-African scholars from the study of Africa. Rather, it is an attempt to expose the arrogance and spirit of invasion with which some of them have approached their areas of specialization.

To conclusively posit orature-based community theater as a model, it is necessary to reinforce a number of observations. One can convincingly argue that in dealing with any social heritage, when direct personal contact with human resources and their physical reality is not possible, the next most meaningful point of contact

is through cultural expression. Within the African setting, it is the performed art forms (and particularly those that are orature based) that put us in direct dialogue with the masses that are the major producers. This in turn exposes us to a long history of cultural resistance that has played a key role in interrogating the impositions of dominating, imperialist transplantations. To explain this fully, I will need to briefly review the history of drama and theater in Africa to show how dominating paradigms were imposed under colonialism and neo-colonialism while analyzing these impositions within the context of enslaving education and the propagation of false consciousness. I will then examine emerging trends in African community theater, pointing out ways in which these efforts provide liberating paradigms in dialectical opposition to dominating paradigms. To allow for focus, the chapter will draw most of its illustrations from the East African scene, which I know best.

"Theater" and "Drama"

I begin with a statement from Ruth Finnegan, a specialist in African "oral literature" who argues that drama as a distinct and developed art form is unknown in indigenous African societies: "Though some writers have very positively affirmed the existence of native African drama, it would perhaps be truer to say that in Africa, in contrast to Western Europe and Asia, drama is not typically a widespread or a developed form" (1970:500). In making her statement, Finnegan is dismissing altogether the notion that drama is "a *developed* form" within the orature tradition. She describes what exist as "phenomena" and consequently proceeds to argue, rather paternalistically: "There are, however, certain dramatic and quasi-dramatic *phenomena* to be found, particularly in parts of West Africa" (Finnegan 1970:500; emphasis added), identifying "the celebrated masquerades of Southern Nigeria" as examples of these half-baked dramas. Although devoting 300 pages to poetry and another 165 to prose, Finnegan disposes of drama, a very prominent art form in African orature, in a mere 17 pages. Preconceptions and transplantations of concepts dictating what constitutes drama explain this block, at least in part.

Coming from a scholar whose work, *Oral Literature in Africa*, is a standard reference in many universities, including African ones, Finnegan's claim should cause concern. It is a clear case of an imposed paradigm based on a definition that is external to many of the African cultures under discussion. Finnegan just falls short of calling the orature genre "primitive drama" in line with Melville Herkovits (1944), the famous Africanist and anthropologist. Judging from commentaries and assertions on ancient African drama, it is obvious that drama, as an art form, has been practiced widely in African societies since ancient times (see, among others, de Graft 1976; Equiano 1987; Graham-White 1974; Snowden 1978; Soyinka 1976; Traore 1972).

Furthermore, Finnegan does not even define what she terms "quasi-dramatic phenomena." Presumably, since in Western reckoning drama becomes theater only when a written text is enacted, the alleged nonexistence of a dramatic text rules out the question of theater. Compartmentalization of knowledge becomes an additional issue of concern here, reflecting an imposed paradigm on the orature world, which is characterized by "connectedness," as demonstrated by the onion structure theory (see Mugo 19991a) and reinforced by such writers as Kenyatta (1938), Jahn (1961), and Mbiti (1970). In orature the division between drama and theater is illusory rather than clear-cut, if not totally immaterial.

Zakes Mda, a well-known and respected colleague in African community theater, perceives theater and drama as distinct art forms, though he does not discuss the implications of this for orature:

> "Theatre" and "drama" are often treated inter-changeably, although they are two distinct types of dramatic expression. Drama is a *literary* composition, while theatre is actual performance that may or may not emanate from *literary* composition. Theatre involves live performance that has action planned to create a coherent and significant dramatic impression. Although a *literary* composition may constitute the basic element of a theatrical performance, theatre is not primarily a *literary* art but uses elements of

other arts such as song, dance, and mime, in addition to
dialogue and spectacle (Mda 1993:45; emphasis added).

A close examination of this definition reveals an inherent insistence
on linking and relating the two concepts even as Mda is straining to
do otherwise. The line between the two genres is so tissue thin that
it defies division. Whereas it is true that theater need not emanate
from literary composition, it does not follow that a non-written
piece is not a text. "The saga of Ozidi," for example, was an oral dra-
matized creation among the Ijaw of Nigeria long before J.P. Clark
(1966) captured it in book form. It was both drama and theater.
The notion of text as that which is written thus becomes external
and problematic when defining African orature compositions. The
following point must be emphasized: no linguistic composition can
exist without a text, which can be either in people's memories or on
a piece of paper. Nonetheless, many African theater practitioners
have come to accept external definitions of drama and theater as
binding when discussing African community theater. This points
once again to the urgent need for paradigms that unravel our own
reality, independent of Western concepts.

African Orature as Historical and Artistic Expression

With this background in mind, I move to the development of
drama and theater. I begin with an essential quotation from Amilcar
Cabral that helps to situate these artistic expressions as part of the
production process in general and more specifically as fruits of
culture. Cabral's words also explain why colonial and neo-colonial
educational paradigms are actively bent on destroying their own
impositions. This is his argument:

> Whatever may be ideological or idealistic characteristics
> of cultural expression, culture is an essential element of
> the history of a people. Culture is, perhaps, the product
> of this history just as the flower is the product of a plant.
> Like history, or because it is history, culture has as its mate-
> rial base the level of the productive forces and the mode
> of production. Culture plunges its roots into the physical
> reality of the environmental humus in which it develops,

and it reflects the organic nature of the society, which may be more or less influenced by external factors. History allows us to know the nature and extent of the imbalances and conflicts (economic, political and social) which characterize the evolution of a society; culture allows us to know the dynamic syntheses which have developed and established by social conscience to resolve these conflicts at each stage of its evolution, in the search for survival and progress (Cabral 1973:42).

In African orature, drama and theater are more than artistic expressions: they are carriers of history, reflectors of the positive and negative forces inherent in the evolution of society. They are also vehicles of conscientization that shape people's vision, even as they explore avenues for resolving the conflicts that characterize human development.

From antiquity right up to the slave trade and the colonial invasions of Africa, these are the terms on which drama and theater existed in various African communities. Theater took place at different kinds of socio-cultural forums such as commemorations of historical events, cultural festivals, ceremonial occasions, ritual enactments and ordinary social events. Theater was therefore used for entertainment as well as artistic commentary and critique of social reality. Generally speaking, theater was produced and consumed communally, but like all other forms of artistic and cultural production, it reflected the socio-econo-political arrangement of the specific society from which it originated. Thus, in "vertical" societies[2] theater performances tended to reflect a feudalistic worldview and were often used to highlight themes featuring the chief, the queen or the king. Examples of this kind of theater can be found in a number of countries that had feudal structures, such as ancient Egypt, the kingdoms of West Africa, Lesotho, Swaziland and Uganda. Under such social formations, theater tended to be a tool for the deification and glorification of the ruling class. It was not unknown in such situations to witness performances dramatizing praise poetry that described the ruler as the "great," the "omnipotent" and the "lion that roars," whereas the masses were

portrayed through images such as "ants," "rubble," "dust" and "grass" that tremble at the voice of the almighty.

It is also important to point out, however, that popular artists – even when in the minority – spoke loudly and clearly on behalf of the people, creating opposing images and symbols in an attempt to assert the humanity of the majority. This was so more often in "horizontal" social formations, where popular artists dominated the scene, taking their cue from the majority whose aspirations for self-assertion and human development they championed.[3] In their dramatizations, the heroes and heroines become what Wanjiku Mukabi Kabira describes as "the little people" of society (1983:1). At the end of the day, it was the small ones – the hare, the deer, the oppressed and powerless small antagonists – who emerged victorious, outdoing bullies such as the greedy hyena, the trampling elephant, and the gulping ogre, who were the antitheses of all that is just and humane.

This dialectical, cultural scene was invaded by the Arab and European slave traders, followed closely by Western colonial invaders. The enslavers and colonizers were not unaware that culture plays the role that Cabral has attributed to it. They knew that to effectively disinherit their victims and dominate their economy, they had to "conquer" them culturally. Frantz Fanon convincingly demonstrated this thesis in his two monumental works *The Wretched of the Earth* (1963) and *Black Skin White Masks* (1967). Even more demonstrative at the educational level, however, is the work of Paulo Freire, the celebrated Brazilian emancipatory educationist, theoretician and community activist. He offers an especially rich analysis of the effects of conquest paradigms that invaders impose on colonized people. He defines cultural invasion thus:

> The theory of antidialogical action has one last fundamental characteristic: cultural invasion, which like divisive tactics and manipulation also serves the ends of conquest. In this phenomenon, the invaders penetrate the cultural context of another group, in disrespect of the latter's potentialities; they impose their own view of the world upon those they invade and inhibit the creativity of the invaded by curbing their expression... In cultural invasion... the invaders are the

> authors of, and actors in, the process; those they invade are
> objects. The invaders mold; those they invade follow that
> choice – or are expected to follow it. The invaders act; those
> they invade have only the illusion of acting, through the
> action of the invaders (Freire 1983:150).

Freire further argues that "all domination involves invasion – at times physical and overt, at times camouflaged, with the invader assuming the role of a helping friend" (1983:150).

This final point is particularly important as we examine the plight of African theater under the paradigms of colonial and neo-colonial education, whose practitioners claim to be agents of development. In this regard, Jacques Depelchin's argument (Martin and West 1999:157-175) that one of the most powerful sources of silencing various aspects of African history comes from within the scholarly discourses of the "major" (read *dominating* or *invading*) histories becomes pertinent. The silencing took all kinds of vicious forms. Indeed, when the enslavers and colonial invaders ambushed African people's history, their abuse of human rights went beyond the robbery of African lands: they also sought to capture their victims' souls. Assertive forms of cultural expression were either captured, forbidden or at best censored.

On the whole, the invaders targeted popular forms such as drama and theater. They repressed those artistic expressions that asserted the people's collective well-being and either condoned or actively encouraged whatever reinforced the power of the ruling classes. In their toleration and promotion of *court* orature, as it might be called, the invaders used divide-and-rule tactics to woo the ruling class into collaboration while silencing the dominated majority. In this way they sought to silence the voices that sang the epic songs of the resisting masses and to chain the bodies that dramatized the theater of the oppressed. Theater performed around festivities, ceremonies, and rituals that celebrated the people's milestones of production, development and social interaction was gagged. Theater that stagnated in religious swamps and caused trembling before tyrannical court enclosures was applauded. More significantly, the invaders schooled court theater artists and prospective artists in the invaders' own performing arts paradigms. Thus, they manufac-

tured robots that became mere imitators of the invaders' values and aesthetics. The players dressed like Greeks, Romans, and Anglo-Saxon gentlemen and ladies, either brandishing swords or playing pianos in upper-middle-class drawing rooms. Passing a vote of no confidence in their heritage and authenticity, this class of theater artists provided the tabula rasa on which – under neo-colonialism, for instance – the artistic paradigms of Hollywood have kept soaps such as *Dallas* and *Dynasty* on African television screens long after they went out of circulation in the United States.

Paulo Freire has this to say about the dehumanizing psychological effects of cultural invasion:

> In cultural invasion it is essential that those who are invaded come to see their reality with the outlook of the invaders rather than their own; for the more they mimic the invaders, the more stable the position of the latter becomes.
>
> For cultural invasion to succeed, it is essential that those invaded become convinced of their intrinsic inferiority. Since everything has its opposite, if those who are invaded consider themselves inferior, they must necessarily recognize the superiority of the invaders. The values of the latter thereby become the pattern of the former. The more invasion is accentuated and those invaded are alienated from the spirit of their own culture and from themselves, the more the latter want to be like the invaders: to walk like them, dress like them, talk like them (1983:151).

The Kenyan Colonial Invasion

Armed with the previously articulated understanding and determined to cement cultural domination among the colonized, invading educators set out to cultivate this kind of mimicry among their theater students. In Kenya, for instance, expatriate theater houses such as the Kenya National Theater and the Donovan Maul Theater in Nairobi were so heavily subsidized by the colonial government that they could sponsor plays from Britain. In this way, audiences in the colony could be treated to unpolluted, direct importations from the metropolis – cast, directors, stage props and all. To complement these efforts,

certain colonial schools were identified as factories for the production of a collaborating local theater elite. These schools specialized in staging Shakespearean plays such as King Lear, Julius Caesar, Othello, Macbeth and even the notorious conquest drama King Henry V.

The Alliance high schools in Kenya featured Shakespearean plays as an annual event. The players "patriotically" chanted: "Once more unto the breach, dear friends, once more/Or close the wall up with *our English dead*" (*Henry V*, act 3, sc. 1; emphasis added). The colonial African school armies thus fought the imaginary French and even ridiculed Queen Catherine's broken English. In the meantime, thousands of Kenyan masses were also "closing up the walls" of colonial enslavement with their living and their dead, as they perished under forced labor on commercial plantations and in the imperialist World Wars I and II.

Insisting on alternative paradigms, however, the African masses were all along dialectically creating alternative platforms of resistance and self-affirmation. When colonial agents organized what was sometimes referred to as "extramural theater" for them, they resisted it. Some of the drama skits, then referred to as "concerts," that constituted this so-called extramural theater were downright insulting. In one of them, the plot depicts an African village so ridden with filth and rats that a plague eventually breaks out. Unable to help themselves or resolve the crisis, the villagers die in staggering numbers. Miraculously, a white government official appears just as the crisis gets out of hand. With the aid of his African understudies, he teaches the villagers how to clean up their surroundings and manages to get rid of the rats for them. The villagers are thus rescued, and in sheer awe they thereafter venerate their messianic hero.

In this drama the audience meets, probably for the first time, grown African men and women who are not only so lazy that they helplessly sit wallowing in the filth, but also so stupid that they are incapable of figuring out how to kill the rats that are gnawing their children's fingers, toes, ears and eyes. As I intimated, the masses boycotted these denigrating invasion theater shows in which they were made to sit on the fringes of existence, watching history pass them by, while they were depicted as dumb, lazy, unintelligent and utterly dependent on their oppressors. To replace these insults, they

created their own conceptions of history, of themselves, and of the world around them. They made use of the limited space under their control, such as religious venues, converting the ground into platforms on which they enacted their own versions of reality. They spread political messages camouflaged in religious symbolism and flowering with militant aesthetics, creating what Carolyn Cooper would call "resistance science" (1994), in the fashion of African American sorrow songs and in the spirit of "Maroon ideology," to borrow again from Cooper. Through these efforts the masses sought to conscientize each other, to decry colonial acts of dehumanization and to assert their human dignity.

These acts of cultural resistance through theater and other means took place in Kenya under the umbrella of "independent schools" and "independent churches," which Fred Welbourne documented from a historical perspective in *East African Rebels* (1961). These alternative institutions were started as far back as the 1930s, and they mushroomed all over Kenya in the 1940s and 1950s, defying violent censorship by the colonial government right up to the advent of independence in the 1960s. A satirical resistance theater emerged to counteract colonial paradigms, with dramatized skits, concerts, song and dance thriving. No amount of repression, efforts at prohibitive legislation, bans or arrests could stop the people.

Amandina Lihamba observes that "as colonial violence intensified theater forms became more militant in protest and resistance against colonial aggression and exploitation" (1990:26). Further, there was a deliberate insistence on using indigenous Kenyan tongues, another clear message of defiance to colonial educators who had privileged English as the medium of linguistic expression.

The Tanzanian Colonial Invasion

The picture in Tanzania was no different. As Lihamba (1990) has shown, the invaders, unable to repress mass-based theater, decided to employ sinister methods to divert its mission and pervert its artistic goals. Community theater g roups were forced to promote colonial business, especially during agricultural shows where the products of commercial farmers were prominently displayed. What

Lihamba does not dwell on is the extent to which these Tanzanian performers themselves may have been on exhibition as specimens of "exotic" African cultures. The tradition of exhibiting human beings is not foreign to invading cultures. Though extreme, the exhibition of Ota Benga in a cage with monkeys at the New York Zoological Park in the Bronx (Bradford and Blume 1992) by American Africanist anthropologists at the turn of the century testifies to the inhumanity of the conquering powers' cultural fossilization of dominated people – another common characteristic of invading paradigms in the humanities and social sciences.

Lihamba notes that prior to 1948, the colonial administration not only actively discouraged African traditional performances but also in some cases actually prohibited them. They were permitted only for "officially sanctioned events such as agricultural shows where the performances were used as crowd pullers for the potential buyers and consumers" (Lihamba 1990:26). Lihamba quotes a revealing passage from a document entitled, "Report of Group V, Cambridge Summer Conference, 1948" in the Tanzania National Archives/38813, which reads as follows: "We attach particular importance to the exhibition or show as a technique... Plays, dances concert parties and the like, can be intimately connected with the exhibition technique especially if traditional festivals and celebrations are utilized as a setting for the exhibitions" (1990:26).

Although awkwardly expressed, the point is made. African artistic performances were faced with yet another danger – commercialization – which would affect them most adversely at the levels of form and content. Distortion and adulteration would accompany imposed paradigms on when, why, how and for what the performances would be produced. The "directors" and controllers would ensure that invasion was pushed to its limit: the objectification of those invaded and their self-image.

Neo-colonial Invasions and Mass-Based Theater

This abuse and commercialization of popular mass theatrical performances has assumed deplorable dimensions under neo-colonialism. Ministries of tourism and culture in many African

countries have at times used theater artists in the same way as they use animals in the game parks: as a means of raising foreign currency by entertaining tourists still in search of the African wild. Since he who pays the piper calls the tune, to use a hackneyed expression, commercial performing artists will often go out of their way to give the tourists what they desire to see. Needless to say, such compromises negatively affect the paradigms governing the production of the performed pieces, distorting indigenous African art forms and turning them into comical exhibitions for the entertainment of tourists. Authenticity is thus sacrificed as the performers dance themselves lame in near-naked painted bodies that match the profiles of jestering acrobatic buffoons, evoking the "noble savage" image of television's Discovery Channel. The Bomas of Kenya, a tourist center, used to feature an acrobat who specialized in distorting his facial muscles with such success that he would momentarily look like a monster. Here, indeed, was living, visible evidence of the cost of tourist entertainment: lost beauty and human dignity.

With these taunting insults on African masses in view, the progressive theater artist has had no option but to join the masses in their efforts to rescue their art forms from invasion under neo-colonialism. More than this, the alliance has recognized the power of the performed word in the process of mass conscientization. This power had been demonstrated throughout the history of anticolonial cultural struggles. Under neo-colonial states and dictatorships, the abuse of human rights has acquired forms just as grotesque as those experienced during colonization. Creators of mass-oriented theater are therefore committed to the revolutionization of this most immediate, communicative art form, with a view to turning it into a lethal artistic weapon that the invaded can use against the systems that oppress them.

At this point it becomes necessary to define *mass-based theater*, relating it to orature and identifying the paradigms that distinguish it from the theater of invasion examined previously. In its ideological conception, mass-based theater also borrows paradigms from revolutionary theater practitioners such as Paulo Freire (1983) and Bertolt Brecht (1964). In his well-known essay entitled "The Popular and the Realistic," Brecht (1964) places popular theater within the

realist tradition. Redefining "realism" outside the paradigms of the so-called great tradition, Brecht contextualizes a shift within 20th century capitalist Europe in which "the people has [sic] clearly separated from its top layer" and in which "its oppressors have parted company with it," becoming "involved in a bloody war against it which can no longer be overlooked" (1964:107). He thus contends that from the point of view of the progressive theater artist: "It has become easier to take sides. Open warfare has, as it were, broken out among the 'audience.'... The ruling strata are using lies more openly than before and the lies are bigger. Telling the truth seems increasingly urgent. The sufferings are greater and the number of sufferers has grown. Compared with the vast sufferings of the masses it seems trivial and even despicable to worry about petty difficulties and the difficulties of the petty groups" (1964:107).

In addition to making other points, Brecht is arguing that in an oppressive situation, theater cannot evade the burden of functional art, a paradigm that is antithetical to the bourgeois notion of art for art's sake. More than this, he is advocating that theater aligns itself with the struggles of the oppressed and avoids a preoccupation with elitist trivialities. In making these observations, Brecht might as well be addressing the neo-colonial African reality. From north to south, from eastern coast to western coast, workers and peasants bend double under the weight of economic oppression, political repression and socio-cultural degradation. More than 80 percent of the continent's population lead a subhuman material existence. Denial of basic human rights – food, clothing, shelter and the wherewithal for self-determination – leaves the majority of the people in a perpetual begging posture. In particular, children have become ready victims of hunger, famine, disease and war. Africa is faced with imminent child genocide that will affect the development of generations to come. Given this situation, the theater artist faces a moral choice: whether or not to continue with the paradigms of bourgeois theater, which depict the masses as nothing more than asides or invisible incidents, when not ridiculing them or wiping them out of history altogether. According to Brecht, to propagate bourgeois theater paradigms is to abet the distortion of reality, if by

reality we mean the overwhelming evidence of the wretchedness of the majority in our midst.

Having dealt with the issue of whose side popular art should take, Brecht proceeds to explain what he means by *popular* from the point of view of aesthetics and vision. This definition is pertinent because it is related to the question of why we should promote mass-based orature theater. As he observes: "'Popular' means intelligible to the broad masses, taking over their own forms of expression and enriching them/adopting and consolidating their standpoint/representing the most progressive section of the people in such a way that it can take over leadership: thus intelligible to other sections too/linking with tradition and carrying it further/handing on the achievements of the section now leading to the section of the people that is struggling for the lead" (Brecht 1964:108).

This model, greatly elaborated by revolutionary culturalists and educational practitioners such as Augusto Boal (1979), Crow and Etherton (1980), Paulo Freire (1983) and others, is the theater paradigm with which progressive theater artists in Africa have been experimenting during the last two decades or so. This movement follows efforts in the 1960s and 1970s that sought to democratize the stage through such paradigms as the free traveling theater, the open-air theater, street theater, and school and college drama festivals. Despite their best efforts, however, these projects still left the masses on the periphery. While recognizing the free traveling theater as an alternative paradigm to colonial theater, I have nonetheless indicated elsewhere its shortcomings:

> Free traveling theaters from western-patterned university campuses could never become the people's theater. The latter were spectators and not active participants. The themes explored by the theaters were liberal and at best nationalistic. The language used was still predominantly English, even though now and again there were attempts to use African languages. The expressions, mannerisms and aesthetics applied did not draw from the "progressive section of the people." The elite were the stars, the articulators of conflicts, the leaders. In short, the experiment was

limited and limiting to the masses: it fell short of the defi-
nition of "popular" given by Brecht (Mugo 1991b).

The same comments could be made about the other experiments
mentioned previously.

In East African drama festivals, however, some of the produc-
tions made an effort to "return to the source," in Cabral's sense of
the concept. On this particular paradigm, I have observed:

> The best thing that resulted from this was the turning to
> what Cabral has called "the source" in drawing inspiration
> from the popular, progressive aspects of African orature.
> The youth treated their audiences to dramatized symbols
> of greed, oppression and tyranny – the hyenas and ogres
> of East Africa's neocolonial ruling classes. They depicted
> the masses as the intelligent hares and heroic "little
> women"/"little men" of orature creations who ultimately
> struggled against their oppressors to final victory (Mugo
> 1991b).

An Orature-Based Paradigm

These efforts created the seeds for orature-based community
theater in which the participation of the masses and their artistic
forms, cultural paradigms, and languages are employed to shape
the form and content of the pieces, as well as the overall visionary
perception of the productions. However, the extent to which the
various forms of orature-based community theater succeed in doing
this varies from experiment to experiment, as subject that has been
extensively treated by, among others, Boal (1979), Crow and Ether-
ton (1980), Kamlongera (1989), Kidd and Byram (1981), Kidd
and Colletta (1980), Mda (1993) and Mlama (1991). There is thus
no need to describe individual community theater projects here. It
will suffice to close with a brief, generalized sketch of the process
involved in creating a desired orature-based model, with a view to
reinforcing its place in the definition of liberating paradigms. The
model used is that practiced by the Zambuko/Izibuko community
theater group in Zimbabwe, of which I was a participating member
when I lived in Zimbabwe. This group has staged performances in

English, Chishona, and Sindebele – the three official languages of Zimbabwe – including works such as *Mavambo, Samora Continua!, Mandela – Spirit of No Surrender!* and *Simukai Zimbabwe! (Rise up Zimbabwe!)*, criticizing "invasions" by the IMF (International Monetary Fund) and the World Bank.

The project of orature-based theater goes back to the people for its themes and inspiration, deliberately drawing on the most positive aspects of self-expression that grassroots communities have evolved over time. The people are not relegated to the role of spectators but are involved as resources and participants in the creative process as well as in performance. The entire group of theater artists thus begins with brainstorming issues that are of concern to the community in which they are based, discussing them thoroughly before identifying the predominant theme on which the dramatization will eventually focus. The brainstorming exercise is normally conducted in the language shared by the creators of the artistic piece, ensuring that each member has freedom to use the tongue with which she or he feels most comfortable. This means that if Chishona, for instance, is the most common and bonding language, it becomes the main medium of communication. Other languages can be brought in where and when necessary. Members contribute orature songs, dances, stories and other creations from their communities. Where necessary, these are researched for the specific production. Every rehearsal opens with dance and song warm-up exercises. Liberation songs are the most popular. Indeed, one of them became Zambuko/Izibuko's signature tune. The song tells how Zimbabwe was liberated through armed struggle, and the artists hold toy guns high as they dance into the theater and onto the stage in celebration of the people's victory.

As the theme is developed and the spoken text shaped, the group begins identifying, from among the available human resources, individuals best suited for specific roles. Each case is discussed openly and critically, with the decision based purely on merit. Workshops in dramatization then begin. As the "script" is developed, each stage of the process is informed by intensive suggestions and viable solutions. Once the oral text is more or less consolidated, scripting and recording finally come into play, but never for the purpose of pro-

ducing a permanent text above amendment. During the rehearsals improvisation and continuous "writing" supersede the authority of a fixed script. When the rehearsals are mature, early performances are presented to other theater artists and members of the general community of artists for criticism. From the comments received, the group then works on perfecting the performance for the general public. Following some public performances, the audience is invited to participate in a session of criticism and self-criticism. Thus the piece and the artists continue to grow with each performance.

The foregoing discourse posits community theater, and specifically orature-based projects, as a paradigm that creates space for democratic participation, involvement, and collective work. The creative process becomes an embracing act; the final product, a shared experience. This contradicts the paradigm of "art for art's sake" and interrogates the perception of creative artistic productivity as the monopoly of intellectual elites. Furthermore, the paradigm provides a possible meeting place between orature and the written tradition. Inclusiveness and collective engagement replace the divisiveness and alienation of individualistic approaches. This explains why oppressed classes and groups such as workers and peasants, as well as women and youth, have responded so readily to the community theater project, which they use as a means of exploring the oppressive economic and political realities that have long suppressed their creativity. African Studies specialists should pay serious attention to this aspect of creative and intellectual productivity as a paradigm worthy of further investigation.

Chapter 6

ELITIST ANTI-CIRCUMCISION DISCOURSE AS MUTILATING AND ANTI-FEMINIST

The space limitation of this chapter militates against a coherent response to the wealth of pertinent ideas raised by Professor Obiora's timely intervention on the question of female circumcision, which my piece is a response to.[1] Until quite recently, the issue has been approached mostly from anthropological, health, policy and popular literature perspectives, but it has never been so closely or extensively examined through a legal lens. Obiora's paper is a striking example of excellent scholarship, based on amazingly extensive library research and presented through elaborate, yet incisive, logical arguments that are articulated with impressive lucidity. While coming from a legal perspective in content and thrust, the paper also traverses several areas of academic endeavor with great ease, offering a rich panorama of multidisciplinary platforms from which a variety of scholars can engage in serious intellectual discourse over this hot issue.

My contribution addresses Obiora's concerns regarding the negative role played by popular literature and other forms of writing that stereotype African women who practice or support circumcision, depicting them "only as victims and preyers-upon each other."[2] This chapter pursues and reinforces a number of pertinent points made by Obiora, the central one being that certain "circumcision protestations contradict feminist principles,"[3] and further, that a reading of

most Western "texts" on the subject "suggests that cultural imperialism and orientalism may well lurk behind tendentious exposés."[4] To liberate my own exposé from the kind of academic elitism that deliberately uses impenetrable vocabulary, enigmatic philosophizing, and alienating "trade" language to display the writer's intellectual power over her/his readers, I will speak to my audience in very plain words. Communication between those debating the subject of female circumcision is so urgently needed that no barrier should be allowed to stand in the way of this burning conversation.

The chapter opens with a disclaimer in which I denounce the practice of circumcision, a move to be clearly differentiated from the negation or demonization of those who practice it. It then moves on to define feminist writing and its supposed role in raising the consciousness of, liberating, and empowering victims of gender oppression, while condemning the systems and structures that enslave them. Through an analysis of *Possessing the Secret of Joy*[5] and *Warrior Marks*[6], I seek to demonstrate the significance of Obiora's call when she reminds elitist-prone feminist militants that true "feminism rejects elitism and vanguardism."[7] My standpoint reinforces the indictment of long-nosed feminists, who, ironically, end up practicing "the very silencing and stigmatization of women that feminism challenges"[8] Supporting Obiora, I argue that what I term "the external messiah syndrome" is a real danger even when one is dealing with the best intended of anti-circumcision campaigners, not to mention agents of Western cultural philistinism parading as feminists. The point made is that armchair activism is a form of invasion, perceiving, as it does, the oppressed as helpless victims: objects who are totally devoid of the agency required to change their oppressive reality. In the case of female circumcision, the approach leads to the objectification of the very women who are, supposedly, under rescue. Overdone, the tendency can lead to not just the silencing that Obiora denounces, but to the mutilation of the subject's entire being. In all this, cultural imperialism and class domination come to the forefront, as does the kind of ideological provincialism that ends up "blaming the victim." Instead, the systems and structures responsible for producing the kind of false consciousness for which the targeted "offenders" are being scathed

should be exposed. In sum, this chapter views any writing that conforms to the above description and tendencies as a contradiction in terms, even as it promotes itself in the name of feminism.

While reinforcing the role of feminist writing in raising the consciousness of liberating and empowering oppressed women, the paper also concludes that such writing should facilitate conversation with women who practice circumcision, rather than dictate to them what is to be done. More than this, such writings should point out avenues through which the women at risk can cultivate agency, so that they can become active participants in the transformation of the oppressive reality facing them. In sum, I conclude that *Possessing the Secret of Joy* and *Warrior Marks* are sorely lacking in fulfilling these tasks.

Why the special attention to Alice Walker? By virtue of Alice Walker's accomplishments as a powerful, well-known feminist writer – taken seriously by most people who read her writings across the globe – her views on female "genital mutilation" have come to constitute the last word on the subject of female circumcision. As well-meaning as Walker's campaign is, however, her fiction mainly has served to validate the "professional mourners" of Achebe's proverbial world, who wail louder than the bereaved, while silencing and vilifying the very people being mourned.[9] Walker's fictional depiction of the African world is condescending and touristic. Her philosophical outlook is informed by colonial and missionary conceptions of Africa, while her analysis draws from anthropologists of that same tradition. These assertions will be demonstrated by a close analysis of *Possessing the Secret of Joy* and *Warrior Marks*.

Before I go into the analysis, however, it is important to make my stance on female circumcision unequivocally clear. Simply, I am totally opposed to the practice. The reasons are many and cannot be fully justified here. A mention of the major ones will have to suffice. One: voluntary cutting, bleeding, and even worse, removing of parts of one's body, even in the name of ritual, is abuse. The ritual inflicts on the initiates traumatic pain and psychological violence that is, in many cases, harmful to the body. Two: given the possible health risks associated with circumcision, especially in this day and age of the HIV epidemic, any unnecessary laceration or puncturing of the

body is negatively adventuristic. Three: the circumcision of girls and small children, in particular, is an oppressive imposition by adults. Such cultural practice assumes that these little people are the "property" of their parents, families and communities, and that they have no right to choose for themselves. The ritual, thus, imposes an *involuntary* and irreversible condition upon them for the rest of their lives, robbing them of choice – a basic human right, even for children. Four: androcentrically constructed sexuality is definitely an issue here, especially given the fact that circumcision is interlinked with an "education" that socializes initiates to view womanhood in patriarchal terms. Five: on the eve of the 21st century, I do not see physical initiation as a necessary rite of passage, even if it is in the form of "ritualized marking of female genitalia... where the clitoris is barely nicked or pricked to shed a few drops of blood."[10] There are other forms of self-assertion that are more relevant to current day needs in which women can engage. Six: all of society's resources in terms of time, energy, focus, and material support should be put into aiding women to acquire skills and experiences that empower them with liberating choices so that they can become true agents of change. Characterizing circumcision as a culturally definitive parameter is tantamount to fossilizing culture, instead of insisting that it dynamically address the most urgent, human needs of a given period. Seven: realistically speaking, for most of Africa the availability of basic health services and facilities, let alone reliable ones, is a critical problem. For this reason, talk of using medically safe ways to conduct circumcision is an abstraction for the majority of poor people on the continent who observe the practice. Eight: it is time we drew a decisive line between liberating cultural practice and outdated traditions, beliefs and rituals. I am yet to be persuaded that circumcision is an expression of liberating cultural practice.

That circumcision as a form of self-fulfillment is necessary among African female youth in 1996, even in the rural areas, is a peculiar claim. It removes the emphasis from where it should be: on self-determination, especially given the systemic violation of poor people's rights at the basic levels of food, clothing, and shelter. The argument that circumcision gives women the opportunity to define themselves as "whole" or fulfilled individuals is a pathetic

myth today. It also absolves Africa's neo-colonial governments of the many responsibilities that they owe the masses, such as provision of resources that will enhance their individual and collective fulfillment. The point under labor is that circumcision is of no use in empowering women to overthrow oppressive conditions, economically, politically or gender-wise. In condoning circumcision, I fear that feminists and self-aware African women risk the danger of being condescending towards their less privileged sisters, prescribing a form of opium for the masses. Would they really put their own daughters through circumcision?

Having made my stance on circumcision clear, it is equally important to underline the fact that my rejection of circumcision is not a moral judgment of those who practice it. After all, there are many rituals that repel one in the very cultures that condemn circumcision. As Obiora argues, "female circumcision is comparable to many perplexing idiosyncrasies... that prevail in the West."[11] Rituals do not make sense to those outside the orbit in which they are observed. The activities that accompany initiation into fraternities and sororities in North America, for instance, verge on body abuse and obscenity. In the fall semester of 1996, or thereabouts, a Syracuse University rugby player posed for a nude photograph on the front page of *The Daily Orange,* a student newspaper, under a heroic sounding headline: "Rocking Rugby." A part of the story read: "At left, a naked Anthony Malliarakis stops for a drink of water after completing the traditional 'Zulu' run."[12] One is prompted to ask: what connotations lie behind naming this weird ritual race the "Zulu" run? Suppose this spectacle had taken place on an African university campus, what kind of write-ups would have appeared in the international press? I can imagine one such possible write up: "*tribal* rugby player runs around the campus in the nude, under *possession,* in fulfilling some *primitive* ritual." In America, however, this act of running naked in public is treated as an item of affirmative front-page news. Take another example: when women pierce their tongues, belly buttons, breasts, and I understand, even their *labia majora,* in order to place rings there, nobody seems to call *such* practices "mutilation." So, who determines what constitutes mutila-

tion and what does not? These are the types of double standards to which Obiora's paper draws our attention.

Indeed, until Nawal El Saadawi pointed out that practices such as breast implantation, skin lifts, nose reconstructions, self-imposed bulimia, anorexia and other forms of so-called women's beautification rituals in the West were tantamount to body abuse, nobody had described them as "mutilations."[13] Thanks to Nawal's intervention a decade or so ago, it has now become fashionable to place these practices on the same footing as female circumcision. In *Warrior Marks*, Walker and Parmar do this, but in only a token fashion. Without a doubt, one clearly heeds Obiora's point that dominating cultures appoint themselves as the barometers of morality and ethical standards while simultaneously double-dealing.

A further important observation made by Obiora's paper is the identification of incriminating language as a key obstacle in the circumcision debate. The use of a term such as "mutilation" that is then extended to dismiss an entire heritage as a "mutilating culture" is so extreme as to stifle dialogue. Perpetrators of systems such as capitalism and imperialism, which incapacitate people just as badly—materially, physically, psychologically and emotionally – are not depicted as practicing "mutilation" or "torture." Witness the number of children suffering from kwashiorkor on the continent of Africa, as a result of imperialist exploitation.[14] This condition can also be described as body "mutilation." Who determines what terms are used against whom? Clearly, epistemological control is related to economic domination. Characterizing circumcision as "mutilation" and "torture" is tantamount to criminalizing our communal grandmothers, mothers, aunts – African women who are mostly poor victims of false self-awareness. They are nothing but victims/survivors of this outdated ritual and calling them "murderers," "mutilators," and "torturers" is unjust. It is blaming the victim.

Like Obiora, I advocate the use of emancipatory education to increase self-awareness among those who practice circumcision, persuading them to abandon the practice through understanding and conviction, not through intimidation. Revolutionary theory, very elaborately developed by Paulo Freire, among others, correctly argues that in the final analysis it is imperative for the oppressed to

liberate themselves.[15] It emphasizes the role of dialogical education, in which the oppressed is an active subject. Imposition, coercion, and punishment from self-appointed moral authorities, especially when they happen to be situated within oppressive patriarchal institutions of capitalist and neo-colonial states, will not facilitate the eradication of female circumcision. Dictation goes against the grain of feminist discourse.

Before moving into the texts themselves, let us define feminist writing more extensively. Like other writings, feminist literature reflects the class position, concerns and ideological orientation – the overall worldview – of a given writer. In an analysis elsewhere,[16] I have placed writers in three categories: reactionary/conservative, liberal/elitist and progressive/revolutionary. Feminist writers fit into these categories, as well. It is my contention that the third category of writers, progressive/revolutionary, articulates the interests of oppressed women best, especially those from the so-called Third World and, consequently, those from the poor populations of Africa. Given the limitation of space, therefore, discussion in this chapter will focus on the third category, using this group as the model against which to assess *Possessing the Secret of Joy* and *Warrior Marks*.

As I intimated before, liberating feminist writing has the responsibility to expose not only the practices but also the institutions, structures, and systems that embody and perpetuate the oppression of women. Through clear analysis of the contradictions inherent in these, such writings should articulate and denounce identified forms of oppression, creating consciousness in the process. The literature also should demonstrate empathy, understanding, concern, and love for the oppressed. Further, the writing should validate the humanity and dignity of the oppressed, depicting them as people who are capable of engaging in transformative action: human beings who possess the potential to overturn the oppressive conditions that militate against their full self-realization. Offering solidarity and committing itself to liberating action, the literature should indicate possible avenues out of the conditions of entrapment, thus dispelling resignation on the part of the victims while infusing them with a spirit of determination, and a thirst for revolutionary change.

Empowering feminist writing recognizes the fact that, in the final analysis, the victims themselves must enact the liberational drama if genuine emancipation is to occur. The writer's task, therefore, is to facilitate the empowerment process and not to take over the victims' struggle. More than this, the writer must guard against the mercenary arrogance of perceiving herself as a savior of people who are incapable of self-emancipation.

In contrast, the discourse in *Possessing the Secret of Joy* silences the main character, Tashi, as a subject, depicting her as an invalid and a dependant who never recovers from her mutilation by M'Lissa, the *tsunga*,[17] or from betrayal by her own mother. The *tsunga* is demonized, Tashi's mother condemned and the entire community indicted for her tragedy. Other than crazy ramblings and tortured thoughts resulting from psychological disorientation, Tashi, the victim of "mutilation," has no voice. Her hope lies in interventions by Westerners who, one by one, come into her life and attempt to rescue her at great sacrifice. One can only echo Audre Lorde when she says "dismissal stands as a real block to communication."[18] A writer cannot dismiss the subjects of her statement and expect a dialogue to result. No doubt dismissive and alienating, the discourse in *Possessing the Secret of Joy* turns Tashi into a victim of double "mutilation."

In Walker's book, the preoccupation with sexuality, almost at the exclusion of the entire human being, results in defining women primarily as genital carriers. The dedication to the novel emphasizes this preoccupation: "This Book is Dedicated/With Tenderness and Respect/To the Blameless/Vulva."[19] I am reminded of a telephone confrontation that I had with one of Alice Walker's agents in July 1992. I had been invited as a panelist to discuss *Possessing the Secret of Joy* at the Equitable Auditorium, New York City, with, I believe, Alice Walker present. The promoter called to ask for details about me. I explained that I was an international scholar and Visiting Professor at Cornell University, a political activist, poet and playwright. As if she had not heard me or thought what I had just said was of no relevance, she proceeded to ask me: "Are you mutilated?" Now that question to a 50-year-old African woman is not just shattering but downright rude. In shock and disbelief, I asked her what she had

said, and she repeated the question. Although I protested against objectification, the woman remained adamant. I was livid and made this abundantly clear by promptly withdrawing my participation. Later, I received a letter of apology from her that, in the last paragraph, read:

> As Tashi so aptly described in *Possessing the Secret of Joy*, there is "a bluntness about African-American women" that she couldn't quite relate to with her new psychiatrist. But luckily after a while, Tashi soon became friends with her American doctor. I hope that you can forgive my African-American bluntness as Tashi did.[20]

For this sister, all that mattered about me were my genitals, but I happened to be a lot more than this. I proved to be a disappointment because I did not fit the stereotype. Her greatest influence, Alice Walker's book, from which she quoted in her apology to me, added insult to injury.

This objectification is what Obiora is talking about when she remarks: "Female circumcision has been so highly touted that it has become the prime point of reference in the West *vis-a-vis* African women."[21] Sensitive to this stereotyping, Angela Davis enters the African world (Egypt) differently.[22] She writes: "As an Afro-American woman familiar with the sometimes hidden dynamics of racism, I had previously questioned the myopic concentration on female circumcision in US feminist literature on African women."[23] One agrees with Dr. Latifa Zayat when she complains: "[W]e are being defined in terms of sexuality for reasons which are not in our own interest."[24] Echoing similar sentiments, Dr. Shehida Elbaz also voices concern, remarking that "the campaign against circumcision underway in the West [has] created the utterly false impression that ... genital mutilation is the main feature of Muslim women's oppression."[25] Davis clinches the argument when she underlines the importance of placing the discourse within "the larger economic-political context of male supremacy,"[26] especially under imperialism and neo-colonialism.

As mentioned earlier, in liberating feminist writing the subject of oppression should not be criminalized. Yet, with the exception

of the character Dura, this is exactly what Walker does with African women in her book, namely: M'Lissa, the *tsunga,* Tashi's mother, and even Tashi herself, a prisoner in the dock for murder as the book closes. The first two are, in fact, depicted as sadistic murderers. Tashi is made by Walker to introduce her mother as follows:

> I studied the white rinds on my mother's heels, and felt in my own heart the weight of Dura's death settling upon her spirit, like the groundnuts that bent her back. As she staggered under her load, I half expected her footprints, into which I was careful to step, to stain my own feet with tears and blood. *But my mother never wept,* though like the rest of the women, when called upon to salute the power of the chief and his counselors she could let out a cry that assaulted the very heavens with its praising pain.[27]

In this African mother we not only have a cold-blooded murderer, but a disciple of the chief and, therefore, an extension of male oppression. "She was the kind of woman who jumps even before the man says boo. Your mother helped me hold your sister down," M'Lissa tauntingly tells Tashi towards the end of the novel.[28]

M'Lissa is clearly demon-like: she is a glutton whose favorite dishes are "lamb curry, raisin rice and *chocolate mousse."* She has "clawlike toes,"[30] she is a "witch,"[31] she is a liar and a murderer[32] who ultimately confesses: "But who are we but torturers of children?"[33] By putting first person plural speech into M'Lissa's mouth, Walker strikes twice, having *the tsunga* incriminate both herself and other women. In fact, M'Lissa is made to boast about the fact that she and other circumcisers have no feelings:

> Can you imagine the life of the *tsunga* who feels? I learned not to feel. You can learn, too. In this I was like my grandmother, who became so callous people called her "I Am a Belly." She would circumcise the children and demand food immediately after, even if the child still screamed. For my mother it was a torture.[34]

Still another woman and mother is depicted as an accomplice in the persecution and "torture" of her own daughter. The daughter

is married to Tourabe, a wife abuser, from whom she eventually runs away, then drowns herself. Here, this young woman's mother is shown as being responsible for her daughter's suicide:

> She'd gone to her parents and asked them how they expected her to endure the torture: he had cut her open with a hunting knife on their wedding night and gave her no opportunity to heal. She hated him. ... Her father instructed her mother to convince her of her duty. Because she was Tourabe's wife, her place was with him, her mother told her. The young woman explained that she bled. Her mother told her it would stop: that when she herself was cut open she bled for a year. She had also cried and run away. Never had she gotten beyond the territory of men who returned her to her tribe. She had given up, and endured.[35]

This mother thus had resigned herself to her fate and so advises her daughter to do the same. Unable to endure, however, the daughter kills herself. Significantly, Pierre, one of the book's messianic figures, narrates the story. He heard it from his mother, another one of the book's messiahs.[36]

Patronized, objectified, and shorn of all human dignity and agency, Tashi may be spared demonic depiction, but is treated like a receptacle, characterized by a dependency that verges on permanent disability. Walker inflicts a victim mentality on Tashi from the moment we meet her in the novel – weeping and in the jungle.[37] Thus, Tashi comes to symbolize the "crying child" and the weeping is said to have stained her life.[38] Moreover, when recovering from her "mutilation," the narrator relates that Tashi's "legs, ashen and wasted, were bound,[39] a practice that I have never heard of in African initiation rituals. Tashi tells Adam: "I am like a chicken bound for market. The scars on my face are nearly healed, but I must still fan the flies away. The flies are attracted by the odor coming from my blood, eager to eat at the feast provided by my wounds."[40] In hypochondriatic fashion, Tashi is shown as having surrendered to fate, very much like the other African women of Walker's novel.

Indeed, this victim of Walker's rendering is also self-destructive. She may be accused of participating in not only her own self-mutilation, but the mutilation of others, such as her son Benny who is born handicapped. After all, Tashi takes herself to the "bush" looking for "mutilation:"

> At first she merely spoke about the strange compulsion she sometimes experienced of wanting to mutilate herself. Then one morning I woke to find the foot of our bed red with blood. Completely unaware of what she was doing, she said, and feeling nothing, she had sliced rings, bloody bracelets or chains around her ankles.[41]

This is presented as the result of Tashi's decision to undergo circumcision. The reader is treated to a gruesome picture of Tashi who, ironically, is supposed to have become "strong, invincible. Completely woman. Completely African. Completely Olinka."[42] The cutting irony on the writer's part is complete at this point.

And the new Tashi?

> It now took a quarter of an hour for her to pee. Her menstrual periods lasted ten days. She was incapacitated by cramps nearly half a month. There were premenstrual cramps: cramps caused by the near impossibility of flow passing through so tiny an aperture as M'Lissa had left, after fastening together the raw sides of Tashi's vagina with a couple of thorns and inserting a straw so that in healing, the traumatized flesh might not grow together, shutting the opening completely... There was the odor, too, of soured blood, which no amount of scrubbing, until we got to America, ever washed off.[43]

To begin with, Tashi is a complete embarrassment to her American husband. She has no confidence in herself, but comes to adore America and its culture. America would be the land of salvation for Tashi, if only this were within reach for a "mutilated" African woman! She also adores Western culture, but in a naive, childlike manner, viewing Mzee, her psychologist, "as a kind of Santa Claus."[44] At one point she vows: "They would all take America away from me

if they could. But I won't let them. If I have to, I'll stop them in their tracks."[45] She loves her "adopted country," we are told. At such moments, of course, she is Tashi-Evelyn, not just Tashi.

In Tashi, we have a crazy imbecile who is not only a burden and liability to the very people that she is dependent upon – Adam, Olivia, Lisette and the Old Man – but a child abuser. She boxes Benny's ears for no reason other than to make him "squeal and cringe," after which she experiences "relief."[47] At another time, she pelts Pierre with stones when he pays her an innocent visit as a boy, making him bleed.[48] She steals Adam's letters (from Lisette) and hates Lisette, who is presented as a model of devotion towards her. In actual fact, Tashi is at times depicted as savage and animalistic: "Evelyn laughs. Flinging her head back in deliberate challenge. The laugh is short. Sharp. The bark of a dog. Beyond hurt. Unquestionably mad. Oddly free."[49] Circumcision is shown as having produced not just an incurable invalid, but a brute.

Having thus dismembered, or rather "mutilated," Tashi's entire person and then having dismissed Olinka (read African) women, Walker leaves her victim at the mercy of her appointed messiahs. These appear in the form of Adam, Tashi-Evelyn's African-American husband who is the son of missionaries in Olinka; Lisette, Adam's French mistress; Tashi's uncle, affectionately known as Mzee or the Old Man; Pierre, the offspring from the affair between Adam and Lisette; Raye, Tashi-Evelyn's African American psychiatrist; and, finally, Olivia, Adam's sister, interestingly never referred to as Tashi's sister-in-law. Benny, Tashi and Adam's son, misses the messiah mark. He is, himself, another disability case who needs Pierre to explain his mother's illness. Indeed, just as Pierre devotes himself, like his mother does, to unraveling Tashi's psychological malady, so does he become Benny's keeper and mentor, nurtured by the corridors of Berkeley and Harvard, which Tashi describes as "shrines."[50] The sources of knowledge sought to analyze Tashi's illness are all Western, including Freud of all people! Even the use of African mythology is corrupted; Marcel Griaule's theory on the origin of circumcision among the Dogon is showcased later, in *Warrior Marks*, where Walker is filmed lovingly stroking the rugged ends of an anthill, supposed to symbolize the clitoris. No one really cares to

know what the Dogon people themselves say or think about their own myths. Thus, African epistemological relevance is dismissed, as are African men, women, and their world. External definitions are imposed on a primarily African problem and constitute the last word as far as Walker is concerned.

In the final analysis, the novel treats us to a monologue and forbids conversation with the subjects under analysis. Here, Tashi's fractured voice and consciousness cannot be accepted as compromises. Lastly, one notes that the prison in which Tashi waits for her execution is also a kind of AIDS hospital. The symbolism is cruel. Like AIDS, circumcision is an incurable epidemic that will wipe out African women. The chapel in the prison, like its builders, the missionaries and the colonials, seems to be their only salvation.

The above should suffice in expounding on some of what Obiora's paper is referring to in speaking about "co-opting imperialist discourses,"[51] as they occur in *Possessing the Secret of Joy*.

In writing and filming *Warrior Marks*, Walker and Parmar have the hindsight gained from the many discussions, debates, and controversies that accompanied the publication of *Possessing the Secret of Joy*. For this reason, there seems to be a deliberate effort on the part of the writers to include African viewpoints. Indeed, it is encouraging that limited interviews are held with African women, even though it appears that the respondents are brought in merely to confirm conclusions that the interviewers bring to the "discussion" table. Here at least, the silencing is less extreme, or perhaps less obvious. It is also commendable that the writers make an effort to relate female circumcision to practices that parallel it in the West, moving away from the fictionalized self-righteous posture of the younger Olivia: "I told her nobody in America or Europe cuts off pieces of themselves."[52] Also significant is the fact that from time to time there is an effort to discuss circumcision within a sociopolitical framework. There is even recognition that circumcision is not the only form of oppression faced by African women and that problems such as "imperialism, colonialism, drought, and other acts of a thoroughly pissed-off Nature"[53] need to be taken into account. So, between the earlier work and this one, there has been some progress in analyzing the problem, but not much.

Viewed from other relevant angles, *Warrior Marks* is also a classic example of alienating discourse and a revealing enactment of "the art of blaming the victim" on both paper and film. The work continues to be condescending towards survivors of circumcision, depicting and treating them as helpless victims. When Walker meets Aminata Diop in London, she tells us: "Deborah and I wrapped her in her coat the minute, each time, the cameras stopped. I took her hand in mine and never let go of her. *I could feel her need of a mother,* and I offered myself without reservation."[54] The reader has the impression that Walker is talking about a child and not a full-grown woman who has all along taken care of herself. Walker is just as paternalistic in her treatment of Senegalese women, having arrived with preconceived notions of them: "The result is women with downcast eyes and stiff backs and necks (*they are of course beaten by fathers and brothers and husbands*). And men look at a woman's body as if it is a meal."[55] The reader is, of course, struck by the generalization and stereotyping. Continued in this work as well is the criminalization of circumcisers and women who participate in the ritual. To Walker, the Mandinka heritage is not just a culture, but a "mutilating culture."[56] Looking at women from "mutilating" cultures, Walker is persuaded by a thesis passed onto her by Ayi Kwei Armah, saying:

> Genitally mutilated women he's known have been very angry. I think now about what that means in a woman's relationship to her child. Does it mean she's often abrupt, cold, withholding and abusive? Or simply that she never smiles, which might be the greatest abuse of all?[57]

The image of the circumciser is disgusting: "I glanced at her hands – extremely dirty, with black gunk under the nails – and thought of her coarse hardness against the tenderest parts of these girls."[58] When Walker interviews the circumciser, she expresses surprise to find that the woman is actually human![59] In the film, *Warrior Marks,* the images are done such that the circumcisers register a very hateful presence; they are hard, cold and threatening, always "armed" with weapons of their trade. A reappearing knife of theirs in the film sends a shiver down the viewer's spine.

Orientalism, objectification, stereotyping, generalizations and impositions of meaning abound in this book. A few examples will suffice. There is an allusion that "sweets" are a part of the African woman's life,[60] associating this with African women's imagined fatness. In fact, at one point Walker would have the reader believe that all African women are oversized, saying of Bilaela, "She's seriously overweight, though not, perhaps, by African standards..."[61] The commonplace habit of chewing a tooth brush is explained anew, in Walker's imposed terms: "But what if there is another purpose? Something to bite down on instead of one's tongue?"[62] When a chicken is killed in the cleansing ceremony for the circumcised girls, Walker imposes her text on the commonplace scene of a headless chicken let loose before it dies: "I understood the message of the sacrifice: Next time, we cut off your head."[63]

In *Warrior Marks*, Alice Walker and Pratibha Parmar, as individuals, replace the fictional messiahs of *Possessing the Secret of Joy*. Parmar has unfortunate assumptions: "Except for the writings and voices of a handful of white feminists over the last decade or so, there has been deafening silence, a refusal to engage either critically or actively with this... area of feminist concern."[64] One wonders whether Parmar ever reads African women's work, for this is one area in which much work and writing have seen daylight and moonlight. From Kenya alone, Parmar should have heard of Rebeka Njau and Charity Wachiuma, but then she does not even know that Ngugi wa Thiong'o, famous as he is, comes from Kenya! What about the work of scholars, researchers, professionals, and activists, such as Asthma A'Haleem, Awa Thiam, Nahid Toubia, Nawal El Saadawi, Shehida Elbaz, Zelda Salimo and many more? Having imagined a void in the arena where anti-circumcision activities are supposed to take place, Parmar concludes, "This reluctance to interfere with other cultures leaves African children at risk of mutilation."[65] Parmar might blush to learn that my own mother, now in her eighties, was active in this work long before she and Walker walked the earth.

Viewing as abandoned victims the African children she comes across while filming, Walker says: "I wanted to take them in my arms and fly away with them,"[66] and again:

> A little girl, five or so, suddenly appeared out of nowhere
> and took my hand. Just for an instant. *I felt she knew I had*
> *come for her sake.* She was the "one African child" (that
> maybe my work against genital mutilation will protect) of
> my dreams.[67]

The echo in the italicized words has an ironic messianic ring.

As Walker and Parmar congratulate each other for their work
and sacrifices on behalf of African children, they deny them of
agency. One can only reinforce the fact that the depiction of the
"victims" is so contemptuous and demeaning that the overall effect
is one of denigration, rather than empowerment. The African
women subjects are presented to the reader as a collection of help-
less bundles of mutilated creatures and as stereotypes who are far
from any semblance of living, dignified human beings. They are
pitied and patronized, instead of being cherished, nurtured, and
invested with faith as human subjects, potentially capable of under-
standing and changing the conditions that dehumanize them. The
writers storm the scene of oppression as gallant messiahs appearing
for the advent of rescuing an altogether apathetic and lesser breed
of human beings. The writers and members of the film crew tower
over the owners of land, presenting themselves as superior beings
who have landed in a world overwhelmed by senseless savagery. The
victims are summarized as mere carriers of mutilated genitals and
very little else besides this. As readers we ask: Where are the human
beings? Surely the women of Africa constitute more than genitals?
The econo-political systems that impose the conditions that breed
these women, who are victims of such marked false conscientiza-
tion, are hardly indicted. At the end of the day, it is the victims
of this backwardness who are blamed. The African mother figure
is whipped and the circumciser crucified. But what kind of socio-
economic system produces these individuals, we ask again? This last
question is important because it puts the finger on the root cause
of oppressive cultural practices, placing the responsibility for basic
change where it should be.

The writers of *Warrior Marks* invade the African world in the
spirit of colonial missionaries and the colonizers who brought, and
imposed, already constructed world-views upon the dominated,

treating them as being incapable of rationality. The authors make no attempt to engage in dialogue with the women they meet in the villages. Instead, they pose framed questions, interrogating their objectified subjects in order to illicit the answers they want from them. *Warrior Marks* and its authors enact their dramas on the world of African women, using imposition as a guiding method/philosophy. The architects of the drama are indeed not just on their self-acclaimed metaphorical personal journeys, but, literally, on long ego trips. During these trips they congratulate themselves and one another, feeling good about shedding so many righteous tears for the unfortunate African women. Paradoxically, they end up psychologically dismembering and mutilating the African women that they have travelled along so many bumpy and dusty roads to save. They violate the women's dignity through labeling, typifying and objectifying. The writers are aloof and omniscient in tone, pulpit-postured in their narrative method, and altogether disempowering in their dominating presence. Ultimately, they pass a vote of no confidence in African women and their latent ability to change the structures that currently oppress them.

The authors of *Warrior Marks* have uprooted the problem of genital mutilation from its context, reduced all other struggles by African women to one issue, transplanted it and kidnapped it to the West and placed it in the hands of liberal feminists. The Western scene is now one in which the proverbial professional mourners weep louder than the bereaved. The real victims remain in the background, virtually invisible and inaudible, even as they continue to put up heroic struggles to liberate themselves from the basic oppressive structures and institutions that give rise to genital mutilations, among other evils.

In conclusion, I would posit that one thing is abundantly clear from this discussion: as exercises in progressive and empowering feminist literature for the oppressed, *Possessing the Secret of Joy* and *Warrior Marks* are both dismal failures. They belong to the tradition of colonialist writing, which is tourist-eyed in its perception and dismissive in its conception of the African world. Such writing disempowers poor African women and depicts them as either passive victims or active criminals, insofar as the question of female

circumcision goes. These women sit in resignation, waiting for the single dramatic act of foreign messiahs. The only way out for them is totally missing: the creation of socio-economic conditions and conscientizing educational/cultural institutions that endow women with the power and agency to name themselves, so that they can do away with oppressive traditions, conditions and relationships. If this is done, it will in time render circumcision irrelevant. However it materializes, it will take time, patience and many prolonged conversations – not sermons. In this crisis, there is no middle course, in my mind, if we are truly after a lasting solution.

Part III

CULTURE, CLASS, GENDER, PAN-AFRICANISM AND HUMAN DEVELOPMENT

Chapter 7
CULTURE IN AFRICA AND IMPERIALISM

Before discussing the effects of imperialism on culture in Africa, it is important to establish a working definition of culture so that we have a common point of departure. Depending on one's ideological frame of reference and, therefore, espoused worldview, the concept could mean different things to different people. The *Concise Oxford Dictionary* defines culture as follows:

> Improvement (by mental or physical) training, intellectual development; particular form, state of intellectual development or civilization.[1]

The definition leaves us with an abstract statement that does not take us very far. For instance, who sets the standards used to define the level of "intellectual development?" Under imperialism, the reference point could be the West and the terms could be dictated by its ruling class intellectuals. So, we would be back to the imperialist notion that people from dominating nations are "civilized" and that those whom they dominate are "uncultured." Alternatively, if we are from the dominated nations of the world, and if we are enlightened, we could take sides with Niakoro's assessment of the colonizers as savages in Ousmane Sembene's *Gods Bits of Wood*[2] especially given their acts of dehumanization against the colonized people.

There are other definitions that can take us some distance beyond our entrapment with the *Concise Oxford Dictionary*'s defini-

tion, but which still leave us lacking specifics. For instance, culture has often been referred to as a life-long process of social and intellectual formation among individuals and groups. It has also been defined as the sum total of a people's way of life, including their beliefs. Culture has also been viewed as the outer manifestation of a people's soul and personality, expressed through their artistic and scientific achievements. William E.B. Du Bois would have shared this last view, as clearly brought out in his *Souls of Black Folk*. Yet another definition would look upon culture as the totality of socially transmitted behavioral patterns, arts, beliefs and all other products of human work and thought, characteristic of a community or nation.

Important as these definitions are, they fail to sufficiently emphasize the vital relationship that exists between culture, as a product of the human labor process, and the economic base from which it is evolved. In *Return to the Source*, the late Amilcar Cabral provides us with this important link – so visibly missing in the foregoing definitions – in line with the Marxist-Leninist ideology. Cabral argues that there are "strong, dependent and reciprocal relationships" that exist between "the cultural situation and the economic (and political) situation in the behavior of human societies." He elaborates:

> In fact, culture is always in the life of a society (open or closed), the more or less conscious result of the economic and political activities of that society, the more or less dynamic expression of the kinds of relationships which prevail in that society, on the one hand between man (considered individually or collectively) and nature, and, on the other hand, among individuals, groups of individuals, social strata or classes.[3]

Thus, culture is created as human beings relate to one another in the process of production, as they respond to their material world to provide themselves with essential and other needs of life, as they respond to the natural world to improve their habitat and as they apply their intellect and imagination to create the non-material world of ideas. To engage in production is, therefore, not only to

inevitably engage in cultural action, but also to engage in concrete historical action.

As Cabral rightly argues:

> Whatever may be the ideological or idealistic characteristics of cultural expression, culture is an essential element of the history of a people. Culture is, perhaps, the product of this history just as the flower is the product of a plant. Like history, or because of history, culture has as its material base the level of the productive forces and the mode of production. Culture plunges its roots into the physical reality of the environmental humus in which it develops, and it reflects the organic nature of the society, which may be more or less influenced by external factors. History allows us to know the nature and extent of the imbalances and conflicts (economic, political and social) which characterize the evolution of a society; culture allows us to know the dynamic synthesis which have been developed and established by social conscience to resolve these conflicts at each stage of its evolution, in search for survival and progress.[4]

The key points that must be grasped here are that: (1) culture is an essential element of the history of a people, (2) culture has as its material base the level of productive forces and the mode of production, and (3) culture is vital in a people's search for survival and progress. What Cabral is, in essence, saying is that culture and its servicing institutions constitute a very socio-political theme. They reflect the nature of the economic base of which they are a concomitant part, along with the other institutions that belong to the superstructure and that support this base while exposing the nature of a given society's class struggle.

There are two broad categories of culture: material culture and non-material culture. The former is manifested through concrete, tangible objects, while the latter is reflected and communicated through ideas. By material culture objects we mean such human tools and utilities as houses, beds, chairs, cooking pots, clothes, machines, etc. By non-material culture, we mean ideas, norms, beliefs, philosophies, ideologies, etc., which come into being as

people reflect upon their material and natural worlds. Both aspects of culture, then, are brought into existence as human beings wrestle with their environment in an attempt to harness its forces and, in turn, mold them so as to provide themselves with, at least, the three basic necessities in life: food, clothing and shelter. The non-material cultural expression is the attempt by the human intellect, imagination and feeling to fulfill the biological, human need to comprehend the world. This involuntary desire to understand the environment, through mastering it, ensures that human beings live without the kind of fear that leads to dependence upon superstition, mystery and magic, pressuring people to pass a vote of no confidence in their human capabilities. The search leads to the twin-need of naming what is in the environment – exploring life – sounding the depths of existence, and, in so doing, exploding the awkward silences that often freeze positive action in people. It is in this manner that fields of knowledge are carved out: Science, History, Literature, Technology, Law, Architecture and so on.

There are two major functions that material and non-material culture can be directed towards. Firstly, they can be directed to the solution of human problems, self-realization and the fulfillment of societal needs. In other words, they can be used for practical, utilitarian and social purposes. Secondly, they can be directed towards negative ends such as domination, oppression and repression, as well as for showy, pompous display of objects and ideas, as means of parading wealth and imposing power. In other words, they can be used for destructive, wasteful and anti-social purposes. Utilitarian, pro-people culture can be liberating and fulfilling. Show/parade, anti-people culture, on the other hand, can be decadent, suffocating, oppressive and enslaving towards the oppressed.

Generally speaking, show/parade culture in Africa is to be found among the members of the ruling class, especially those representing social strata such as the foreign bourgeoisie, the comprador bourgeoisie and sections of the reactionary petty bourgeoisie. These social groups, as a rule, exhibit consumerist attitudes and adopt extravagant styles of living, dressing, eating, etc., to show off their money-power. In their affluence, they are content with feeding pets beef and milk while unwilling to share their wealth

with the poor who live in a cultural environment of poverty, crime, violence, hunger, malnutrition and disease. Many of us could produce example upon example of the kinds of show parade culture "exhibitions" that we witness everyday in our midst. For example, some members of the ruling class will spend thousands of dollars, kwachas, nairas, shillings – on dinners and cocktail parties, to show that they can outspend one of their kind. At these cocktail parties, the bourgeoisie will work their nerves to exhaustion, displaying plastic smiles to people they abhor, or exchanging petty gossip on the "idiocy" of their house "servants" and "maids," but mostly, boasting to each other about their most recent acquisitions.

Pitted against this cultural world of extravagance, consumerism and inauthenticity, is the cultural world of utilitarian culture, mainly consumed by the progressive intelligentsia, workers and peasants. On the other hand, under neo-colonial situations in Africa, the culture that the masses consume cannot even be described as utilitarian, for, most of them live under absolute deprivation. Their cultural existence operates at the very margin of bare survival. Many of them live in box houses, in tiny rooms, and hovels to be found in the sprawling slums of neo-colonial African cities. Others have no homes at all and live in the open air, under all kinds of cruel weather conditions. These deprived poor are usually born and bred in a socio-econo-political environment (and, therefore, cultural environment) full of drunkenness, violence and crime experiences that will certainly negate their positive growth as human beings. Others are in the rural areas where they live in semi-deserts, tiny huts (often sleeping side by side with goats, sheep and hens) that serve as bedrooms, dining rooms, sitting rooms and kitchens. They are seriously threatened by disease, malnutrition and even starvation. With death daily staring them in the face as they struggle to exist, these people know a culture of suffocation.

Given the above observations, it is unanalytical, unscientific and a serious generalization to speak simply of: African culture, Zambian culture, Nigerian culture and so on, leaving the matter at that. We must go beyond these populist frontiers and specify the class peculiarity of the cultural experience that we are speaking of, thus giving it an economic base, which, consequently, defines its

practical reality. We must, further, move beyond a definition that merely reduces culture to expressions, such as: dancing, singing, performing acrobatics, wearing dashikis, decorating oneself with beads, etc. For, important as these expressions may be (as aspects of decorative culture), alone, they do not constitute culture. They are only its manifestations, as opposed to being its essence. More than this, we must rise above the kind of derogatory conceptions that would define African culture as a return to the feudal way and view of life, where, for instance, women and children are assumed to be inferior to grown males and treated as subservient minors, relegated to the periphery of historical action. Living culture's place is not in a "museum," but at the center of historical events, infusing them with dynamism and new interpretations of life. Within the context of "museum" culture, so-called bogus "African culturalists" will go to extremes reducing culture to the ability on the part of the male to acquire a collection of "wives" and to father children (left, right and center) without assuming parental responsibility over them. There are even those "African culturalists" who would argue that the lack of punctuality and the inability to organize themselves to work in a disciplined manner are part of the "African culture." This is not only a bastardization of culture, but also the kind of self-denigration that should be treated with contempt.

We reiterate the point that in a neo-colonial situation where various socio-economic classes stand in contradiction with and opposition to one another, members from different classes consume very different cultures. We are arguing that in a class society, culture cannot be homogeneous. For instance, the commercial farmer consumes a very different culture from the peasant farmer, or the workers on his/her farm. The worker lives in a doghouse, while the farmer occupies a many-roomed bungalow. The government minister definitely consumes a very different culture from that of his/her driver. The university professor's cultural world is certainly very far removed from that of the worker who cleans the corridors of academia – and so one could go on. Although these people may work for the same institution, live in the same country and even share a common racial origin, because their economic base is not the same, the social and cultural realities are totally different. It is that

factor which defines their social and cultural status. The challenge, then, is for us not to romanticize or homogenize cultural experiences between members of antagonistic social classes. Culture is defined by realities that transcend the commonality of geographical frontiers, the sharing of a common language and even the bonds of kinship blood. To establish this fact, it would have been useful to do a detailed analysis of the cultural blends that are consumed by the various classes of neo-colonial Africa, but the scope of this chapter does not allow it. We shall focus upon the two major expressions of culture, which, broadly speaking, stand in antagonism to one another under imperialist domination, namely: the culture of econo-political power, oppression and domination on the one hand, and that of resistance against impoverishment, waged by the masses against exploiters, in an attempt to achieve liberation and self-assertion. However, before we establish the focus on these two types of culture, it is important that we examine the institutions through which culture is preserved, transmitted and reinforced in order to understand how imperialism manipulates these to maintain cultural and economic domination over Africa.

The most important of these institutions are education (incorporating the arts, the sciences, the social sciences, the performed arts, literature, language, music, etc.), the media and religion. These institutions, and others like them, come into being as individuals and the collective group produce social formations in the process of production and as they attempt to respond to social needs, while trying to develop and advance the human society. Once created, the institutions play a role in shaping both individuals and the collective group. It is, therefore, no accident that next to the economy of a dominated people, imperialism will always aim at controlling the latter's cultural institutions or eliminating them altogether, leaving a vacuum that will facilitate the imposition of the invader's own institutions. This explains why colonialism, for instance, so ruthlessly destroyed African people's cultures and their institutions. By doing this, imperialism aimed at crushing not only the dominated people's way of life, but their very "soul" and "personality" so that economic conquest could become complete, for, cultural zombies would not be in a position to resist. In this regard, Cabral has observed:

History teaches us that, in certain circumstances, it is very easy for the foreigner to impose his domination on a people. But it also teaches us that, whatever may be the material aspects of this domination, it can be maintained only by the permanent, organized repression of the cultural life of the people concerned... In fact to take up arms to dominate a people is, above all to take up arms to destroy, or at least to neutralize, to paralyze its cultural life. For, with a strong indigenous cultural life, foreign domination cannot be sure of its perpetuation.[5]

Let us now look at education as the most significant of the three cultural institutions that we discuss in this chapter. Education is a key institution for inculcating and promoting cultural practices. It acts as a communicator, as well as a reservoir of culture. In a neo-colonial situation, it has a class point of reference. In other words, as one of the most political social institutions, education is not and cannot be ideologically neutral. "The political system that nurtures it into being ensures that it exists to serve its interests, to service its econo-political system."[6] Further, it is through such values that individuals attempt to unravel their surroundings, to reach into themselves and unto each other.

We are using, in other words, the defined aesthetics of a specific sociocultural background, as our point of reference and even more specifically, we are projecting the worldview and ideology of a given class. And, lest we forget it, Karl Marx had a point when he stated that the history of each given epoch is the history of the ruling class. Often, the education institutions that we are part of are nothing but more serving departments for the ideas and social values of the ruling class.[7]

It is Paulo Freire who argues in *Pedagogy of the Oppressed* that there are two main kinds of education; education for domination and enslavement, on the one hand, and on the other, education for liberation. The first type he describes as "banking education," in which the learner is a passive recipient and the teacher a "depositor" or "banker." This type of education is characterized by a master/

subject relationship between the teacher and the learner, with the former as the master and the latter as the subject. The second type of education, Freire describes as "problem-solving." In this kind of education, the learner is at the center and the teacher works as a team member with the learner, acting as a resource person. Both are participants and actors, but the learner is the focus. This type of education is characterized by dialogue and debate between the learner and the resource person. "Banking education" propagates a culture of dependence, fear and silence. "Problem-solving" education nurtures a culture of reflection, experimentation, dialogue and self-assertion.

Obviously, it would be against the interests of imperialism to encourage the second type of education. It favors "banking education," establishing schools among the dominated people that are in the style of educational systems in the homeland of imperialism. Such institutions are equipped to the helm, in terms of syllabi, ideological and cultural content, to serve the purpose of imperialism by ensuring the production of "parrots." To complete the process of brainwashing, the imperialists then send the "parrots" to the metropolis for the final touches. After that, the finished product is brought back to Africa to constitute the one to ten percent of the collaborating reactionary elite population, working hand-in-hand with the comprador bourgeoisie and the dominating ruling class in the metropolis to ensure the imperialist enslavement of the African masses. It is no wonder, then, that today, the soil of Africa holds an institution such as the Kamuzu Academy in Malawi, where the cream of Malawi's intelligentsia-in-the-making is taken and schooled in "dead" languages such as Greek, Latin and Hebrew, not to mention other areas of education that can only serve the purpose of alienating them from the African masses and their problems. Teachers for the institution were originally imported from the metropolis. Malawian teachers did not feature anywhere, unless they had been schooled in bourgeois classics and could speak foreign tongues in the accent of the imperialist cultures' ruling class. Imperialism has a very well planned, systematic educational program for the training of its targeted collaborators because through such an education, the capitalist ideology can be stamped on the mind and the personality

of the learner. In this way, the ideology of creating a world for a privileged few at the expense of the majority is so ingrained that its students will die defending its "divine" rightness.

Through this kind of education, imperialism has succeeded in producing African children (mostly to be found among members of the African comprador class) who, for instance, pronounce their African names in an assumed Anglo-American accent so that a name like Chipo gets pronounced as "Cheepow," and so on. In Zimbabwe, one finds beautiful African names that make perfect sense within an African cultural context, rendered into living jokes after being translated into English. Witness names such as "Anyway," "Whatever," "Action," "Smiles," "Reason," "Clever" and so on, to which people happily answer, to the amusement of those from imperialist cultures whose language we are using to translate our personality! In imperialist education, language is a tool for cultural conquest. Indeed, colonialism and imperialism have used it for that very purpose. Frantz Fanon was correct in observing that "to speak a language is to assume a world, to carry the weight of a 'civilization.'" For, language communicates a society's values and the worldview of those values. So, under imperialism, language is forced upon the dominated peoples, while their own mother tongues are relegated to an inferior position and categorized as "barbaric." This is effective to the point where the elite of the dominated cultures become even apologetic, if not ashamed, of using their own tongue. They will go to the extent of speaking these in Ox-Bridge, Parisian and US accents to emphasize the difference between them and their masses. To this day, competence and outstanding performance in imperialist languages remain key factors in determining how far a person in Africa can move up the academic and career ladders. The importance of the languages of conquest has been so emphasized that political leaders who are masters in our languages and only semi-proficient in, say, English will opt to speak to the masses in English. It becomes pathetic to watch them sweat and stumble over English words, reading laborious English scripts, sometimes not knowing where to pause for commas or full stops. "Amin" jokes and those of colonialist chiefs who insisted on "murdering" English rather than use the African tongues they were masters of to address "Madamu Queeni, the Horrible Mrs. Phillipu," funny as

they may be on the surface, are very expensive within the context of cultural imperialism.

Once the dominated cultures have been schooled in imperialist ideas – particularly at the level of the reactionary elite – they find no shame in copying the dominating cultures and especially the image of their ruling class. Thus, one will find, for instance, elite males in neo-colonial Africa dressed in three piece suits and even in a few known cases, wearing bowler hats and carrying umbrellas – extinct British ruling class style – in the steaming heat of 90 degrees plus. The women will, in turn, roast their hair with chemicals to make it straight so that they can, if the occasion demands, toss it about as they speak – Western-style. These are the caricatures that Frantz Fanon once referred to as "walking lies." They are people who are actively engaged in the process already referred to as passing of a vote of "no confidence" in themselves and their cultural heritage. As Paulo Freire has correctly argued:

> Cultural conquest leads to the cultural inauthenticity of those who are invaded; they begin to respond to the values, the standards and the goals of the invaders... In cultural invasion it is essential that those who are invaded come to see their reality with the outlook of the invaders rather than their own; for the more they mimic the invaders, the more stable the position of the latter becomes.
>
> For cultural invasion to succeed, it is essential that those who are invaded become convinced of their intrinsic inferiority. Since everything has its opposite, if those who are invaded consider themselves inferior, they must necessarily recognize the superiority of the invaders. The values of the latter thereby become the pattern of the former. The more invasion is accentuated and those invaded are alienated from the spirit of their own culture and from themselves, the more the latter want to be like the invaders: to walk like them, dress like them and talk like them.[8]

Like education, under imperialism the media is used to promote the worldview of economically dominating classes. The newspapers, the television and radio are stamped with the images of the ruling class, relegating the masses to the background, from where they are

depicted as passive watchers of a passing history – a depiction that is completely ahistorical, for it is the masses who are the real actors in the process of production. And, as we have already argued, the process of production is, in the final analysis, the factor that pivots history and development forward. Having curtained the masses off the pages of the newspapers and magazines, the imperialist media proceed to aggressively stamp the pages with images of the ruling class culture and make these the reference point of the dominated people. Nowhere is this better illustrated than in the films and advertisements that are splashed on most television screens. There was a time in the 1980s when hours upon hours of Zimbabwe TV programming was devoted to such films as "Dallas," "Dynasty," "The Colbys," and other soap operas that presented the US as one long episode of material paradise.[9] This fictional US of Hollywood intrigue and moral decadence is not the real US of the majority. A representative US world would at least show workers laboring in the factories and other industries for very little pay, most of them going home to the ghettos at the end of long hours of toil. Hollywood soap operas do not show us the millions of homeless people in the US, the poorly fed, and the semi-literate poor. They do not show us the slums of Newark, New Jersey, Harlem, the impoverished world of Native American reservations and such images of cultural deserts. So, the African audience consumes this Hollywood propaganda, the imperialist dream, provided through the courtesy of rich business advertisers – a world that undermines their very being, even as it feeds them with the mythical "American dream."

Business advertisements, whether in newspapers, the radio or the television carry equally aggressive propaganda, parading the cultural world of the invader in dress, eating and living styles for mass consumption. The language in which they are conveyed is so psychologically and ideologically damaging that it can make the poor feel like criminals for being unable to afford what is on "sale." For instance, there used to be a radio and television advertisement in Kenya that went like this:

"Mothers who love their children give them Ribena."[10]

Implied is the fact that mothers who do not give their children Ribena (because they are too poor to afford it) do not love their children. At that time, a bottle of Ribena of approximately 350 mls cost about 20 shillings. An average worker's salary was then 300 shillings a month and, so, a bottle of Ribena was completely out of reach for such a person. The masses are assaulted by such images wherever they look. Images of products like Coke, Fanta, Sprite, Sparlette, etc., are splashed across the sides of the buses that they queue for and on the walls of the buildings that they clean, so that wherever they turn, they are feeding on and being lured to the consumerist culture of their exploiters. The cultural images that the masses feed on in a neo-colonial situation are cruel, demeaning and oppressive.

As if this were not enough, the masses often find themselves placed in a position where they are forced to produce "culture" for the consumption of and in the taste of the ruling class, for entertainment and other purposes. Witness what goes on in some tourist resorts. The masses are made to entertain the tourists through acrobatics, dances, songs, etc. The dancers, often dressed in Stone Age gear, constituting of paraphernalia, such as animal skins and feathers, their bodies painted in obnoxious color schemes and other kinds of wild decorations (to project the image of the "bush" African), will dance their feet sore to the amusement of the watchers. At the end of the day, the money they sweat for finds its way into the pocket of the rich ones who employ them as dancers and acrobats. They go home tired and hungry. Some of the African countries which promote this kind of tourist-oriented culture are also known to be popular attractions for providing "virgin boys and girls" for the kind of tourist who has such inclinations. The imperialist press advertising industry in some European countries have actually been known to carry such advertisements, reeking as they do of dehumanization. In tourist-oriented culture and in the advertisements that promote it, human beings are turned into commodities for consumption by the wealthy.

Religion is the other institution that has been used for cultural and ideological domination under imperialism. Religion can mystify the objective material reality, creating dependence on superstition and fate. As "the opium of the masses" religion can shroud reality,

burying believers in clouds of mysticism, superstition, fatalism and dependence on supernatural powers. The believers thus pass a vote of "no confidence" in their ability to change their material reality for the better, happily singing songs of abdication, such as: "This world is not my home. I am just passing through. My treasures are laid down way up beyond the blue," etc. This they sing while their oppressors take over the wealth on this earth. The sweat of the workers and peasants creates this earthly "heaven" for the rich.

The history of Christianity in Africa, for example, is steeped in blood, racism and oppression – from the days of the slave trade to the era of Apartheid South Africa. Under colonialism, the Bible was used as a tool for conquest, alongside the gun. Witness how the Dutch Orthodox Church in Apartheid South Africa historically used quotations from the Bible to justify the inhuman world of racial discrimination and economic deprivation of the majority African people. Indeed, bourgeois historians have often christened the era of imperialism the "Christian civilization". Today, Africa likely boasts the highest population of Christian converts, representing an incredible array of religious denominations. John Mbiti (1990) is, ironically, right when he observes that Africans are notoriously religious. I would add that they seem to have the monopoly of "spiritual wealth," but remain destitute and beggars in terms of material wealth. Religion (read colonial Christianity) is indeed one of imperialism's "gifts" to the oppressed and it has been internalized to the extent of becoming a way of life.

The indoctrination of the dominated through religion is not an accident under imperialism. It is a means of domesticating oppression, through an accented emphasis on humility, submissiveness and abdication on the part of the oppressed. They surrender, as it were, to supernatural powers and the representatives of secular power here on earth, being taught that this is "the will of God." Under imperialism, religion does not emphasize liberation theology, but teaches the oppressed to "love their enemies" and to "do good to those who hate them." It teaches "If your enemy hits you on the right cheek, turn the other one." It teaches the oppressed to "suffer without bitterness," accepting the role of martyrs here on earth as a reward awaits them in heaven. Under imperialism, religion can be used, as

language is, as a weapon for the pacification and conquest of dominated societies. It glorifies poverty, pain and suffering, making them look noble; making it look as if those who persevere these evils are spiritually dignified. So, "the wretched of the earth" are taught to accept the role of dignified beggars and "slaves" on this earth, while their exploiters establish a paradise, built on their sweat and blood.

It is with the foregoing in mind that Lenin described religion as an ideological weapon and an enemy of the struggling masses:

> Those who toil and live in want all their lives are taught by religion to be submissive and patient while here on earth and to take comfort in the hope of a heavenly reward. But those who live by the labor of others are taught by religion to practice charity while on earth, thus offering them a very cheap way of justifying their entire existence as exploiters and selling them, at a moderate price, tickets to well-being in heaven. Religion is the opium for the people. Religion is a sort of spiritual booze, in which the slaves of capital drown their human image, their demand for a life more or less worthy of man.[11]

From the foregoing, it is clear that under imperialism the institutions of culture have been used for the purpose of facilitating the domination of the oppressed. The institutions constitute a part of the superstructure that is clearly designed to cement the economic base that the superstructure supports. It is, therefore, obvious that to achieve cultural liberation, the dominated people have no choice than to dismantle the oppressive economic base that gives rise to such oppressive cultural institutions. It is for this reason that Cabral has said:

> The liberation of the productive forces and consequently the ability to determine the mode of production most appropriate to the evolution of the liberated people necessarily opens up new prospects for the cultural development of the society in question, by returning to that society all its capacity to create progress... Thus it may be seen that if imperialist domination has the vital need to practice cultural oppression, national liberation is necessarily an act of culture.[12]

Under imperialism, the exploited masses of neo-colonial Africa might go beyond where Cabral left off and assert that the creation of a society based on the principles of scientific socialism is an act of culture. Why does one say this?

This chapter has made it clear that imperialism has imposed on the masses of neo-colonial Africa a culture of domination, through a capitalist economic system. The oppressed masses have continued to fight and struggle against this, creating over time a culture that is dialectically opposed to that of imperialist domination – that of resistance against domination. However, their full victory over cultural imperialism will only be obtained by the creation of an economic system that does not breed cultural imperialism. There is only one alternative to the capitalist mode of production – that of the scientific socialist mode of production. Thus, the only logical choice for the creation of a true popular culture for the masses of Africa is the adoption of the latter economic system. This will, in turn, produce people who have the "capacity to create progress" and who are able to evolve a new humanitarian culture that affirms the dignity of human beings.

Chapter 8
GENDER, ETHNICITY, CLASS AND CULTURE

۹

Introduction

Since culture is our point of departure and emphasis in this symposium, it could be argued that there are at least three major topics within the one topic assigned to me: culture and class; culture and gender; culture and ethnicity. Independently, each one of these is a huge, inexhaustible theme for discourse and deservedly so. Combined the concerns make a somewhat challenging combination in that they constitute an unwilling alliance, which, to some extent, defies the marriage we are trying to enforce upon them. If separation keeps threatening even as we attempt to create coherence in our discourse, therefore, the disconnection should not be surprising. Indeed, we will have to keep serious negotiations ongoing so as to avoid possible conflict, which we would then have to resolve in keeping with one of the objectives of this symposium!

The chapter will begin with a broad definition of culture and its role in society as a positive as well as a negative force, depending on how and why it is created or utilized. We will then proceed to examine the way(s) in which culture intersects with ethnicity, gender and class, alternately. In the process, the chapter will:

1. explore possibilities of cultural action(s), intervention(s) and constructions that would undercut class disparities which breed social conflict;
2. propose dialogical cultural projects that would help construct negotiable space amidst ethnic differences; and
3. advocate emancipatory gender practices that underline the interdependence and collaboration between women and men in solving the problems that stand in the way of human development.

A Definition of Culture

Culture is one of the most extensively defined concepts in social, political, educational and artistic arenas. What follows is an attempt to assemble together as many of these definitions and conceptualizations as possible, including mine, especially those articulated in "Culture in Africa and Imperialism," which are recapitulated here for the purpose of reinforcement (Mugo:1993). Being one of the liveliest debates in academia, no discussion on culture can be exhaustive, least of all the one in this chapter that collapses three projects into one.

Human beings create culture as they relate to their material environment and total reality in their capacity as producers and as agents of human development/change. They create two main genres of culture: material culture and non-material culture. The first manifests itself through tangible objects. The second thrives in the realm of ideas. By material culture we mean the production of concrete tangible objects and utilities such as houses, beds, clothes, food products, cooking utensils, cars and artistic products such as baskets, pottery, carvings, paintings, books, musical instruments and so forth. By non-material culture we mean the production of knowledge for consumption at the intellectual and imaginative levels, which can be utilized for the creation of material culture, as well. Ideas, beliefs, philosophies, norms, ideologies etc. are examples of non-material culture substance. They are given birth as people reflect upon their material, natural and supernatural worlds in an attempt to fathom, as well as conceptualize existence. Thus, non-

material cultural expression is an attempt by the human intellect, imagination and feeling to fulfill the biological human need to comprehend life and the world. "It is in this manner that fields of knowledge are carved out: science, history, literature, technology, law, architecture and so on" (Mugo:1993).

Both types reflect the creativity of humankind in relation to the production process in an attempt to harness meaning out of existence. This harnessing ensures the satisfaction of basic and secondary human needs, while perpetuating life in general. Both types of cultures are created through individual and collective efforts on the part of human beings in their interaction with each other, with natural/unnatural phenomena/forces and with historical experiences/processes.

Among the many definitions of culture that exist, there are two by theoreticians who provide mandatory reading and reference within the context of prevention and resolution of conflict. These are: Amilcar Cabral's discourse in *Return to the Source* (Cabral:1973) and Paulo Freire's expositions in *Pedagogy of the Oppressed* (Freire:1973) and *Cultural Action for Freedom* (Freire:1972). Cabral contextualizes culture within the production process, describing it as an essential element in the history of a people and as a vital tool in the search for their survival and progress. He sees cultural assertion as inseparable from the struggle for freedom. Freire identifies the socio-econo-political institutions that are used to create, inculcate, reinforce and propagate culture – education being his chief focus. Others include media, religion and law. These institutions of the superstructure support a given economic base that is the lifeline for cultural production. Coming from different contexts and routes – Cabral from the armed struggle culture of pre-independence Guinea Bissau and Paulo Freire from the fertile soil of Latin American political activism/cultural resistance – the two arrive at a similar conclusion. As people from dominated cultures, both distinguish between two main cultural traditions: culture for conquest, oppression and enslavement and its dialectical antithesis – culture for self-naming, liberation and true human progress. Cabral's and Freire's positions validate the argument made by "Culture in Africa and Development," namely that material

and non-material cultures "can be directed towards the solution of human problems, self-realization and fulfillment of societal needs whereas on the other hand "they can be used for destructive, wasteful and anti-social purposes."

We now move on to other characteristics of culture.

Since human beings are the creators of culture, their interventions in life determine the kind of culture that evolves at a particular time in history and how it consequently defines their collective social personality, as it were. Thus, culture is never static, but always dynamic. It is constantly changing, progressively or retrogressively, in keeping with the socio-econo-political, historical climate around its creators. Cultural creation or activity is a continuous, perpetual process in the construction and reconstruction of pertaining reality. It is not a predetermined or unalterable phenomenon. Culture is also obstinately resilient, especially in the face of repression and threatened extinction. This is a characteristic that all forms of fundamentalism forget in trying to arrest change by imposing an allegedly divined or fixed notion of human behavior.

Earlier on it was argued that culture is created as people respond to their particular material environment to perpetuate life, invest it with meaning and satisfy given needs. It is for this reason that global cultures differ from one another, registering differences in accent and forms of self-expression as they reflect the peculiarities and particularities of their given contexts. However, global cultures also have similarities and reflect basic fundamental principles that they share with one another, even though such convergences may be differently expressed. Moreover, cultures do not exist in isolation from each other. Through meeting and intermingling, they influence and shape one another. This intermingling can be positive and enriching, but it can also be negative and impoverishing, especially when the exchange is undemocratic, uneven or dominated by one side. Equally bad is what happens when cultures emphasize isolation and exclusion rather than understanding and dialogue in their encounters. Cultures with institutionalized racism such as "apartheid" structures exemplify this relationship.

If global cultures recognized and respected the dialectics of equitable, democratic exchange in dealing with each other, they

would coexist in harmonious collaboration, as opposed to colliding in clashing antagonism, informed by chauvinism and prejudice. In this regard, one has to vilify dominant cultures for acting as bullies and bulldozers when in confrontation with other heritages. Let us illustrate why and how this is the case.

Imperialist domination has consistently violated the principles of cultural self-definition and self-determination among dominated peoples over the course of human history. Arrogantly viewing the culture of the dominator as superior and universally binding, imperialism aggressively imposes foreign cultural expression on oppressed cultures, making itself the point of reference. Colonialism actually had the arrogance to assert that the countries it invaded had no cultures. At best the colonials conceded the existence of "savage" cultures which they went on the rampage to wipe out through acts of savage terrorism, systemic coercion, enslaving education and ambushing religion. The physical and psychological effects of these forms of Western colonial, cultural terrorism(s) are phenomena that still have to be fully studied if possibilities of prevention and resolution of conflict are to be fully explored through cultural inter-vention. Before even embarking on the notion of conflict resolu-tion, we have to ask ourselves the following questions among others:

- What kind of mentality was behind the horrors enacted by the colonizers?
- What traumas were experienced by the colonized?
- What role did the project of economic domination and control play in all this?
- What lasting effects has the experience had on both the former colonizer and the colonized?
- How have the experiences influenced and continue to influence the culture(s) of neo-colonialism?
- What lessons can we learn from all of this in our efforts to accelerate conversation between cultures as a means of neutralizing conflict?

To wrestle with these questions, we need to revisit discourses such as those contained in the following sources, among others: *Discourse on Colonialism* (Cesaire: 1955), *How Europe Underdeveloped Africa* (Rodney:1972), *The Wretched of the Earth* (Fanon:1963), *Bury My Heart at Wounded Knee* Brown:1970), *In the White Man's Image* (Lesiak:1992) and any "Slave Narrative" or colonial/neo-colonial tale of oppression that one may pick at random. In all these accounts, the story is basically the same: imperialism has used/continues to use culture and religion as tools for the attempted rationalization of econo-political control/domination of others. This very fundamental point of departure must be candidly acknowledged if we are to get at the heart of this conversation on the role of culture in the prevention and resolution of conflict(s).

So far, the chapter has, in a very brief and sketchy manner, tried to articulate the dynamics around a theoretical definition of culture. At this point, we move on to the questions of ethnicity, gender and class, in an attempt to demonstrate the way the cultural process shapes each one of them. We shall also study the locations as potent areas of cultural conflict as well as potential platforms for conflict resolution. We shall, for instance, suggest ways in which ethnic and gender differences can be enhanced to promote complementarity and positive diversity rather than division. However, it will also be demonstrated that, ultimately, the contradictions and antagonisms inherent in existing dominating social constructions of gender and ethnicity cannot be truly addressed outside the class question. Focus on the centrality of class and economic control will thus become extremely important when proposing possible cultural forms of prevention and resolution of conflict. The need to determine who defines, or who should define the possible action agenda to be adopted is of vital importance.

Culture and Ethnicity

Although the term "ethnicity" remains highly controversial, this chapter will not take up the many debates that reflect the exchange between the various scholars. A simplified definition will have to suffice for the task before us.

Ethnicity brings together basic groups or core communities of people who share the same geographical space, a common language, at times religion, often, common ancestors and a collective history. In some cases, ethnicity is indistinguishable from nationhood. However, a lot of times – and this is the case with many nations of Africa – a few or numerous ethnic groups come together to constitute a nation. (Some cultural and political analysts conceive of ethnic groups as nationalities, or sub-nationalities, within the larger collective national entity.) When the second scenario is the reality (different cultural entities coming together to form a nation), we find that ethnic groups, or sub-nationalities, have a core culture that they each bring to the larger, collective national cultural entity.

Now, this experience of sharing the various spaces: geographically, historically, linguistically and even blood-relatively can be validating, nurturing and liberating if used for positive bonding, collective identification and self-naming. Indeed, it is only natural that human beings should embrace themselves and their origins, as well as enjoy a solid sense of belonging and identity. There is warmth, comfort and security in being surrounded by bonding, and uniting socio-cultural affirmations. However, when ethnic and/or national self-identifications become excuses for chauvinism, domination, seclusion, exclusion and non-recognition of others, conflicts arise. Dismissal of other cultural beings implies that "they" are less human than "us": "we" thus abdicate the human obligation to affirm "their" being. If pushed to extremities, "others" become imagined enemies and xenophobia leads to the desire to persecute or exterminate "them." It is this kind of mentality that has historically fanned atrocities such as genocide, holocausts, lynchings, massacres and other forms of "ethnic cleansing" under racism, apartheid, nazism/neo-nazism, neo-colonialism, etc. Tragically, these continue even as this chapter is under composition.

As already argued, historically, Western imperialism beats the record here, especially when one revisits crimes committed under slavery, colonization, so-called "world wars" and liberation struggles. Supposed Western cultural superiority was the white "ethnic" philosophy used by the enslavers and colonizers to justify the colonization of Africa and other global territories. It serviced the project

of economic exploitation of the South by the North, which continues to this very day.

The near extermination of other cultures has historically been the prerogative of the leading so-called "developed nations." The most notorious example is the genocide of first nations people in the Americas and the "Aborigine" people of Australia and New Zealand. Moreover, the West and America, in particular, built technological advancement on the sweat of African "slaves" who survived holocausts, massacres and other fatal atrocities that wiped out up to 100 million people, according to some historical sources, including Chancellor Williams' *The Destruction of Black Civilization* (Williams:1961). Hitler's Germany later repeated a holocaust of six million Jews in its gas chambers, all in the name of racial purity – an extreme form of what has come to be known to-day as ethnic cleansing.

Conversely, it is instructive that in Africa, during historical *zamani* time, to use John Mbiti's terminology (Mbiti:1969), except for periods characterized by war and other forms of conflict, ethnic societies had, by and large, devised means of living with each other's cultures. Attempts by one group to exterminate "others" were extremely rare, if not unheard of. Now ironically, it seems that the violent cultures of colonial invasion and imperialist conquest have schooled colonized societies in the art of "enemy" extermination. The legacy of mass graves has become an African reality. It was something unheard of in Africa's *zamani* history. From accounts such as the autobiography of Olaudah Equiano (Gates, ed.: 1987), Achebe's *Things Fall Apart* (Achebe:1959), *The Destruction of Black Civilization* (Williams:1961) and so on, it would appear that there was a strict code of ethic that enforced "humanitarian" treatment of enslaved people (irony!) and captives of war. But look at how painfully and tragically recent history in Rwanda and Burundi stares us in the face! A similar culture of violence and extermination of "others" informs the ethnic cleansing sprees of Eastern Europe, the massacre of the Arabs in Israel and similar calamities in other parts of the world.

As the world drowns under the rhetoric of "global village" proponents, there is serious need to painfully face the problems

of seclusive and exclusive ethnicity. These remain real even when hidden under the shroud of political correctness. The so-called "new world" order seems to be re-aligning the North into new predominantly white economic ethnicities. However, as far as the South (and Africa, in particular) goes, the impoverishment of the majority under IMF and World Bank policies have created not just disorder, but more ethnic divisions as people fight over scraps of leftover resources.

This said, one hastens to point out that contrary to popular advocacy, cultural differences are not the basic cause for ethnic conflict and strife. Rather, divisive econo-political agenda and their agents exploit the differences for their own controlling interests and expediency. Such divisiveness then craftily plays upon geographical affinity to separate ordinary people who would otherwise be united by a common history of economic exploitation and other forms of deprivation. Because the people are fed with false consciousness and are so extremely vulnerable in their perpetual state of wretched poverty, they become easy targets to this manipulation. What is needed is true conscientization that assembles the masses together as a collective group who share a common culture: economic deprivation. This sense of a larger reality, or crisis, if you will, needs to be instilled in the people as a means of bringing them together. The people need to constitute new "ethnicities" based on a common history of economic struggle. They need to map out their shared space in terms of avenues for survival, threatened as they are by hunger, disease, poverty and other crises.

This realization was a part of the momentousness of national and liberation struggles when sub-nationalities united around a crisis, forgetting their differences, rallying behind the call for freedom. There is no doubt that national liberation and armed struggles have been the high, flowering moments of African cultures outside antiquity civilizations and the epochs of the great empires. During those periods of achievement, cultural multifariousness and plurality seem to have been recognized and celebrated as strengths, not viewed as liabilities. In this vein, today, at the national level, there should be an effort to celebrate the multifariousness of the cultures that combine to make our nations, nurturing each one of

them, big and/or small. More importantly, the cultures should be challenged to create a rendezvous where they meet with each other in genuine exchange and conversation. Only in this way is it possible to evolve an enveloping national culture, based on a blending of those practices that unite rather than divide. Ultimately, this should be the ideal: the creation of a unifying national culture that will enable countries to move forward in pursuance of collective goals and a sense of linked destiny.

Indeed, fundamentally, there are more bonds than barriers between people of the same nation. Moreover, with will and determination barriers are surmountable. Looking for the human being in one another, as opposed to geographical labels, is one way of transcending real or imagined differences. It is for this reason that engaging helps us perceive other nationalities and global people as a part of the human family to which we belong and with whom we share the same space on this planet. To share the space harmoniously means leaving as much room for others as we take up ourselves. If this does not happen, hogged, or grabbed space is going to remain under contention and there will be no peace.

If the crises facing the nations of Africa and the world at large do not force humankind to dialogue across cultures in order to find solutions, there is little hope for collective survival. There is a need to forge liberated zones of new "ethnicities" and "nationalities" that transcend limitations of geographical space and cultural parochialism, for, Frantz Fanon was right: even at its best, nationalism has its pitfalls (Fanon:1963).

Africa needs to revisit the Pan-African project, its problematics notwithstanding. If infused with an internationalist and class vision, the project is one of the few options that remain. Active psychological re-mapping of Africa to liberate it from the boundaries imposed by the Berlin conference has to take place. Focus should be on the activation of regional unities, communities and economic federations that might undercut ethnocentrism. While this is being done, the democratic rights of individuals and groups should be ensured, be it these groups' minorities or majorities.

Next, how do the cultural politics of gender fit into all this?

Gender

Constructions of gender in most world cultures are further breeding grounds for conflict and contention. Inequalities between men and women thus have to be urgently addressed as a part of the agenda for the prevention and resolution of conflict. The very languages we speak make men the point of reference for the human race, which is conceptualized in male terms. Male children are desired above female children in most cultures. Males mostly own and inherit property, under legal protection. History is constructed around men's achievements. Males dominate the positions of power that define the direction the world is to assume. They are culturally associated with strength and are, in many cultures, conceived as agents of protection and security while women are constructed as dependants requiring protection. Yet, the irony is that, today the globe's predominantly male political leadership presides over a world characterized by war, destruction, homelessness and other forms of inconceivable insecurity.

Where and how does the woman enter this scene? We only need to focus on one central thesis to open up this discourse. Namely: in most global cultures, the woman's high point of recognition is as a mother, especially when she gives birth to male children. Indeed, there are all kinds of proverbs and sayings that venerate women as child bearers and rearers. Outside the cultural portfolio of mistress for home affairs, however, the woman's role in Africa's econopolitical power equation is one long lament. Where token recognition is made, it is often symbolic and devoid of executive power. This inequity has to be urgently placed on the negotiation table if women are to contribute meaningfully to the resolution of conflict. At this point, it is illustrative to do a roll call of the many resounding negative themes surrounding gender cultural intersections and inequalities, in demonstration of foregoing remarks. A number of these points underline what has already been said above and have been elaborately dealt with elsewhere by this author (Mugo:1993):

- Patriarchal abduction of history, which only gives token recognition to women's achievements, but most times sub-

jects them to alienating marginalization, if not total exclusion.

- Control of the institution of marriage, placing it under patriarchal possession to the extent that women become a part of the male's possessions, even by name.
- The captivation of language so that the male becomes the point of reference in even defining what constitutes humanity.
- Consequent imposition of silence, sometimes virtually strangulating female voices when they dare to explode the silences around their lives.
- Subjection to gender-targeted forms of violence, including rape, pornography, prostitution, battering and so on.
- Characteristic monopoly of power by males, abrogating women to the role of followers.
- Male control of women's sexual and reproductive rights, using this power to define and confine them and in this way denying them freedom to achieve full self-realization.
- Domestication of women, often perverting the notion of motherhood to rationalize servitude and exclusion from power sharing.
- Sexist discrimination accompanied by stereotyping and objectification of women – processes that rob women of their dignity and human uniqueness as a gender.
- Feminization of poverty ...

The list could go on, but a quotation from Robin Morgan's edited work, *Sisterhood is Global: the International Women's Movement Anthology* (Morgan: 1984), demonstrating how a multitude of problems converge on poor women, completes the picture. The picture is quite sobering, for, if women's lives are at such risk, those of their children are equally endangered, meaning that many of the world's future generations may not be around to enjoy the peace we seek. Clearly, there is an ongoing silent war on poor women and it is real even though it may not be dramatized by the sound of guns and bombs where women are also on the firing line:

> Not only are females most of the poor, the starving, the
> illiterate, but women and children constitute more than
> 90 percent of all global refugee populations. Women
> outlive men in most cultures and therefore are the elderly
> of the world, as well as being the primary caretakers of
> the elderly. The abuse of children is a women's problem
> because women must bear responsibility for children who
> are abused – nutritionally, educationally, sexually, psy-
> chologically etc. Since women face such physical changes
> as menarche, menstruation, pregnancy, childbearing,
> lactation and menopause – in addition to general health
> problems we share with men – the crisis in world health is
> a crisis for women (Morgan:1984).

For as long as poverty and suffering remain feminized, there can be
no hope for world peace. Africa, the poorest continent in the world,
should take heed of this warning.

"Being a girl is hard!" replied a Zimbabwean primary school
female child, when I asked why a lot of girls in her class had answered
that they would have preferred to have been born boys in a survey
questionnaire, a decade or so ago. From birth to death, women are
not only culturally constructed to reflect this disadvantagement,
but also forced into situations where they constantly engage in acts
and pronouncements of self-depreciation and self-denial. They are
culturalized to be quiet conspirators in their own oppression, never
telling, even when they are abused and raped. Sometimes they are
even coached to defend or rationalize the very social crimes that are
committed against them as women. This process of self-negation
indicates what a destructive role negative cultural gender construc-
tion has had on women in general as well as on young girls. It leaves
them on the periphery of historical conception whereas, in reality,
they are at the center of the action(s) that move that history forward.

In a lot of cultures the exclusion of women from positions of
high visibility, especially when looking at locations of executive
political power, is chilling. The need for protest, dialogue and legis-
lation to break the silence around women's existence is more urgent
than ever now. The crises that face the world target women, children
and youth, first and foremost. These constituencies must refuse

silencing and abandon conspiratorial participation in their own undoing. The motif of breaking silence is very central here and on this, a lot of women have written extensively, among them: Audrey Lorde (Lorde:1980); Adeola James (James:1990); Ellen Kuzwayo (Kuzwayo:1990); Githae Mugo (Mugo: 1985, 1994, 1994); Nawal El Saadawi (Saadawi:1983), etc. In emphasizing the need for the explosion of negative silences around women, one is reminded that in the Gĩkũyũ language, "woman" literary translates into "the one who keeps her mouth shut." This culturalization and socialization of women to speak as little as possible, or keep their mouths shut, must be urgently interrogated. Above all, women must refuse to oversee the strangulation of their voice by speaking out instead of observing this imposed negative silence. Only then can they assertively and articulately sit around the negotiation table to discuss the prevention and resolution of conflict.

This aside, one wonders how many peace missions, nationally, regionally and internationally, have included women in their delegations! If any have done so, how central have the women delegates been in the negotiation process? This second question is important because we are all too well aware of neo-colonial delegations that include women for extracurricular services and sometimes for cultural "decoration!" This is an insult to female integrity and intelligence, worse than their exclusion.

An anecdote is in place here. In mid-1995, the Moi regime that had instigated ethnic cleansing activities in the Kenya Rift Valley region, decided to appoint a team of "elders" to resolve the conflict. The delegation was supposed to bring together the cultural group involved in the so-called "ethnic clashes." This contingency of "peace makers" did not include a single woman. Yet, women have all along constituted the majority of refugees, destitutes, homeless and dispossessed, created by this crisis. Even more ironically, the delegation of "elders" and "leaders" negotiating the peace settlement included some of the very politicians who had initiated the call for ethnic cleansing. Not only had they made this call at public political rallies: they had proceeded to mastermind the logistics of carrying this plan out and ultimately oversaw the execution of the atrocities that followed. More than this, they had actually used government

human and other resources to carry out their agenda. So, the resolution of conflict was under the stewardship of yesterday's supervisors of crime, now become peacemakers entrusted with the lives of those who had survived the first round of ethnic cleansing exploits.

This illustration dramatizes what is general practice all over Africa and the world. Women are excluded from peace negotiations while those who make war sit at the table to preside over the very process that they have violated. The contradiction in so far as most African cultures go is that, in reality, in the family and the extended family set-ups mothers, aunts and grandmothers normally constitute human cultural shelters. That is where embattled youth, in particular, run for protection when the going is rough. Generally and culturally speaking, women have smaller egos than men. They are more open to negotiation. Indeed, outside the class equation, women are, by and large, more supportive of community group efforts than their gender counterparts – an important factor in advocating peace.

Given all this, it is a matter of urgency that women take their rightful place around the tables where peace negotiations are in process. However, unless this goes hand in hand with the resolution of the problem of feminization of poverty, the road to lasting peace will remain a flood of mirages. Without resolving this problem, Africa is doomed. After all, women make up the bulk of Africa's population and an overwhelming majority of the refugee community. The patriarchal and sexist practices that characterize most African cultures have to be eliminated if there is to be hope for the prevention and resolution of conflict. What one is saying about Africa is true of other cultures. The world cannot ignore more than half of its population and hope to sort its mess out without them. Fortunately, a lot of countries seem to be gradually paying attention to the fact that women's enforced invisibility, even as their majority numbers speak out loud, will never make the woman question disappear into thin air. It is on the table to stay.

However, when all is said, if women are going to bring a new voice onto the conference table, that voice must be liberated from patriarchal constructions of power and privilege. It must bring new paradigms of resolving current conflicts and injustices. The voice must also transcend the trappings of class, for, it is at this level that

the privileged woman's majority sisters face the type of exclusion that condemns them to ultimate wretchedness.

With this in mind, we turn to the question of class.

Culture and Class

Within the African context, one can safely say that colonial and missionary education played a major role in solidifying class patterns that existed in *zamani* Africa, as well as in creating new formations. Neo-colonialism has grounded and sharpened these formations even further. Given this fact and as I have argued elsewhere, it would be a dangerous generalization today to speak of say, "African culture," "Zimbabwean culture," "Nigerian culture," "Senegalese culture," "Egyptian culture," "Malagash culture," etc. and leave the matter at that. To reiterate: in a neo-colonial situation, members of the various classes consume very different kinds of culture, even though they are geographically and historically situated within the same locale. For instance, in Zimbabwe, the cultural world of the commercial farmer (let us assume s/he is African) is radically different from that of the communal area small farmer. Both are African, but they consume very different political and economic cultures. Similarly, a university professor's lifestyle is definitely not the same as that of the woman who cleans her/his office, or the domestic worker who washes her/his clothes. Certainly, the million plus worth residence of a government minister is much more habitable than the unaccommodating shack of the watchman who remains awake all nights (hopefully, at any rate) to ensure that the former sleeps in peace. Yet, the two may be from the same village, the same clan and the same district. In other words, whereas these people have the same color, speak the same language, share a single nationality, remain the cultural products of the same history, probably belong to the same religion and even happen to be related etc., because their economic statuses place them in different classes, the cultures they consume end up being worlds apart.

In connection with this, I have argued elsewhere (Mugo:1993) that in a class situation such as the neo-colonial one, we cannot afford to romanticize culture as a uniform process or experience. To

illustrate this further, let us, for the sake of simplification and given the limitations of this chapter, focus on two major class constituencies in Africa: the very poor and the very rich.

The masses of Africa consume a culture bred on the impoverished soil of basic needs survival. Those who are lucky have shelter, clothing and food, but not much more. However, there are many who do not have these "luxuries." There are others who have lived under conditions of war for years and yet more who know no life other than that of refugee camps. For these, education and literacy are extremely hard to come by. They thus grow up under a culture of insecurity, perpetual want and even ignorance. Over and above this, generations who have been reared in the slums of Africa's big cities, under abject poverty, have grown up consuming a culture of violence and brutalization. These deprived poor are usually born and bred in a socio-econo-political environment (and, therefore, cultural environment) characterized by drunkenness, violence and crime – experiences that will certainly negate their positive growth as human beings. Then, of course, there are the generations of youth orphaned by war, famine and disease, especially AIDS... and so one could go on. There is no doubt that Africa's masses, and in particular their children, are an "endangered species" which is also to say that short of a great revolution, future generations will be characterized by a devastating culture of poverty. They will inherit conflict and chaos because their future is severely mortgaged by present ruling classes and political regimes. What does this mean? It means that there will be no peace: not even for the wealthy.

In contrast to this world of economic and cultural poverty, under which, ironically, the poor determinedly and obstinately continue to create resistant cultural forms, we have the wealthy of Africa. Leading lifestyles equivalent to those of their counterparts in the so-called "developed world," the problem of the affluent of Africa is not money, but how to spend it. Many of them do not really care about African culture. They even demean it by viewing it as a heritage that licenses excesses and indiscipline. Witness how they talk of polygamy and promiscuity as African male prerogatives, unpunctuality as a style of observing "African time" and failure to meet deadlines as the African way of life – "taking it easy" and

turning existence into one big party. At other times, dictatorial behavior and the silencing of youth are explained away in terms of elders' privilege. However, beyond such opportunistic purposes, all else is lip service to "African" culture. For many who combine elitism with wealth, true identity and loyalty remain more with "Western culture" than with their own heritages.

These classes consume what I have termed show/parade culture. It is a culture of loud boasting and extravagant consumerism. It parades wealth and engages in cutthroat competition as the affluent try to outdo each other in the game of showing off their money power. Many of them spend most of their wealth and time in the West where they also send their children to school. Locally, they live on islands of obnoxious affluence, being driven in humongous cars that consume petrol and the environment with a vengeance, as if there is no tomorrow. The majority work hand in hand with foreign economic interests in their business speculations, not hesitating to carve Africa up all over again, if need be, in the name of "development." Dining and wining with their foreign business partners, spending holidays in Disney World and Disneyland, these Africans consume a culture that replicates little Hollywoods in the midst of deserts of poverty right under their mansions. The culture they create is largely one of imitation, extravagance, arrogance and decadence – altogether lacking in creativity.

To sustain this world, they create a political culture of oppression and repression, blocking democratic processes that seek dialogue and change. Witness the presence of military and civilian dictatorships, which remain the subject of abundant scholarship and discourse, especially among political scientists. Regrettably, this chapter cannot go into these debates. Suffice it to say that progressive intellectual platforms are important spaces within which to discuss possibilities of conflict resolution, including forward looking places of religious worship which should also be targeted since, whether we like it or not, this is one place where ordinary people congregate. Progressively used, the pulpit can be turned into a platform for the conscientization of the masses who must be involved in the struggle to unseat the unjust systems that cause conflict.

In this section, we have focused on two major econo-cultural expressions in neo-colonial Africa, based on class analysis: the

culture of the oppressed and the culture of the affluent. The limitations of the chapter have not allowed a more detailed analysis of the other classes and strata between the two extremes. This is the work of another project.

In recapitulation then, broadly speaking, the two major cultural expressions discussed stand in antagonism with each other. As a rule, the culture of affluence and econo-political power operates in alliance with the culture of foreign domination against the interests of the majority of ordinary people. Consequently, the oppressed are engaged in a continuous, resilient struggle for survival and self-assertion, creating a culture of defiance and resistance as they do so. Given this understanding, it is obvious that there is no way of addressing the antagonisms between these opposing cultural interests outside the framework of economic control/deprivation and their antithesis, the struggle for economic emancipation. In other words, the structure(s) of the systems that breed them must be tackled if we are to pull out the problem from its roots.

Conclusion

The disparities, contradictions, antagonisms and injustices brought about by negative and discriminatory categorization of people in terms of gender, ethnicity, class (and other "camps") have to be ruthlessly confronted if we are to prevent or resolve conflict(s) around us. Failure to address these conflicts within the framework of economic arrangement will only lead to a *cul de sac,* for, as argued, it is in the process of responding to the economic system that culture is created. Cultural and social constructions created during the process then define gender relations, even as they mold the ideological orientation that shapes the conception of "ethnicities." Yet, all said, it is also important to realize that all these processes and constructions intersect at the crucial point where true humanity meets and becomes named. It is for this reason that the particularized struggles to resolve conflict at the levels of gender, ethnicity and class must be interlinked if they are to succeed. They should not and cannot be waged in isolation from each other. The time to come to a circular conference table where all sit in occupancy of equal negotiating status is now.

Chapter 9

RE-ENVISIONING PAN-AFRICANISM: WHAT ARE THE ROLES OF GENDER, YOUTH AND THE MASSES?

Introduction: Approach, Hypothesis and Structure

Deliberately using a communicative, popular style of writing, this chapter posits a straightforward hypothesis, which is stated as follows: having been left on the periphery when the original project of Pan-Africanism was conceived, Africana women, youth and the masses must assume an integral role in re-envisioning a practical agenda this time around. Beyond the urgent task of affirming women, youth and the masses as central agents in bringing about the project's realization, the question of class remains just as immediate and calls for extensive, open discourse, alongside that of race. However, our focus is the engenderment and democratization of Pan-Africanism to include women, youth and the masses. The issues of race and class require a different essay on their own.

The chapter posits that even though not cited in intellectual discourses that have so far come to be the literary canon on Pan-Africanism, in their activism, as well as participation, women were and have always been the heart of Pan-Africanism's *essence,* or if you like, substance. My point is that Pan-Africanism may be seen as manifesting itself in two major ways, which are equally impor-

tant: through the movement itself and through its lived aspects. As a movement, Pan-Africanism has been characterized by fluctuation, registering bouts of life and dormant lulls. On the other hand, its lived aspects, actual substance or *essence,* have always remained alive and persistent over historical time. Ordinary people, or the masses, including the majority of Africana women, have been the key keepers or carriers of this *essence.*

For now, the point to revamp is that for the contribution of the women and the masses to be recognized or embraced, Pan-Africanism needs to be defined beyond the congresses and proclamations with which it has come to be exclusively identified/associated. The latter conception of the project not only sidelines women, youth and Africana masses at large, but also makes the whole affair a monopoly of intellectuals. This limited, limiting and certainly, a-historical conception of Pan-Africanism partly explains why the project has never quite translated into a full-scale social or mass movement. These and other aspects of Pan-Africanism's unfinished agenda need to be candidly addressed if the project is to be revived, re-shaped and revalidated. In other words, advocates of Pan-Africanism will have to engage in ruthless self-criticism if the effort to recreate the movement is to succeed. Women, youth and the masses have to move into the center of business and become the soul of the renewed movement.

The chapter is presented in four parts. It opens with an introduction that lays out the background against which a renewed call for Pan-Africanism is occurring, including a rationalization on the focus given to women, youth and the masses. The second part offers a theoretical definition of Pan-Africanism. In the third part, we provide a few brief case studies of selected African-American women who historically epitomize the tradition of lived and practiced Pan-Africanism. Lastly, there is a focus on African women and the seventh Pan-African Congress in Kampala, which is viewed as historical in having provided a platform for women and youth. We conclude by emphasizing the roles that women, youth and the masses can play in bringing about the realization of Pan-Africanism as a mass movement on the continent, as well as globally.

Introductory Background and Rationale

Africa, more than any other part of the world, is in desperate search of possible solutions to the myriad problems that currently confront her, ranging from poverty, back breaking external debts, uneven development, ethnic tensions, civil wars, disease, natural disasters and a host of other life-threatening calamities. The descriptions that accompany the very mention of Africa exude what has come to be known as *Afro-pessimism* in some political science circles. Witness the following random sample, which I picked up from listening to the BBC London, Voice of America, CNN and from reading the *New York Times* over a period of two hours in 1997: "the poorest continent in the world," "a continent in perpetual crisis," "a region torn by war," "a region in turmoil," "large sections of Africa are threatened by the AIDS epidemic," "the refugee problem is at explosion point." Between then and the beginnings of the new millenium, the drama in catastrophic naming has more than escalated, producing even more depressing images.

Whereas we have to constantly insist upon re-conceptualizing Africa in affirmative terms, even in the face of the worst of disasters, we nonetheless cannot afford to play the ostrich game by burying our heads in the sand, for, there is no doubt, our African home is on fire! All manner of possible solutions and alternatives have been prescribed: economic, political, ideological, structural, cultural, religious... you name it. The worst of the recipes have come in the form of World Bank and IMF structural adjustment programs, resulting in increasing *maladjustment* (Mugo 1994:83-84) rather than improvement! Enough has been written on and said about these recipes of disaster, coming to us externally as the North's solution to the nightmare of Africa's external debt, which the West's political economy of resource extraction and exploitation created in the first place. But, what is Africa's own alternative?

One internal or homegrown, proposed solution comes in the form of renewed advocacy for Pan-Africanism. Recently, this call has tended to be associated with President Thabo Mbeki of South Africa and his campaign for an African renaissance. However, as I have argued in "African Culture in Education for Sustainable

Development" (Mugo 1999), Mbeki's African renaissance vision must be seen as a part and parcel of the historical Pan-African project. I suggest that we, in fact, view it as a continuation of the debate revived by the Seventh Pan-Africanist Congress in Kampala, Uganda, 1994. The realization that a fragmented Africa is doomed to failure explains the urgency in Mbeki's voice as well as other voices such as that of President Gaddafi, who has launched his own campaign for Africa's re-unification.

Clearly, Pan-Africanism is becoming a hot agenda item on the conference table as people of African origin strategize on how to effect Africa's second liberation – the process of democratization that now sweeps across the continent. The irony is that, flying in the face of these efforts, whatever their limitations or possibilities, are the bullets, bombs, spears, arrows and machetes sharpened by ethnic animosity fuelled by warlords, factors that are currently causing division and bloodshed all over Africa.

The rationale behind Pan-Africanism as a proposition is that, historically, people of African origin share experiences that continue to link them, whether they like it or not. Further, the problems that most African countries currently face are so similar that economic and political unity – as well as other means of co-operation – may provide part of the answer. Now, more than 50 years since Ghana, the first African nation, won its independence from Britain, it has become increasingly evident – from many perspectives, but more so from an economic standpoint – that, for the majority of Africa's population, *Uhuru* has only translated into a bitter struggle for survival, as opposed to being a celebration of true or total freedom.

What happened to the euphoria of nationalism that saw the birth of the OAU (Organization of African Unity) in 1963, which was a source of so much hope for Africa? Some scholars have proposed that through its formation, the OAU only succeeded in sabotaging the real unification of Africa that might have taken place, as was proposed under a Pan-Africanist framework by Kwame Nkrumah and others. In so doing, this line of argument goes; the OAU not only undermined the project, but also ended up condoning neo-colonialism. Elenga Mbuyinga's book, *Pan Africanism or*

Neo-Colonialism?: The Bankruptcy of the OAU (1982), makes one of the most coherent cases on this thesis.

Similarly, the United Nations is seen as a bureaucratic white elephant that has continued to leave Africa on the margins of its priorities. The foot dragging that has accompanied belated interventions during recent political crises such as those in Angola, Burundi, the DRC (Democratic Republic of Congo), Eritrea, Ethiopia, Liberia, Rwanda, Sierra Leone, and Somalia, to mention the most obvious, has given credibility to this cynical perception of the world body. Moreover, in its conception of the New World Order, America seems to be competing with the United Nations as the alternative global power, especially where military intervention is concerned. It is within this context that the call for Pan-Africanist revival has gained momentum in recent years.

In advocating a re-visitation of the Pan-African project, further reasoning points out that the notion of the world as a "global village" has increasingly moved from being a philosophical proposition to becoming an actualized reality. Specifically, in its New World Order advocacy, the North seems to have translated the idea into an economic and military asset. Witness the following: systematic efforts by the EU (European Union) to convert Europe into one industrialized "village," or market that dominates the rest of the world; pressure on the part of America to ensure that NAFTA (North American Free Trade Agreement) takes off – mostly to *his* imperialist designs; continuing trade negotiations between the United States and some of *his* traditional political ideological foes, such as China and the Soviet Union for domination purposes; ongoing negotiations concerning membership, realignment and expansion of NATO (North Atlantic Treaty Organization) in an effort to militarily link North America with Europe even further and so on and so forth.

In the light of all these developments, cynics observe that, with America in the lead, the North is indeed creating a New World Order for itself, shaping it as a part of the pertaining international capitalist market. However, what this process is doing for the South and Africa, in particular, is to create a world of serious "Disorder," especially through IMF and World Bank structural adjustment pro-

grams/policies. The same observation could be made concerning the euphoria around the so-called end of the Cold War, which seems to have ended between the two former super powers, but which is clearly raging for the Western dominated countries of the globe.

The only real structural change, cynics quip, is that now there is just one *chef* (boss) – the United States of America. Consequently, the reason super power global tensions appear less vicious and even less of a security concern is that America now only has *himself* to compete with. In all this, CNN has become a surprisingly effective ambassador. Stay in any hotel worth its name on this globe and CNN is most likely going to be there to welcome you – to Hollywood, mainstream, commercial and corporate America.

In so far as Africa goes, for instance, America's cold war boasts abundant, constant, casualties – culturally and ideologically – even as it freezes the minds of its unconscious consumers. For instance, possession, or even proximity to, anything emanating from the United States of America is considered the hottest event in Africa today – including second hand clothing! This, as Hollywood features a new version of Tarzan that has black stars!

Given all this background, therefore, proponents of Pan-Africanism would argue that, in failing to bring the "all African people" project to fruition, the Africana world might have neglected a dream whose original objectives – at least some of them – have ended in the hands of the North, profiting and enhancing Western development and hegemony, all at the expense of the South. For these and other reasons, the current re-visitation of Pan-Africanism as an alternative option in promoting economic and democratic development among Africans on the continent and in the Diaspora is not at all surprising.

Consider Africa, once more, and the heavy prize that a lot of the countries are having to pay as a direct consequence of ethnic antagonism and prolonged devastating wars that have resulted in unprecedented, vicious bloodbaths. Division and sectionalism of all types mock the very notion of nation states in neo-colonial Africa. Indeed, state mismanagement has reached such an alarming level that in a number of cases the notion of "state" has become a mere paper and boundary formality rather than a practical reality. It is

difficult to conceive countries such as the DRC, Liberia, Rwanda and Burundi, Sierra Leone, Somalia, to name only a few, as viable "nation states," as they currently operate. The spirit of nationalism that swept the continent during Africa's national liberation struggles seems to have, ironically, diminished with the advent of independence and has, in some cases, been actually succeeded by reversal processes.

Indeed, many of Africa's neo-colonial states have reverted to the colonial designation of Africa's cultural nationalities as a conglomeration of "tribes," conveniently used to explain away animosity stirred by the political leadership and instability that characterize people's existence. Thus, only a few decades following the advent of independence, the highest expression of nationhood, and the various communities that make up African nationalities have been conditioned to feed on division and separatism, rather than on a vision of relatedness and oneness.

The result has been that wars fuelled by ethnic animosity (behind which the real econo-political issues hide) have, arguably, cost Africa more in human lives that any other disaster – natural or man-made – while resulting in the highest number of refugees in the entire world. From the south to the north, the east to the west, one cannot name a region in Africa that has escaped devastation and human tragedy, related to war and its effects. Needless to say, women and youth constitute the highest percentages of the victims and survivors.

It is in the face of all this that I examine the relevance of Pan-Africanism, a project that has been on conference tables that have featured Africana agenda since the nineteenth century, but which, for all kinds of reasons, has not quite witnessed viable, practical actualization. The question is, does Pan-Africanism hold any relevance for Africa and indeed for other Diaspora Africans, under the so-called New World Order, or the fashionably popularized, yet quite elusive, globalization process? Further, how does the project impact on the ongoing democratization process in Africa?

More than this, how does it fit into the current resistance struggles being waged by women and youth, as they seek recognition, democracy and empowerment at the social, political and economic

levels under IMF-World Bank "New World Order" economic policies? How will Pan-Africanism resolve the thorny question of class? Does Pan-Africanism offer any reason for optimism, or are we stuck with chronic Afro-pessimism? These are all issues that need to be tackled by the re-envisioned Pan-Africanist project. Regrettably, the scope of this chapter does not allow space for tackling all of them.

Summary of the General Line of Argument

To address some of the above concerns, the chapter provides a working definition of Pan-Africanism, examining its overall objectives and the econo-political reality that it has historically sought to challenge. Given limited available space, my definition does not dwell on details, nor does it attempt to coherently trace the development of Pan-Africanism as a social movement. This has been extensively done by a lot of scholars, including the following – who have produced whole scale works on the subject: Adenkule Ajala (1974); Ayodele Longley (1973); Elenga Mbuyinga (1982); George Padmore (1956); Joseph Nye (1965); Kwame Nkrumah (1957, 1963); Lemelle and Kelley (1994); Makhosezwe Magubane (1987); Olisanwuche Esedebe (1982, 1994); Ras Mackonnen (1973); Robert Chrisman (1974) and others.

After galloping through a simplified, working definition, therefore, the chapter proceeds to analyze the contribution made by a selected sample of African American women during the evolution of Pan-Africanism, emphasizing *essence* and *practice*. In choosing this focus we argue that heretofore, discourse on Pan-Africanism has tended to focus on the theoretical and logistical aspects of the phenomenon as a social movement, neglecting the core that defines it – the actual practice. It is this "actual practice" that the African American women who are surveyed historically epitomize.

Another question arises out of this: why, then, have women remained so peripheral in pertaining definitions and studies of Pan-Africanism? The interrogation of the peripheral status of women, youth and the masses in defining and enhancing the project is especially important seeing that they represent major social constituencies that have historically suffered neglect whenever political agenda

are under construction or reconstruction. We also argue that the inclusion of women, youth and the masses is essential if a revival of Pan-Africanism is to succeed, even if only for the reason of their critical mass numbers alone.

This reinforces emerging discourses in the work of other Diasporan women scholars. For instance, in her work, Carol Boyce Davies (1994) engages in a very informative critical analysis of Pan-Africanism, African/Black Nationalism and Afrocentricity, describing them as "totalizing" discourses for their tendencies to monopolize the construction of the Africana world as a male prerogative. Here, we proceed to demonstrate how herstory of activism on the part of continental African women resembles that of their Diaspora counterparts in reflecting the *spirit, essence and practice* of Pan-Africanism, embracing this as the core that is needed to seriously launch Pan-Africanism afresh. A further proposition is that the re-visitation must move away from a fossilization of Pan-Africanism and head towards an application that addresses the current African reality. Such a definition must wrestle with basic areas of contention such as race, gender, class, ethnicity, nationalism, regionalism and so forth.

A simplistic or romantic definition and understanding of Pan-Africanism that hegemonizes its construction is more harmful than helpful at this critical point in history when lived reality makes the very concept of unity a contradiction in terms, even as collective human need insists that it be invoked. Pan-Africanism calls for united activism on the part of women, youth, men and the masses at large, envisaging women as pivotal. The reason for this is that, currently, women assume the lead in interrogating the status quo, gendering history and discourse, advocating for the equitable distribution of global wealth, insisting on a redefinition of power relations and generally fighting for a more peaceful, humane world. These are the discourses that must characterize the reconstruction of Pan-Africanism, with all the complexities inherent in the challenge.

Ultimately, we conclude that Pan-Africanism is not only relevant for Africa today, but that it needs to be urgently placed on the agenda for revitalization and actualization, placing an emphasis on it as a mass movement, with progressive women, youth and men shaping it anew. It recapitulates and reiterates the fact that

unless women, youth and the general African masses are involved in redefining the new Pan-Africanism project right at its inception – meaning that their involvement has to move beyond mere inclusion to assume indispensable agency – there can be no serious future for Pan-Africanism. Thus, progressively reconstituted, the movement is perceived as a possible vehicle for the acceleration of the democratic process in Africa.

Another revamped point is that, as in the case of women, youth and the masses, Pan-Africanism cannot hope to ignore the question of class if it is to succeed. This issue was placed on the table, with very controversial consequences that almost disrupted the sixth congress in Dar es Salaam, Tanzania (June 19-27, 1994), but it was never addressed exhaustively. For one, some of the delegations that had raised it – concerned that Pan-Africanism was becoming abducted by "the state" and championing the rights of the workers – either boycotted the congress (led by the Caribbean region), or found immigration requirements and other blocks placed in their way as means of locking them out of deliberations.

Cyril L.R. James, who was largely responsible for organizing the gathering, ended up boycotting the congress in support of the delegations that were protesting state take over. It was Walter Rodney who summarized the vital concerns at hand best when, in challenging the legitimacy of governmental delegations (especially in the persons of neo-colonial heads of state), he rhetorically asked: "which class leads the national movement? How capable is this class of carrying out the historic tasks of national liberation? Which are the silent classes on whose behalf 'national' claims are being articulated?" (Rodney 1994). These questions remain on the table today and will not go away in their insistence that they be wrestled with.

A Definition of Pan-Africanism

Pan-Africanism is both dynamic and still evolving. As such it does not have a "standard," or static, or conclusive definition. Indeed, an approach that insists on an "absolute" definition is a-historical in that an idea, or philosophy, defines itself in the process of evolution. The process of evolution reflects the various stages of the philoso-

phy's growth and the kind of shifting emphasis that it acquires as it seeks to address a constantly changing reality around it. The longer the phenomenon remains under evolution, the more changes it passes through and the more complex it is likely to become conceptually. Consequently, the more complicated the task of defining it also becomes. These observations apply to Pan-Africanism, making a precise, absolute definition elusive, especially depending on the particular aspect of Pan-Africanism one is looking at, whether the philosophical side of it, the movement aspect, or the political dimensions. However, it is equally important to observe that these aspects intersect. This said, to meaningfully discuss the subject, it is important that the chapter provides a basic definition, or point of departure, as a means of contextualising our discourse.

Simply defined, then, Pan-Africanism can be viewed as a philosophy or ideology that seeks to bring together all people of African origin *(pan* being the Greek word for *all)* (Davidson 1989:32). It is also a movement based on the shared resistance-oriented history of global Africana people. As an ideology, Pan-Africanism may be viewed as an interrogation of Eurocentricism, but more than this, it is an affirmation of black people's undermined "Africanness." In this respect, Pan-Africanism translates into an alternative text to imposed Euro-centricity, emphasizing the need for global Africana people to unite against white-constructed imperialist domination.

As a social movement Pan-Africanism constitutes organized rebellion and resistance against white hegemony, oppression, domination/injustice politically, economically, culturally and racially. This tradition of resistance goes way back in the history of black people. Historical acts of resistance such as those exhibited by Queen Nzinga of the Dongo Kingdom in Angola, as early as 1623, when she declared her land a liberated zone for any enslaved African person who stepped on it, is a good example of a pre-Pan-African, "Pan-Africanist" vision. The maroons in Jamaica provide us with another paradigm in their ideas and practices that enabled them to unite enslaved African peoples into a formidable force against their enslavers. Among their best-known leaders was the legendary woman fighter, Nana of the Maroons. The *quilombos* have another historical narrative that is almost identical to that of the maroons,

except for the difference in geographical location, mostly rooted in Brazil. Touissant L'Ouverture and his revolution, which made Haiti the first republic to be liberated and ruled by formerly enslaved people, is yet another text.

But, perhaps the most obvious case of early "Pan-Africanist" ideological advocacy is David Walker, an enslaved African who lived in the United States of America between the 18th and 19th centuries. As Karim Essack (1993) points out, Walker, in his 1829 publication, "An Appeal to the Colored Citizens of the World," demonstrated such an advanced visionary insight that his Pan-Africanist thinking this early in history is unique. First of all, Walker was able to link liberation from slavery to the problems of white supremacy and economic exploitation (Essack 1993:8).

Moreover, as James Turner (1993:15) reminds us, Walker deserves credit for having issued "the first clear, widely publicized call for Pan-African solidarity." He argued for "The need for black people to develop a far greater sense of solidarity, especially between the 'free' and captive populations within the United States *and between the children of Africa here and [among] Africans in the rest of the world*" (italics mine). Other early efforts include movements led by Bishop Turner, Martin Delany, Ottobah Cugoano, Paul Cuffee and many more who advocated a "return" to Africa, be the journey physical, historical, political or spiritual.

All the above Pan-Africanist-oriented social movements/campaigns deserve credit that is abundantly overdue for initiating the process of defining and shaping both the ideology and movement of Pan-Africanism. Of special significance is the visibility of Africana women as leaders and active project participants in some of the above historical examples, as is the involvement of the masses of enslaved people.

Moving into the 20th century, arguably, the single most important "Pan-Africanist" social movement was Garveyism, said to have been the biggest mass movement in world history at its height, with a membership of over five million people all over the globe. Garveyist Pan-Africanism emphasized the centrality of race and advocated a return to Africa and the promotion of black capitalism. It taught pride in racial identity, stressed the importance of collective

historical experience among blacks and called for a united response in confronting political and economic domination, especially given the racist history of this oppression.

Another major group that has defined yet a slightly different strand of Pan-Africanism are the Rastafarians who look upon Ethiopia as a spiritual homeland. Conversely, the so-called New World and hot bed of racism, is viewed as a place of captivity and, therefore, named "Babylon." Rastafarians also envision a return to Africa. In the early days of the movement the return was three-fold: physical, cultural and spiritual. With time, the cultural and the spiritual have come to dominate, even though a physical return remains symbolically very significant. Although Rastafarianism has been depicted by some literature as a religious movement that feeds on notions of a romanticized, mythical Africa – a Garden of Eden for followers (Patterson 1964) – the movement's contribution to African consciousness should never be dismissed.

Indeed, Rastafarians' continuing pride in Africa is of particular import today when embarrassment and disassociation are the norm, especially among the elite. During visits to Jamaica over recent years, this author has been most impressed by the Rastafarians' sense of African history, even though romantic in certain respects. The root-edness of the movement among the masses is another characteristic that is particularly worthy of note.

There are, of course, other movements and heritages that have been part of defining Pan-Africanism. They include the follow-ing, as the most significant: Negritude; African Nationalism; the Harlem Renaissance; Black Power; African religions and so on. Unfortunately, available space does not allow for their analysis. Suffice it to say that the few examples given demonstrate how prob-lematic a uniform definition of Pan-Africanism is. For, ideologi-cally, some of the differences among the movements and heritages are quite major. It is their basic concern that brings them together at the critical point of convergence, namely: a collective recogni-tion of the need to embrace and affirm their humanity, blackness/African-ness, in the face of imperialist dehumanization /negation, symbolized by "whiteness" as an oppressive, systemic construction. We will return to the role of other social movements that are "Pan-

Africanist" in orientation, but which have been excluded from the literary canon of Pan-Africanism, when we look at the case studies of African American women.

At this juncture, we turn to Pan-Africanism as a formal, political movement. The most familiar historical conception of Pan-Africanism as a movement is that which traces the beginnings of its formation to the 1900 so-called "Protest Conference," organized by Henry Sylvester-Williams and attended by William E.B. Du Bois and others to discuss the deteriorating living conditions of people of African origin in London. Although focusing on black London, the concerns addressed were linked to those in other parts of the Africana world, including Africa, where imperialist domination had led to the impoverishment of blacks. Following the "Protest Conference," the first Pan-Africanist Congress was consequently convened in 1919, under the leadership of Du Bois who became the pivot around which ensuing congresses between 1919-1945 were organized.

The 1919 congress launched further protests – even though in the form of appeals – on empire builders, especially in Africa. It also confronted the problem of intensified racism, particularly as manifested through lynching and other forms of violence against people of African origin in America. The second, third and fourth congresses (1921, 1923 and 1927) pursued these issues; but turned more and more to the question of Africa's colonization, culminating in the famous 1945 Manchester Congress. This was the watershed that unleashed the flood of African nationalism on the continent and in the Caribbean, eventually leading to the various independence movements and struggles – be they passive, or armed.

The Manchester Congress was also historic in its inclusion of a small group of workers. The deliberations clearly spelt out the kind of society envisaged. "With the fifth congress it was not enough to have Africa ruled by Africans. Socialism meant that the majority, that is the workers and peasants must rule – that is, the society must be so oriented that it had to fulfill the aspirations of the majority – which was to end poverty and illiteracy" (Essack 1993:27). A number of African delegates at this conference ended up as Heads of State for their respective countries. Among them were Hastings

Banda of Malawi, Jomo Kenyatta of Kenya and Kwame Nkrumah of Ghana. Needless to say, none of them really made history for placing the woman question on their national agenda!

There was a lull between the 1945 congress and the All Peoples African Congress, which took place in Accra, Ghana, in 1958, following Ghana's independence. Kwame Nkrumah will always be remembered for his passion and commitment in advocating the total liberation and unity of Africa. For him, Ghana's freedom was meaningless outside the liberation of the entire continent, and he dreamed of a "United States of Africa." Thus, with Nkrumah as host, the 1958 congress placed particular emphasis on the process of Africa's de-colonization.

Another lull ensued before the convening of the 1974 Dar es Salaam congress, already highlighted in an earlier part of this chapter. As intimated, the question of class occupied center stage and so did the debate on Negritude. This congress took place at the peak of liberation struggles in Southern Africa and thus high on the agenda was the political liberation of Angola, Guinea Bissau, Mozambique, Namibia, "Rhodesia" and South Africa. At least one paper highlighted the role of women and there was a proposal that one of the objectives of the seventh congress should be "to lead the youth with their aspiration and expectations into the 21st century" (Essack 1993:64).

The controversy around the role of the working class within Pan-Africanism has already been alluded to. By and large then, it can be said that interrogators of state-domination at this congress, whether in attendance or in *abstentia,* did succeed in placing on the table some of the concerns that were later addressed by the Kampala congress. This seventh congress, which took place in Kampala, Uganda, in 1994 has already been mentioned and will be discussed in a later section.

From this skeleton outline, it becomes clear that the needs of given historical epochs have shaped the meaning and accent of Pan-Africanism, changing and adding onto its original objectives. It is also important to point out that the main actors credited for the evolution of Pan-Africanism have been men and they have come from the educated elite. Not even Amy Ashwood Garvey, a staunch woman

Pan-Africanist, who was very vocal at the Manchester conference, has received more than a passing mention, mostly oral, in existing male-centered historiography! However, it is the case of Anna Julia Cooper that exposes the level of gender silencing. Recent research on Cooper's intellectual and activist contribution by Janis Mayes reveals that there were two women delegates present at the 1900 "Protest Conference" in London. Anna Julia Cooper was one of them.

According to Mayes' findings, Cooper contributed a paper at the conference on education for women and boys. Surprisingly, this paper was not among the conference proceedings published by W.E.B. Du Bois following the conference. Curiously though, around 1903, Du Bois started writing on women, very much along the same thematic lines as Cooper had addressed in her missing paper. As a matter of fact, she had been talking and writing about these issues for at least twenty years before Du Bois broached them. This is clearly evidenced by her coverage in *A Voice from the South,* Cooper's pioneer work, published in 1892. This silencing, erasure and abduction of women's texts is quite disturbing, as is the peripheral positioning of workers/peasants in Pan-Africanism as a historical movement. The resuscitated project will not move much further than its predecessors unless these imbalances are corrected.

For the time being, it is important to emphasize, in our continuing definition that from the inception of Pan-Africanism, institutionalized racism, which Du Bois once described as the major problem of the 20th century, was a central theme in bringing together people of African origin. "The Africans, this racism insisted, are inferior. They have made no history. They have created no civilization. They cannot rule themselves: we superior Europeans must do it for them" (Davidson 1989:31). It is with this in mind that Magubane provides the following definition of Pan-Africanism: "The Pan-African consciousness has always been a determined effort on the part of black people to rediscover their shrines from the wreckage of history. It was a revolt against the white man's ideological suzerainty in culture, politics and historiography" (Magubane 1987:230). More pertinently, to the current discussion, Magubane points out:

> Pan-Africanism is a living activity and not a fossilized
> doctrine. It is and was men [sic] of Africa and of African
> descent finding their place in a world, which defined them
> negatively and excluded them from the community of
> nations. Pan-Africanism was born and grew in circum-
> stances where the black and the African had no status and
> no country they could call their own (1987:134).

Some might argue that the last sentence is no longer relevant;
even as others might insist that deracination from "home" was never
a concern for continental Africans. However, the general point being
made about the global marginalization of the majority of Africana
people is just as pertinent now as it was in the nineteenth century.
Indeed, the question of who can authoritatively claim ownership of
"home" in terms of economic ownership and self-determination of
African lives and resources crucially interrogates any easy dismissal
of the point under labor, even and especially, under neo-colonial
independence.

From a working class perspective, it can be argued that Pan-
Africanist consciousness has to counter domination especially in
economic terms, recognizing "monopoly capital [as] the leading
element in imperialist expansion", more so today, perhaps, than when
this rallying call was issued (Rodney 1982:176). This point requires
emphasis in the face of theories that would confine Pan-Africanism
to the African American and African Caribbean worlds, under the
contention that the two groups of Africana people needed/need it
more than continental Africans due to their historical deracination
from Africa. The argument is further flawed by the current situa-
tion of mass migrations from the continent, as those who are able to
escape flee economic devastation, swelling the populations of Afri-
cans in the Diaspora at an alarming rate, not to mention migrations
within the continent itself. Uprootment, marginalization, debase-
ment and humiliation continue to be issues of concern among all
global Africans.

Walter Rodney makes a valid, painful point when he observes
the following, concerning the awareness that the forebears of Pan-
Africanism had regarding the negative repercussion of a weak Africa
on their images as people of African descent: "Having realized that

their inferior status in the societies of America was conditioned by the fact of being black and the weakness of Africa, the Pan-Africanists were forced to deal with the central problem of Europe's exploitation and oppression of the African continent" (Rodney 1982). The relevance of this quotation is that in its current perpetual status of crisis, the African continent is as much of a liability to Africans at home as it is to those dispersed around the globe.

Whatever the movement's other shortcomings, Pan-Africanism's insistence on making historical linkages between Africana struggles in the entire world, including the mother continent, is a major strength. Pan-Africanism's contribution to the African independence project will always remain a great historical statement. As is evident from the foregoing, Pan-Africanism as a philosophy has been around for a long time and although emphasis and strategies of realizing the ideal may differ, the task of interrogating white hegemony and supremacy has been a constant factor. In this regard, as Magubane argues: "Pan-Africanism can, in the final analysis be reduced to a challenge to that supremacy, not only in the United States [and other parts of the Diaspora in the West], but globally" (1987:127).

To summarize, then, simply defined, Pan-Africanism can be viewed as a philosophy, or "ideology consisting of two key elements: the common heritage of people of African descent all over the world; and the obligation of African people to work for the interests and the well-being of one another everywhere" (Khapoya 1994:164). As already intimated, it is vital to engage in discussion, addressing the problem with this hegemonic conception of African people. For now, suffice it to say that it is this concept of a common heritage and the need for collective action to achieve the liberation of Africans that have been theoretically and politically evolved to basically define Pan-Africanism over the years. The movement, accordingly, attempts to unify Africana people, searching for a collective solution to their oppression. Whether or not this is an idealistic, unattainable dream becomes a hypothetical question that only a determined historical intervention on the part of all progressive, global, Africana people will have to prove one day.

Selected Case Studies of African American Women and Pan-Africanism

As intimated, in defining Pan-Africanism, it is important to go beyond the theoretical and structural aspects of the philosophy and the movement to the actual essence, or practice. I am arguing here that Pan-Africanism is more than a theoretical ideology, or a formal movement: it is an actual way of life. Looking for the *essence,* therefore, becomes a necessity, if we are to understand the contribution of women, in particular, to the emergence of Pan-Africanism both as an idea and as a social movement. Andocentric silence and gaps in this respect, as well as in women's overall contribution to black history are starkly exposed by, among others, the works of: Davis (1983); Giddings (1985); Margaret Busby (1992); Terbborg-Penn *et. al* (1989) and many more.

The bulk of these works reveals the fact that women were at the heart of the conception of Pan-Africanism as a social movement and that more importantly, their lives have always comprised its lived definition. It needs to be understood that all through history, women have actively and practically, participated in providing Pan-Africanism with its *spirit* and *essence,* particularly at the level of every day activities that shape the values upon which the ideology stands.

Indeed, what the above references abundantly demonstrate is that interventions by various women, in terms of leadership and social organization, were part and parcel of the kind of mobilization that it took to lay the groundwork for Pan-Africanism. The consciousness created by these women's political/social activism built the foundation upon which Pan-Africanism has continued to stand. Indeed, in their vision, most of the women were Pan-Africanists, even though they may not have attended the historical congresses that have thrust men forward as the points of reference in defining the movement.

This chapter perceives the following criteria as central in defining the essence of Pan-Africanism: embracing one's Africanness as a means of negating alienation and denial of human dignity based on racial discrimination; daring to name oneself, in defiance of imposed false constructions by the "other," particularly in the face of racist

stereotypes; rising above individualistic self-interest for the sake of enhancing threatened collective survival and the recognition of the masses as a vital force for purposes of liberation. The few examples that follow will suffice to demonstrate that the best of African American women leaders lived and practiced Pan-Africanism at its best, silences of existing historical narratives notwithstanding.

Paula Giddings records how in the early 18th century, when even *The Liberator,* the then most progressive anti-abolitionist newspaper, took the position that "The voice of woman should not be heard in public debates" *(*1985:49), Maria Stewart, an African American woman, militantly defied that whole patriarchal construction of femininity. She not only gave public speeches on abolitionism, but proved a formidable feminist who denounced the notion that women were responsible for their own degradation, while openly indicting America, *who caused the daughters of Africa to commit whoredoms and fornications* (my italics) and cursing the offender thus: "upon thee be their curse" *(*Giddings 1985:52*)*.

As Giddings observes, for Maria Stewart, as well as other black women abolitionists and feminists of the time, including Sojourner Truth, "when it came to a question of priorities, race for most of them, came first... it was the issue of race that sparked their feminism" *(*1985:55). There has been considerable debate on the question of what should assume precedence for women: nationalism or feminism? However, it is not within the scope of this chapter to engage in that particular debate. Suffice it to say that the two concerns are not necessarily contradictory: it does not have to be a case of "either, or." What needs to be noted here is that in their concern for the collective welfare of people of African origin and the desire to struggle for their liberation, these women demonstrated what I call the essence of Pan-Africanism, defining it through practice.

In the section of her book where Paula Giddings discusses the aftermath of the American Civil War, the role played by women of African origin in reconstructing the devastated black community is extremely important in our continuing definition of the *essence* of Pan-Africanism. The women believed that the black community was in a crisis and that it was threatened by possible extinction through political abandonment and subjection to escalating vio-

lence. I will quote Giddings in order to fully capture the significance of this particular historical intervention:

> Standing on the brink of this racial precipice, convinced that they could save the race, black women saw their role in almost ecclesiastical terms. They were "the fundamental agency under God in the regeneration... of the race, as well as the groundwork and starting point of its progress upward, "wrote Anna Julia Cooper in her *Voice of the South* (1892), one of the best-written books of the period... It was the black woman, continued Cooper, who "must stamp weal or woe on the coming history of this people..." The responsibility was a tremendous one, for as she had told a group of black clergymen six years earlier: "Only the BLACK WOMAN can say 'when and where I enter... then and there the whole *Negro race enters with me*' (1985:81-2).

Even more significantly, beyond this collective perception of themselves as a part of the larger Africana community, black women also clearly "understood that their fate was bound with that of the masses" (Giddings 1985:97). This pro-people consciousness was so prevalent among the women leaders of social movements at the time that even the best-educated, wealthy elites among them – Mary Church Terrell, for instance – subscribed to the philosophy of mass-centeredness. According to her, "Self-preservation demands that [black women] go among the lowly, illiterate and even the vicious, to whom they are bound by ties of race and sex ... to reclaim them." The patronizing tone notwithstanding, one has to appreciate the fact that this communal concern touches on the intersections of class and gender, representing a remarkably advanced position, given the period of history that we are looking at.

There is a big lesson in this as a rethinking of Pan-Africanism takes place. As far as these women were concerned, class privilege had to give way to the collective project of liberating all black people. There is obvious contradiction here since the question of class privilege is economically determined and cannot just be wished away. What is significant, however, is that these elitist black women were aware of the fact that discourse on feminism could not afford to

situate itself outside the collective struggle and vice versa. At the pertaining historical moment, with white feminists pressurizing for absolute loyalty to the feminist cause, while, at the same time, the needs of the race called, this was indeed a strategic and logical position for these African American women to assume. It enhanced badly needed unity within the black community. In connection with this Paula Giddings writes:

> With the black movement now under siege, black women were also very sensitive about the issue of black unity. Ida Lewis, then the editor-in-chief of *Essence* magazine, said in an interview with Eleanor Holmes Norton: "If we speak of a liberation movement, as a black woman view my role from a black perspective – the role of black women is to continue the struggle in concert with black men for the liberation and determination of blacks" (1985:309).

One only adds that this statement is best understood when placed within the context of nineteenth and early twentieth century black activism when black women also enjoyed a lot of support from their black male anti-abolitionists. The best of these were also collaborators in the feminist struggle. Frederick Douglass stands out as the most obvious example. He had no qualms identifying himself as a feminist. This advanced gender position on the part of black male abolitionists is well brought out by Angela Davis in *Women, Race and Class* (1983). In this work Davis also emphasizes the uniqueness of black women in their ability to transcend the many contradictions and moral affectations that oftentimes motivated the actions of their white counterparts. Discussing their contribution to the anti-slavery cause, which, I would add, laid some of the earliest seeds of Pan-Africanism in the Diaspora, Davis writes:

> Unlike white women, however, who had also flocked into the abolitionist campaign, black women had been motivated less by considerations of charity or by general moral principles than by the palpable demands of their people's survival. The 1890s were the most difficult years for black people since the abolition of slavery, and women naturally felt obligated to join their people's resistance struggle. It

was in response to the unchecked wave of lynchings and
the indiscriminate sexual abuse of black women that the
first black women's club was organized (1983:128).

In summing up this section, from the few examples given, one
observes that African American women, representing the best of the
resistance tradition, personified the finest of Pan-Africanist *essence*.
From Harriet Tubman, the so-called "Moses" of the underground
rail road; to Ida B. Wells, the brilliant journalist of the anti-lynching
campaign; to the formidable organizer, Mary Bethune who was as
proud of her African origins as she was assertive of her gender... and
many others, we celebrate the embodiments of the *essence* of Pan-
Africanism, empowering to those who practice it and their com-
munities at large.

In the Caribbean region, the history of women's contribution
towards the nurturing of the Pan-Africanist *essence* and presence is
just as rich. The accounts of resistance organized around *quilombos*
or *maroon* societies and the role played by women to fuel them are
particularly impressive. With women at the center and the various
frontlines, these societies emphasized African culture and spiritu-
ality, using both as tools for resistance, rebellion, self-definition
and empowerment. Examples that readily come to mind are the
already mentioned figures of Nana of the *maroons* and the *quilombo*
women, but there are many others, including Gertrude Gomez de
Avellanda of Cuba, Mary Prince and Mary Seacole. Unfortunately,
the scope of this chapter does not allow for a deeper rendering of
these experiences and contributions.

Continental African Women and Pan-Africanism

The following brief examination of the contribution by conti-
nental African women to Pan-Africanism continues to emphasize
the importance of the *all* or *pan* component in our operational
term. The analysis particularly underlines the fact that in a situation
such as that of Africa where on the negative side of life devastation,
fractured existence and death constitute recurring themes, women's
constant role in reconstructing "home" is an *essence* that truly
embodies hope for Africa's survival. The discussion also highlights

aspects of progressive African cultural value systems that women specifically embody. These provide us with further aspects of *essence* that a re-envisioned Pan-Africanism can borrow from in shaping a progressive consciousness.

The inherent argument here is that under colonialism and neo-colonialism, African cultures have become so devalued that in seeking for meaningful alternatives we do not look for lessons from our living heritages. The tendency to look outside for answers to our problems ends up making the solutions foreign and therefore, short-lived. A progressive *return to the source* in the Amilcar Cabral (1973) sense should be a part of Pan-Africanism's renewed journey in self-search and reconstruction. Elsewhere, I have elaborately argued the need for this progressive return (Mugo 1991a).

Since *zamani* times in Africa, women have been at the heart of cultural production at the material and non-material levels, including the task of generating ideas, shaping expression and socializing the young. Within an orature family set up in most *horizontal* social formations, grandmothers have always held the portfolio of orature *griots,* as have mothers. In this capacity they have enriched their communities as artists at the hearth of African wisdom and as general keepers of nurturing tradition. They have been agents in the task of keeping collective memory alive. All this is significant in affirming and validating values, ethics and aesthetics that have been under attack by histories of colonialism, neo-colonialism and imperialist domination.

Unfortunately, the creativity of African women is being crushed under the kind of precarious existence that this chapter has outlined in the introduction. The inescapable conclusion is that re-envisioned Pan-Africanism will have to place economic liberation high on its agenda if this suffocating creativity is to be released instead of being wasted in the battle for basic survival. In pursuing this proposed alternative, the revisited project will need to do away with *waheshimiwa* orature, which is a product of *kasuku* or state *ululation culture,* both of which are essentially antithetical to the Pan-Africanist *essence* and *practice.* I have argued as follows, elsewhere:

> The abduction of orature through state patronage is a very
> serious cultural coup in the hands of today's African ruling

classes. Luckily, alongside this *waheshimiwa* orature, the resistance tradition or *mapinduzi* orature, is being created in the mines, the factories, the *matatus,* on the farms, in homes and other areas of productive democratic praxis (Mugo 1994:59).

The role of women as the hearts of families and communities and consequently, the *centers* of *home* is another key factor that should be embellished by the proposed reconstruction of Pan-Africanism, taking care not to confuse this with domestication. The search for home, physically, culturally, spiritually and metaphorically is becoming a very painful experience for a lot of people on the African continent. Earlier on, this chapter alluded to the problem of refugees in Africa, the majority of whom are women and children. A new Pan-Africanist consciousness that stresses the primacy and human rightness for "home" as a part of its goal, will address this burning issue and the tragedy of homelessness. A Kenyan Mau Mau liberation song recounts how during the armed struggle people were so united and accountable towards one another for survival that if a bean was all there was for food, it would be split between each and everyone who needed food. The spirit of sharing, materially and spatially, should be cultivated and adopted as apart of the advocated Pan-Africanist *essence* in recognition of the need for co-existence. "I am because we are; and since we are, therefore I am" (Mbiti 1989:106) should be a guiding principle.

Africana women's spirituality has played a big role in history and herstory, going back to *zamani* times. Some of Africa's great female leaders were also resources in community spiritualism. The following easily come to mind: Mbuya Nehanda Nyakasikana, Me Katilili wa Menza, Mihayra Bint Aboud, Yaa Asantewa and many of their Diaspora counterparts. Their spirituality translated into practical, or lived religion, which was an everyday affirmation of life, nurturing the best in humanity. Peripheral existence and the hopelessness that both breed seem to have left huge holes in people's hearts and many of them seek to fill these gaps with either alcohol, hysterical/fanatical religion and all manner of eschatological cults.

During my visits to Kenya over the last several years, I have come to conclude that every second person that I used to know less than

20 years ago has become a "born again Christian." Problems are seen as emanating from the devil, or as resulting from human sinfulness, or as being some form of punishment from God, including the scourge of HIV/AIDS! Many workers and peasants are ready to bear suffering passively, claiming that the return of Jesus Christ is around the corner. The ideological void is so big that something is urgently needed. Pan-Africanism could fill this existing void.

The re-envisioned project of Pan-Africanism should utilize the structure of a women's mass movement as a vehicle for people's mobilization. Silences around women and women's issues require urgent explosion, given their vulnerability under neo-colonialism. Name any deadly calamity and the likelihood is that you will find it at one or the other of an African woman's door. When it comes to enjoying power, the picture is the exact opposite: only a select few occupy positions of power that can influence decision or change. The renegotiated Pan-African project has to redress this imbalance.

In this regard, the Seventh Pan-African Congress should be commended for the concerted effort that it made to engender and democratize participation, thus amending the omissions of earlier congresses. It is, therefore, important that we review the Kampala Congress in some detail, for I believe that it contains useful lessons that could inform the proposed re-visitation of Pan-Africanism. The sources consulted on this congress include: Tajuddin Al-Rahim; Roy-Campbell; Horace Campbell; Global Pan-African Movement's document on Plenary Resolutions and the journal, *SAFERE*.

The most historic achievement of the Seventh Congress was the high profile that it accorded gender and the women's agenda, as well as the emphasis that it placed on mass mobilization. The motto of the congress was, "Don't agonize; organize!" The youth were also given a very special platform. At the conference's plenary session on resolutions, Resolution 9, entitled, "On the Youth and the Future of Pan-Africanism" was passed. It addressed the rights of youth and children, free education, child marriage, physical and sexual abuse, child labor, street children, networking and other matters. A PAYM (Pan-African Youth Movement) was formed and it was agreed that prior to the eighth congress, a special youth congress would be convened. High on the agenda as well were issues such as structural

adjustment programs, environmental control, liberating education and culture, conflict resolution, science and technology.

At this point, special focus on women's participation is called for. The congress was preceded by a women's pre-congress meeting, which registered 300 people, of which 74 percent were women. In their deliberations, the women stressed the fact that for Pan-Africanism to be of relevance during the 21st century, it had to purge itself of male-centeredness, which had characterized it since the movement's formation. Throughout the congress, women met on a daily basis to discuss strategies for forming the PAWLO (Pan-African Women's Liberation Movement) to facilitate mobilization and organization around women's issues on the continent and in the Diaspora. The principal aims of PAWLO are:

1. to promote solidarity between women, by building an umbrella organization uniting women and women's organizations that have a Pan-African agenda;
2. to provide fora through which women can bring about effective changes to their lives in a democratic and emancipatory manner; and
3. to equip women with the knowledge, expertise and confidence to challenge all structures of oppression (Roy-Campbell 1996:142).

Specific aims include:

- Increasing women's awareness of their ability to resist all forms of oppression as well as providing the necessary support services to assist them in their resistance;
- Providing a forum for women to consider issues which have a direct impact upon them and hinder their ability to effectively participate as equal citizens in the society; and
- Rewriting African women's history with an emphasis and focus on women as agents rather than victims of history.

The concerns that PAWLO has identified for immediate attention are: "culture, environment, youth and children, law and human rights, political education and participation, education and training, health and welfare agriculture, refugees and migrants, research and documentation and science and technology."

All over the world, Africana women are at the forefront of those who are advocating Pan-Africanism, but they are also insisting that it must be redefined so as to place them at the center of its reconstruction. Speaking of black women in Canada, Glenda Simms observes: "Marginalized socially, economically, culturally and politically they must forge a new consciousness from fractured identities" (1995:33). Nicola McLaughlin is even more elaborate and emphatic in defining the need for a Pan-Africanist, internationalist coming together:

> With all our diversity, we are bound by a common commitment to a qualitatively enhanced future for the living and the unborn. For we recognize that, as black women, we are disproportionate victims of the world economic order, environmental degradation, disease, and narcotics. We are evidence that the intercontinental black women's consciousness movement realizes that our individual and collective strength mandates crossing borders of many types, connecting, and nurturing our bonds to each other - whether we be indigenous women, Southern women, Northern women, racially oppressed women, rural women, refugee women, or women of different ages, with varied personal histories, and belonging to diverse religious faiths, political ideologies, social classes and cultures (ibid: 59).

The Pan-Africanism here is internationalist in thrust, but clearly conscious of the black woman's unique position and role in history. The message here is also ideal for women situated in Africa, where the borders have come to represent division instead of connoting diverse locales from which people can launch a chorused liberation program. The new Pan-African consciousness must inculcate in its adherents the urgency of a psychological re-mapping of Africa to collapse existing divisive borders. This gains importance when one recalls how randomly African borders were drawn at the Berlin

Conference of 1894-95 as Western nations scrambled for every inch of the continent. People are defying these borders, practically and metaphorically on a daily basis.

Women traders all over Africa have become experts in border crossing and defiance. Not all the ECOWASs, (Economic Community of West African States) or the EACs, (East African Commission) or the SADCs (Southern African Development Community) of African economic conception can contain these mass traders. It can be argued that the people have learnt to redraw the borders, as it were, or to simply defy them. This is not surprising, for, in the final analysis, the regional organizations surrounded by these borders end up servicing their systems of bureaucracy more than benefiting the masses whose economic interests they claim to represent.

Undoubtedly, then, one of Pan-Africanism's challenges remains the redrawing of borders at the geographical, regional, national, cultural, psychological, linguistic, ethnic, class levels and so forth. If the globe has indeed turned into a metaphorical village, what stops Africa from turning itself into a homestead? Why not? Is it not abundantly clear by now that division is not the answer? Is it not obvious that the small class of affluent ones can achieve nothing for Africa in the absence of the majority? It is this chapter's contention that the family and homestead metaphors may provide a lot of answers, if not all. There may even be some slim hope that perhaps if Africa were to adopt a "family" vision, maybe all the well-to-do "fathers" and "mothers" who now constipate themselves with over eating, while children around them die of starvation might be struck by a sense of shame. They might come to understand that starving Africa's future generations is tantamount to committing senseless genocide.

Conclusion

This discussion has provided the background against which a fresh call for Pan-Africanism is occurring. Demonstrating the elusiveness of a binding definition of Pan-Africanism, the discussion has nonetheless revisited selected attempts to formulate a descriptive exposition of the various strands of philosophical and ideologi-

cal ideas represented by the concept. Following this attempt and taking care to show the interrelatedness between Pan-Africanist theory and lived Pan-Africanism, termed *essence,* the discussion has briefly surveyed the contribution of selected African American women who have herstorically demonstrated this. Using the case studies to justify the point under labor, the chapter has called for greater recognition of and stress upon essence and practice – which highlight the contribution of women, generally silenced by male-centered history. The last section has turned to the African continent, showing the role of women within the orature cultural framework, while distinguishing between progressive and backward strands. Highlighting creative values, the chapter has suggested that these could be used in the reconstruction of Pan-Africanism.

Thus, we ultimately conclude that Pan-Africanism is desirable in today's Africa. However, Pan-Africanism will have to be reconstituted such that it addresses current needs, trends and developments. Most importantly, the task of evolving an extended all-embracing definition must involve women, youth and the masses of Africa's societies. As a matter of fact, in their fight for democratic space and empowerment, black women are already and increasingly turning to Pan-African solidarity as a feasible alternative to externally imposed solutions. Only, they are demanding that they be placed at the center of the re-conception process and will not accept mere token "inclusion."

Pan-Africanism will have to be a long-term project. To be realized it will require the collective will and resources of the global Africana community. This chapter submits that if black women, globally, were to sponsor Pan-Africanism and turn it into a mass movement as a tool for advocating their collective liberation, the world would be forced to pay serious attention to their words/needs. Last word: given the crises facing the mother continent, African women should spearhead the launching of a truly gendered, mass-oriented, youth-empowering, re-envisioned Pan-Africanism.

Part IV

DEMOCRACY, EMPOWERMENT AND CONSTRUCTION OF NEW SITES OF KNOWLEDGE

Chapter 10

Advocacy for Empowering the Masses: Translating Rhetoric into Action

The bulk of current debates on the question of democracy, especially in the Northern hemisphere, have tended to equate the process of democratization with the establishment of free market economies and in particular the USA, where since the presidency of Bush, official US policy has designated the United States of America as the measuring rod for global democracy and the barometer for ideological direction. Generally speaking, attempted enforcement of this advocacy has not taken much trouble to examine the specific socio-cultural or historical contexts of given countries in order to determine the manner in which the proposed Northern hemisphere or US democracy projects are to be inserted into concrete, existing foreign realities. Yet, historical experience, cultural understanding of phenomena and the need to involve the majority of given populations in determining the way forward would appear to be crucial, indeed, indispensable ingredients of the democratic project, if any lasting change is to take place.

This chapter moves from the foregoing premise to posit that, in the final analysis, it will not make much of a difference what kind of political systems we introduce in Africa – one-party, multi-parties or military dictatorships – as long as we continue perceptualizing power the way we do at the moment, as the monopoly of the educated, the powerful, the wealthy and the commercial élites. What

complicates this situation even further is the fact that a lot of those who comprise these constituencies often operate as extensions of foreign domination. Bluntly, then, as long as the empowerment of the masses is missing, as long as political rhetoric pre-empts true action on the part of the masses towards individual and collective self-determination, no genuine democracy will have taken place in Africa. The chapter proposes that the ordinary people of Africa must reclaim their denied freedom of action and the right to determine changes affecting their lives, without which they will remain pawns in the hands of the political elite. The chapter further advocates that for true democracy to take root on the African continent, the process must address the economic conditions under which the majority lives, even as it advocates civil, political and human rights. Lastly, the discussion outlines possible activities for the conscientization and empowerment of the masses, as they struggle for their democratic rights. The activities are proposed under the assumption that the democratic process is an ongoing undertaking that needs to be routinely reinforced, as opposed to being a one-time event accomplished at the stroke of a pen.

Before looking at concrete ways in which the empowerment of the masses can be effected, we need to analyze how their agency was subverted, or lost, in the first place. The task of understanding the origins of our woes is vital to the search for their remedy. To do this, we will look at the historical role that the masses have played in negotiating for democratic space from antiquity through colonization to the present, demonstrating, in the process, that the concept of democracy is not a foreign importation to Africa.

Antiquity and Ancient/Zamani Periods

Here, antiquity, ancient and medieval times, or *zamani*, to use John Mbiti's (1969) time reckoning, represent the general period that is referred to as "pre-colonial" by those who use colonialism as the landmark of African history. During this period in Africa, most groups within a given community/society had access to human rights' advocacy, however imperfect their political systems may have been and however faulty the avenues used might appear under interrogation. This was the case whether one is referring to matrilin-

eages, patrilineages, or to use Cabral's terminology, *vertical* societies or *horizontal* ones (Cabral: 1973). In making this observation, one neither seeks to generalize on issues nor to engage in idealizing the past. There were, of course, exceptions to the rule, especially if one evoked such discourses as patriarchal domination, sexism and the disprivileged status of the youth, particularly before puberty. But then, these concerns are inherent in most cultures even today.

To return to the issue at stake, let us take the family institution as an illustration. Whereas one observes that the politics of patriarchal control privileged the adult male, often condoning dictatorial practices on his part, especially as head of the household, on a closer look it becomes clear that his authority was not absolute. Lest this be misconstrued as support for patriarchal control, however, let me say from the start that the practice of privileging men, which continues to the present, should not only be denounced but identified as a part of Africa's political problem, seeing the mess that the predominantly male leadership has made of the continent. This done, it becomes important to point out that, having created the beast, cultural control also ensured that the man did not operate as a dictator, who was above the law. Through various mechanisms of power control, such as delegated agency, peer criticism, maternal counsel and so on, the society was assured that male authority was questioned when acts of tyranny and dictatorial practices threatened the interests of those around him. For instance: a mother could intervene on behalf of her child; aunts and uncles often spoke up for offended nieces and nephews; initiation sponsors defended the interests of their ceremonial charges, etc. The process continued at the political level: age groups guarded the rights of their members; clan heads represented their lineages, and elders protected the integrity of the community.

To arrive at a decision that affected the entire community, a lot of deliberations and negotiations had to take place. Extended *palavers*, lasting days and even weeks, if need be, were part of the democratic practice of the time. They took place at family, clan, community and societal levels, depending on what the deliberations were about. The system ensured that those who presided over such discourses were honorable individuals (mostly men, unfortunately, even though

some societies recognized women), chosen by their communities. Those under censure were allowed space for self-defense, and most decisions were arrived at through consensus.

One reiterates the fact that the foregoing is not an exercise in the idealization of *zamani* African political systems, which, as intimated, were plagued with contradictions such as patriarchal domination, gender discrimination and the peripheralization of youth. It is, however, a firm assertion that democracy existed and operated under indigenous set-ups, especially horizontal ones. The advent of colonialism eroded rather than promoted African democratic customs and practices.

Colonization and Democracy

The violence with which agents of colonization invaded Africa was accompanied by such extreme abuse of human rights for the colonized that the perception of so-called "Western civilization" as an agent of democracy becomes an ironic contradiction in terms. It should also be kept in mind that colonization and the carving up of Africa at the Berlin Conference in 1884-85 followed the trans-Atlantic slave trade, in the course of which Africans were subjected to a holocaust unequalled in history, at the level of numbers alone. Various sources estimate figures raging from 20 to 100 million lives (e.g., Rogers 1961; Williams 1961).

Under colonization, African political and cultural institutions were forcefully dismantled and replaced with foreign ones. Land was confiscated, especially in colonies where the colonizers set up settler economies. The colonized had no voice, except through imposed leaders who served the interest of colonial governments. Thus, ordinary African people lost their freedom of action, as colonialism engaged in the deliberate creation of a small group, or class, of privileged people to help them in robbing the former of their democratic rights. This was done through government, missionary and private educational institutions, which were structured to produce either a collaborating elite, or at best a minority that functioned as a buffer between the colonizers and the colonized. In a lot of cases, the colonial governments succeeded in this "divide and rule" tactic; in other

situations they miserably failed, as the targeted privileged community of elites broke ranks, identifying with their people's struggles.

With the exception of a very small percentage of Africa's intelligentsia, since the advent of colonialism the elites have essentially constituted a breed of "spoilt children," who have come to conceive power and their assigned role as the representatives of the masses as their inalienable rights. This elevation of the African elite was actively nurtured by colonialism through an educational system that designated them as special people, who were required to prove that they were different from their own kind in order to pass as "civilized." The more successfully they parroted the colonizers, the greater the privileges they were allocated. They were trained to be loyal servants of the colonial government and specifically groomed as leaders of their communities even though increasingly alienated from these. In trust and blind adherence to the spirit of collective responsibility, the masses, on their own part, made the mistake of surrendering power to these "representatives," only to find themselves habitually betrayed, when it came to the pursuance of self-interest.

The unprincipled jostling for power that has characterized elitist leadership in Africa demands that the masses cease to disempower themselves by becoming too dependent upon and confident in the mentorship of the privileged classes. In hindsight, it becomes clear that some of the antidemocratic woes that plague African masses today can be traced to the tradition of creating gods and goddesses out of their educated elite. This was the case during the era of colonial domination, through the euphoria of national independence and, currently, under neo-colonial dictatorship, reaching the point where it has turned into a virtual veneration cult. In some countries, to imagine the death of the president is to commit a treasonable offence, and to use the term "president" for anyone other than the head of state is to engage in sedition as was the case in Kenya under the dictatorship of President Daniel arap Moi.

Neo-Colonialism and Democracy

The cult of creating deities out of political leaders becomes especially relevant when we look at the institution of the presidency

in Africa, which, under neo-colonialism, has come to symbolize dictatorship. Led by the reactionary and liberal classes of elites, the African masses became accomplices in elevating their presidents to positions of omnipotence, thus abdicating their rights to criticize them and even to vote them out of office for abusing power. The presidents' omnipotence was reinforced by a culture of sycophancy and groveling worship that called for absolute obedience and submission among the followers. Language, songs, dances, and mannerisms were evolved to express the new cult of presidential worship, which translates into a culture of self-debasement on the part of the worshippers. Writing from Brazil, theorizing on the "culture of silence" (Freire:1973) might as well have been analyzing the African situation. Those of the heads of state who sponsored this cult and culture began seriously to view themselves as living deities, embracing such titles as "President for Life", "the Almighty" (Mtukufu), "Our Father", "Father of our children," " the wise one" and so on. Swelling with flattery and drunk with a false sense of their immortality, such heads of state turned into absolute dictators: tyrants who would not tolerate criticism, because they perceived themselves as being above the law. Some of them even changed their nations' constitutions in order to underline the infallibility they had assumed.

In the economic sphere, neo-colonial dictators have turned African nations, their wealth and resources into private monopolies, if not their private backyards, unilaterally owned and controlled by them, with the aid of a handful of loyal followers. In league with multi-nationals and foreign-controlled businesses, most of these leaders have amassed so much wealth that what they own could keep their poverty-stricken countries provided for over long periods of time.

Obviously, the neo-colonial leadership does not consider itself accountable to the electorate and only comes to the people when faced with a crisis that requires the latter's support. The masses must demand this accountability, insisting that action matches the rhetoric that we hear so much from the leadership, especially around election time. Those acquainted with the African political scene are witnesses to the fact that the masses suddenly turn into VIPs during voting seasons. Needless to say, the VIP-ship only lasts until the elec-

tions are over to resurface once again next election period around. At such times, even the omnipotent presidents pay lip service to the people, as they campaign for their parties and for themselves, except in situations where they have installed themselves into power for life. At election time, therefore, these normally unapproachable politicians suddenly turn into the people's "servants," sometimes even having their audience believe how reluctant they are to stand for elections, but feeling duty-bound to do so due to the pressure from the electorate.

Instead of encouraging the people to fight for their democratic rights, the neo-colonial culture of repression leaves the masses exposed as victims of this trickery. As a result, the masses have, as it were, abandoned the driver's seat and become passengers in a recklessly driven vehicle, over which they have no control. The only sure way for survival now is to stop the vehicle and either liberate the driver's seat or choose alternative transportation. Question: how do the masses become sufficiently mobilized to empower themselves and do away with the rhetoric that constantly deceives them that they have democratic power when the reality points to the contrary?

The Empowerment of the Masses
for Democratic Change

It is reiterated that without economic power, there can be no meaningful democratic participation on the part of the masses: civil and political democratic rights can only be tokens, as they remain under the control of wealthy patrons. This argument is well made by Selby, among other advocates of economic democracy, when he identifies self-determination and the right to life as basic human rights: "The right to life is the most basic of all, for without it all other rights are in jeopardy" (Cited in Mugo;1991). Going from the same basic premise, the Catholic Institute for International Relations criticizes in its publication *Rights to Survive – Human Rights in Nicaragua*, "Western-style democracies" for not taking "economic and social rights as seriously as political and civil rights" (*ibid.*) The publication proceeds to argue that "Without the fulfillment of basic needs and the protection of life... the other rights

cannot be enjoyed" (*ibid.*) Pursuing the same theme, a publication by Jobs and Skills Program for Africa, entitled "Basic Needs in Danger," observes as follows:

> The basic needs approach is a reminder of one of the most fundamental objectives of development: to provide every human being with the opportunity for the full physical, mental and social development of his or her personality (ibid.).

This discourse is of significance to development agencies working within the African context in that they should take it as a challenge to translate the recommendation into action by becoming advocates for the economic upliftment of the masses. The task is particularly urgent, given the current wave of apocalyptic religious beliefs that instill resignation and apathy among the poor by encouraging them to accept their suffering and poverty as the will of God and to look up to heaven for answers. Many politicians make use of this gullibility, conditioning the masses to accept fatalistically their underprivileged position as the ordained order of things. Under these circumstances, the masses are tempted to give in to despair and to take the least of their democratic rights as gifts and privileges from the government. Development agency workers should act as animators and agitators, linking physical development with individual and collective human development, which cannot occur outside the struggle for self-determination.

As Walter Rodney insists in *How Europe Underdeveloped Africa* (1972), no country has the right to claim that it is developed, as long as the majority of its citizens live on the borderline of poverty and mere existence, characterized by a lack of mental, spiritual and psychological growth. He emphasizes that, as the key resource for development, the people and their welfare come before all else.

One of the measurements that development agencies should insist on using in gauging the success or failure of their efforts is the extent to which they have managed to transform human resources, empowering them as agents for change. In doing this, they should allocate children, the youth and women a special place, for these are the forgotten majorities in Africa, and yet, they hold the key for the success of the developmental process. In connection with this, the

masses should be made aware of the contents of the Banjul Charter, to which their governments are signatories. The document places special emphasis on democracy, human rights and the question of self-determination. Indeed, in recognizing the importance of material well-being and the centrality of people as the key resources for development, the Banjul Charter ends up making a more profound statement than the United Nations Charter. It condemns systems and institutions that thwart democracy, some of which, even though supposedly extinguished, still linger on, assuming new forms: colonialism, neo-colonialism, apartheid, Zionism, foreign military bases, racism, ethnicity, sexism, linguistic domination, religious chauvinism and so forth.

Development agencies should devise ways of using this document for raising the awareness of the masses in an effort to make them aware of their legal and other rights. Ignorance is the best recipe for ensuring the domestication of oppression and the breeding of false consciousness, because once these are internalized, the oppressed involuntarily grow to accept their conditions as a normal state of affairs. By evoking the contents of policy documents, even though they too may contain a lot of rhetoric, the masses would be holding their governments accountable for the inhuman conditions they live under. Demonstrations against the contravention of these public documents would expose the offending governments to the Pan-African and international communities, levels of exposure that most regimes dread. The International Human Rights Day would be an ideal occasion for focusing on the charters, thus linking democracy to human rights – a connection that must be insisted upon. Other methods, through which this kind of raised awareness can be achieved, are outlined below.

Practical Activities for the Empowerment of the Masses

A selected sample of such activities includes the following:

1. Using the people's indigenous forms of knowledge and incorporating these into development projects whenever possible, e.g., environmental conservation, education through the

use of orature, methods of healing, traditional nutritional knowledge, etc.

2. Educating the masses and women in particular, to refuse acceptance of misery, poverty and oppression as their lot or as divine will. The efforts might mean targeting churches, mosques and other religious platforms, as well as collaborating with progressive clergy, to sponsor programs through which this internalization of exploitation can be discussed. The use of adult education has been known to produce new men and women who end up reclaiming their denied freedom of action and democratic space in the development process.

3. Literacy classes and community theater projects have also been proven as some of the most effective methods for individual and collective conscientization. A good example is Zimbabwe, where women's and youth's creative writing groups have mushroomed all over the country during the last decade and are proving to be very effective means of promoting self-articulation, which is essential in the process of naming ourselves, our problems and our achievements, further carvings of democratic space.

4. Providing all forms of support for the establishment of alternative media, however humble these efforts might be.

5. Lobbying for the inclusion of democracy as a subject in schools' and colleges' curricula. To lead to this, the planning of national workshops, during which selected teachers are trained to mount the project, would enlarge the team of lobbyists. Educational radio broadcasts are other means of reaching more community practitioners. Alternatively, the sponsoring of book projects, which involve the writing of materials on democracy by educators or learners, would serve a similar purpose, even though targeting a smaller audience.

6. Supporting mass-based self-help projects, co-operatives, workers' and trade unions, community organizations, etc. Historically, it is groups such as these that have been most instrumental in spearheading struggles for democratic change.

7. Organizing annual cultural festivals that focus on democracy as an umbrella theme.
8. Lobbying for the declaration of a global democracy decade, similar to the women's decade.

In these and other projects, women and youth should be the major targets. The alienation of both groups from power, control and the direction of development policies must be brought to an end, as must the silencing of them, which has left them in the background of historical action. The irony of all this is that in reality, it is the women who translate developmental policies into concrete progressive change, because they do most of the work, while without the youth, Africa's future is threatened by a void.

Finally, let us revisit the adage that like all other forms of change, the democratization process is an ongoing, long-term and even lifetime undertaking. It must also be emphasized that democracy is not given: it is a basic human right. Development agencies need to adopt these notions as mottos and to cultivate long-sightedness in installing their projects, even though crying needs will always demand immediate action, which may dictate short-term solutions. Further, agents of democracy must be guided by faith in the people whom they work with, as well as in their inherent capacity to change their worlds, given the means, the skills and the chance. The notion of creating or imposing development for people is antithetical to democratic practice. Above all, people must be their own primary agents for the achievement of progress and development. An outsider cannot liberate people, unless they are sufficiently aware to seek their own liberation. Consequently, the most democratic projects will remain those that produce wholesome, fulfilled human beings, equipped to chart their own futures.

Chapter 11

MEETING POINT BETWEEN BASIC, SUBSIDIARY AND PEOPLE'S RIGHTS: LESSONS FROM AFRICAN ORATURE

This chapter addresses the topic, "Meeting Point between Basic, Subsidiary and People's Rights: Lessons from African Orature." I teach African Orature in the Department of African American Studies at Syracuse University as one of my areas of interest because it is a crucial part of indigenous African systems of knowledge. Indeed, I have been teaching African Orature for quite some time now as a deliberate statement regarding the significance of perceiving Africa as a site of knowledge, even though global constructions of what constitutes intellectual work have tended to marginalize such African paradigms. This intervention becomes critical to today's forum because we cannot champion rights for African men and women and yet continue to marginalize the very channels of communication that the majority of them use in order to articulate their understanding of what constitutes human rights. I am arguing, quite simply, that we need to "return to the source," to use Cabral's (1973) terminology, in order to listen to the people on whose behalf we are speaking. We need to hear how they perceive and interpret human rights as well as what they expect from them. At the expense of belaboring my point, the argument is that in turning to African Oracy and Orature, we make contact with ordinary African people's discourses. Now, since it is these men and

women whose rights mostly suffer violation under neo-colonialism and imperialism, the responsibility of including their modes of self-expression becomes urgent if we are to avoid the danger of leaving serious, indicting gaps in our own text, not to mention the risk of committing the academic "crime" of silencing the very narratives of the subjects of our human rights advocacy.

At this point, it is important that we define African Oracy and Orature as indigenous systems of knowledge. According to Pio Zirimu and Austin Bukenya (1987), oracy refers to "the mastery and effective and productive use of the spoken word." It is an art form used by orators, oral artists and other highly skilled orate communicators who operate within the verbal tradition that constitutes the main heritage consumed by the majority of African people, especially in the rural areas. Through it, indigenous African knowledge experts preserve and communicate verbal texts of history, law, philosophy, politics, religion, orature, economics, etc., analyzing them from specific intellectual perspectives that reflect their authentic reality. Orature, the verbal art of oracy, which employs language and performance to create stories, legends, myths, family histories, poetry and drama, is a key branch of oracy. Zirimu and Bukenya (1987), consequently, describe orature as one of the best manifestations of oracy in action because, according to them, the composition and performance of a competent piece involves great skillfulness in imaginative, technical and organizational abilities. I would add that such a text is characterized by artistic depth, complexity and sophistication.

In *African Orature and Human Rights,* I have demonstrated how Oracy and Orature compositions constantly express human rights concerns (Mugo 1991a). I have also discussed the extent to which societies creating the narratives embodied by them either reinforce or neglect human rights while analyzing their conceptualization of what constitutes human rights for the individual and the group. We will return to this later. For now, it is important to address the concepts of "basic," "subsidiary" and "people's rights."

In the document, *Right to Survive: Human Rights in Nicaragua* (1987), "basic rights" are related to "economic and social rights," while "subsidiary rights" are perceived as "political and civil rights."

The document observes that "Western-style democracies have never taken economic and social rights as seriously as political and civil rights." It proceeds to argue: "It is not claimed that subsidiary human rights are unimportant, simply that basic human rights are logically and morally prior to the rest. Without the fulfillment of basic needs and the protection of life and personal security, the others cannot be enjoyed." The concept of "people's rights" comes from the Banjul Charter, entitled *The African Charter on Human and Peoples' Rights*, an Organization of African Unity document. While advocating what might be described as "universal human rights," the Banjul Charter evokes specific situations relevant to Africa, such as colonial and neo-colonial legacies (I would add, military regimes and dictatorships), "in which the masses are relegated to the periphery of historical focus and recognition, enjoying only a few, if any, human rights at the hand of imperialism." It advocates, among other actions, the need to "coordinate and intensify... co-operation and efforts to achieve a better life for the peoples of Africa," highlighting the "linkage between economic development and socio-political development." To use its exact wording: "civil and political rights cannot be dissociated from economic, social and cultural rights in their conception as well as universality... the satisfaction of economic, social and cultural rights is a guarantee for the enjoyment of civil and political rights."

The emphasis on the centrality of "basic rights," which does not mean a de-emphasis on "subsidiary rights," is crucial within an African and "Third World" context, debatable as these basic operative terms might be. However, because they are so intertwined, it is clear that we cannot and should not, separate them either. The world of African Oracy and Orature, which insists on a holistic conception of reality as opposed to a compartmentalization of phenomena, is abundantly clear about this as will be demonstrated shortly. Before this, however, a practical illustration is relevant.

Let us take a hypothetical, though realistic, situation in an unspecified African country that operates as a military regime or police state, under one of these dictators who has appointed himself "Life President" by decree. Domestic political activism and international pressure have forced the dictator to "allow" multi-party

elections to take place after several decades of despotism. Time for elections has arrived. We are located in one of this country's big impoverished urban slums, or in a poverty-stricken deep rural village. A worker/peasant has to walk for five miles to cast a vote because s/he cannot afford bus fare. S/he is so weak with hunger that s/he simply cannot make it to the voting booth. Economic deprivation has robbed this worker of the right to vote. In another part of the city, or village, there is a well-fed political activist, but the night before voting day, s/he is arrested under trumped up charges and is locked up. S/he too is deprived of the right to vote. However, let us push the analogy further. If the condition of the hungry worker/peasant persists, death may result and, in this case, life, a basic right, will have been violated, with irreversible consequences. On the other hand, unless the well-fed activist is killed in jail, s/he is more than likely able to hire a lawyer and at some point get out of jail (even if a short term is served), returning home to vote next time around. In this illustration, the moral of the story is that whereas separation of rights is both artificial and undesirable, the violation of "basic rights" may lead to a situation in which the victim is not alive to assert other rights. In the African situation, and indeed universally, those who enjoy "basic rights" often have more access to other forms of freedom than do the economically deprived. For me, ensuring, practically, that the poor and powerless enjoy the quality of human rights "reserved" for the rich and powerful under capitalist or neo-colonial conditions is the real test facing global democracy.

Human Rights Symposium

In this respect, it is instructive to note that the United States of America, which purports to be the model democracy of the world, has a long way to go in achieving this ideal. A case in point is the fact that America ratified the Declaration of Human Rights except for the article that gave the United Nations the right to declare a country as being in violation of human rights if it denied its natives basic human rights. That protocol was seen by America as being applicable to the plight of first nations people (Native Americans). Signing it would have had obvious implications, given

the many aspects of "basic rights" violations, such as dislocation of first nations people from their land, their disadvantaged economic status and so on.

Understandably, then, the South and other economically exploited parts of the world place great emphasis on the International Covenant for Economic, Social and Cultural Rights. As stated, the Banjul Charter does a similar thing by underlining "peoples' rights." Focus is on the quality of life among people rather than on property, abstract ideas, and "bourgeois rights," which normally give top priority to protection of their class members as owners of wealth and power.

Given the "progressive" thrust of the Banjul Charter, which in my view is an improvement over the United Nations Declaration of Human Rights, it is ironic that the African continent has experienced some of the worst forms of human rights abuses that have violated both "basic" as well as "subsidiary" rights. However, I would still hold that the existence of these documents as official records is vital, in the same way as the illegalization of apartheid was a great watershed in the struggle against the violation of majority human rights. This argument holds even though apartheid-like economic conditions may still exist today for the majority of African people. In this regard, one of the most encouraging things about Beijing for me was the connection that a lot of women's discourses made between economic exploitation and other forms of gendered oppression. We have to applaud women from the South for their insistence on this perspective and for the refusal to compromise on it.

Now, taking into account the broad framework of reference set up above, let us return to African Oracy and Orature as instructive systems of knowledge as well as practical paradigms from which advocates of human rights could usefully draw in their work. First of all, it is most pertinent to emphasize that, whereas we can generalize on aspects of oracy and orature in Africa, given the vastness as well as diversity of the continent, it is necessary to particularize the conception and usage of both concepts. It is also important to point out that, whereas the bulk of oracy and orature texts are progressive, there are forms that can be described as reactionary, especially in terms of ideological and gendered visions. I will, therefore, limit

myself to Kenya and specifically to the Ndia group of the Gĩkũyũ people, who live on the slopes of Kirinyaga (Mount Kenya), as it was there that my research, presented in *African Orature and Human Rights* (1991a), was conducted. Moreover, given the space limitations of this discussion, I will invoke only the progressive aspects of Ndia orature and oracy, limiting myself to a brief examination of their communal worldview and what it teaches about the possible advantages inherent in this holistic vision of conceptualizing human rights.

During *zamani* times, Ndia society was, in socio-political formation, horizontal. Now, although colonialism officially destroyed and prohibited this indigenous arrangement/system, substituting colonial rule with its accompanying institutions of coercion, the actual lived practice of Ndia horizontal cultural ethos was never dismantled. In spite of Christianity, colonial education and an imposed foreign legal system, the worldview of Ndia oracy and orature has maintained continuities from, as well as self-redefinitions of *zamani* reality, even where the changing dynamics of culture have given birth to new or different expressions. It is, therefore, safe to generalize and say that, among the Ndia, society was conceptualized (and by and large continues to be understood) in terms of a theory that I have analogized as an onion structure. The onion structure theory captures a worldview in which the existence of the individual, the collective group and the world around them are so intertwined that they constitute an indivisible whole. At the center of this world, we have a nucleus, or core. This "small" but critical and defining center or nucleus is the individual. The individual is surrounded by the immediate family, then the extended family and around that, the community. The community is surrounded by a wider circle of society at large, beyond which is the wider world. These "circles" or "rings" of human existence are surrounded by those of the ancestral spirits, the deities and beyond them, that of the supreme deity. Always close to the human world is the world of nature and the far away, world of the unknown. All these "circles" and "rings" constitute layers upon layers of accumulating meaning, increasing solidity and cohesive completeness. They are concentrically related, operationally interconnected and functionally interdependent. They

maintain tight contact with each other in an effort to preserve their wholeness. To remove one layer is to make the structure suffer from incoherence and lack of solidity. Similarly, the human world must handle the various "worlds" that are around or adjacent to it (those of the ancestral spirits, the deities and nature) such that a sense of harmonious co-existence reigns. If this is neglected, all existence runs the risk of stepping out of measured rhythm and the outcome is chaos. In this conception of reality, each form of existence is a force and possesses an integral life of its own that has a right "to be." This applies to the ancestral spirits as well as to the natural world. Animals, rivers, trees, mountains and so forth are all forces that have life. One entity may use the other, but in the course of doing so, it must avoid collision, antagonism and destruction of the rest.

Proverbial language and greetings are the best expressions of this desired harmony. Greetings, for instance, are prolonged and "circular" in form. The originator of the greeting will ask: "How are you?" The person responding answers: "I am well," and then asks, "And you, are you well?" The greeting then goes on to ask about the "wellness" of other concentric circles: the family, the extended family, the weather, the crops, the world at large, and so on. This pattern of greetings is typical of Ndia people, as it is of the Baganda of Uganda and the Shona of Zimbabwe, for instance. Among the Shona, the greeting is instructive of the depth of desire for this collective well-being of persons. The originator of the greeting asks the Chishona equivalent of "How are you?" The respondent answers, "I am only well if you are well." The ideology behind this kind of reciprocal concern in the majority of African cultures has been best summed up by John Mbiti under the notion of a binding African philosophy of life: "I am because we are and since we are, therefore I am." In this conception, one is one's brother's or sister's keeper, to reverse Cain's biblical retort, "Am I my brother's keeper?" when God reportedly asked him the location of the brother he allegedly killed.

I am arguing that these connected and interrelated relations and the affirmation of one another as human beings may very well be one of the philosophies that we want to emphasize as we look at ways of asserting individual and collective human rights. Wole Soyinka (1972) echoes this approach in his book, *The Man Died*,

when he asserts something to the effect that "the man dies in each one of us who keeps silent in the face of oppression." That is what the *zamani* worldview of African Oracy and Orature teaches us. It is a cultural contribution that Africans can bring to the conference table of human rights discourse, where they often sit as students of Western formulations. Indeed, sectors of the Western world have started borrowing from some of the positive wisdom of African Orature, quite untypical of their colonial fore-parents. For instance, colonial missionaries called it "animism" when those that they colonized described rivers, rocks and trees as having life. A few years ago, the first lady of America, Hillary Rodham Clinton, even used an African proverb, "It takes a village to raise a child," in one of her talks about the collective responsibility of rearing children. In *zamani* times, this same philosophy ensured that no children were labeled "bastards" or rendered homeless. Among the Gĩkũyũ people, during the Mau Mau armed struggle, there used to be severe food shortages, so the freedom fighters composed an orature song urging any individual who came by a single bean to have the love to split it among all those around him/her in a spirit of sharing. Later, communities created *harambee* (self-help) developmental projects in which communities pooled their efforts, skills and financial resources in order to build schools, bridges and roads. They sought to ensure individual as well as collective survival and growth. One could go on providing positive examples of *zamani* oracy and orature ethics. Suffice it to say that some of the most successful historical moments in asserting human rights for all on the African continent have been those that have been inspired by the described collective vision, informed by a spirit of accountability between the individual and the group.

In neo-colonial Kenya (re: Africa), the *harambee* spirit has been replaced by individualistic grabbing of wealth by the powerful. Recently, human rights activists have had to hold demonstrations against the appropriation of public spaces by the ruling class. The president of the country, Daniel arap Moi, has been reported as being behind the allocation of public parks, forests, and even graveyards as "gifts" to some of his supporters, under the guise of licensing "development projects." In *zamani* philosophical concep-

tion, this would have been inconceivable. All over Africa, narratives of refugees, homeless people, hungry populations, street children, "grabbing" and obnoxious, illegal, individualistic accumulation of wealth have become the new ethos. Naked abuse of "basic" and "subsidiary" human rights persists, even as efforts in resistance and assertion of abused humanity multiply. African opposition leaders travel all over the Western world looking for paradigms and models of democracy to imitate. Yet, many of the answers are embedded in our own histories and heritages, whatever their shortcomings. Learning from others is important and even necessary, but not when the point of departure is self-dismissal.

This discussion is a challenge to search in our backyard, dig deep into those parts of our history that are affirmative of human rights, salvage whatever is positive and then keep searching elsewhere as we move forward, grounded "home." Memory and deliberate recollection for the purpose of "regrouping" are most healthy. Current African generations have a historical duty to come to grips with what has gone on in the past. They can then use that knowledge to denounce practices that have historically generated human rights abuses while embracing and holding onto those that have asserted their humanity.

Given the fact that this discussion has not examined the "backward" moments in Gĩkũyũ/Ndia (re: African) oracy and orature traditions, including narratives of patriarchy, sexism, superstition, inter-societal wars and so on, this effort might be termed an idealization of the *zamani* socio-cultural ethos. However, hopefully, the point that I set out to make has been made. In other words, metaphorically speaking, mine was the role of one who sought to run harvested seed (from a specific granary of African Oracy and Orature) through a broad sieve, collecting together good grains while leaving the chaff alone for another day of sorting out. My ultimate proposition is that, using some of the good seeds, Africans can bring a few good baskets of home grown grain, arriving as planters at the communal global field where human rights advocates are already gathered for work.

Chapter 12
TRANSCENDING COLONIAL AND NEO-COLONIAL PATHOLOGICAL HANGOVERS TO UNLEASH CREATIVITY

Let me begin by really expressing deep appreciation for the invitation to come to this soap summit as the keynote speaker. When Dr. Njogu invited me, I explained that recently I have been cutting down on my speaking engagements for all kinds of reasons - including health concerns. However, in the end there was no way I was going to say no to Dr. Njogu as he twisted my hand, not just arm, so hard that I ended up accepting to come. Frankly, were it not for health problems, I would never have needed any arm-twisting to accept an invitation to come to Kenya. Just a mention of the motherland would have definitely done the trick!

So, I am really delighted to be with you all and wish to express gratitude to the PCI for funding my travel here. In particular, I want to thank Lillian Chege for shouldering a lot of work in preparing my itinerary, which was a little problematic. Once more, it is truly a pleasure to be at this summit and to have the opportunity of networking with all of you.

Permit me now to become a bit personal and recognize in our midst here two very special people - my sisters. Mrs. Kiereini is a former Chief Nursing Officer in Kenya, currently serving as the chairperson of AMREF's Board of Directors and Mrs. Marekia

is former secretary/office administrator, who is now a business-woman. Please join me in welcoming them to this soap summit even though they only came to offer me sisterly solidarity by listening to my address. As for all the many friends that I see here and whom I cannot name individually, I embrace each one of you and just want to say how delighted I am to see you at this forum.

At this juncture, I would like to comment in quite some detail on the symbolism of this moment when we find ourselves meeting in Kenya. I feel the need to do so for several reasons that will unfold. But, do not worry! Even though I was given up to one hour to make my remarks, I am going to do my best to cut down on my text because there are some people here who need to get away soon. In fact, I am going to speak to my speech rather than read it out and so if it is a little incoherent please understand that it is because I am trying to be sensitive about taking too much space when time is proving to be such an elusive commodity. Moreover, jet lag has been playing tricks on me and I haven't been sleeping well at all since my arrival. As a result, I am feeling a bit lightheaded.

But, let me move onto symbolism.

The first level of symbolism that I wish to comment on is the tenacity that has made this summit convene at all. Personally, I am quite amazed that it is taking place. Only a week ago, there were e-mail alerts that all international conferences scheduled to take place in Kenya had been canceled for security reasons. Dr. Njogu must have been very vigilant because before I could get onto my computer keyboard to ask him whether the information under circulation was correct, he had sent out an e-mail to all summit participants simply announcing: "the conference is on." That was how brief and decisive his message was. For me, the symbolism here is not to be missed: we have to design our own agenda and move on with it as opposed to taking our cue from others.

You see, the government of George Bush seems to be determining national and personal agenda through security coding – red, orange, yellow and green. There is so much drama around this that it is creating more fear than a feeling of safety. Now, according to this security system, Kenya is a security liability – in fact, a country that poses a serious terrorist threat. So, I am rather surprised to see

that many of you are still living here and remain alive. I am happy too to have been here for three days and to be still alive. Seriously, going by the gravity of these alerts, those of you who live here should presumably have packed your bags by now and fled, while the rest of us would never have boarded the planes to come. But we decided to be crazy and come and it seems that there was some sanity in our madness because we would have been foolish not to come. The lesson is that remaining focused on our agenda and commitments is critical in accomplishing the work that we have mapped out for ourselves.

The second level of symbolism, especially with all these security concerns before us, is that instead of panicking, we should be fired by a sense of urgency to complete the work before us. Speed is critical. It is, in fact, a matter of life and death, particularly when it comes to tackling the HIV/AIDS pandemic, which is more of a source of terror/horror on a day-to-day basis, more devastating than any terrorist attack we could imagine. Please don't get me wrong, terrorist attacks are lethal and we have already witnessed the extent of their unimaginable terror; but thankfully, in most situations they do not happen every minute of the day. Deaths from HIV/AIDS do. The symbolism of the urgency confronting us becomes a teaching moment, compelling us as artists, culturalists, journalists, writers, activists, etc., to do something, now. We must move forward with all human speed possible. We have to seize every possible moment to intervene in order to avert this human calamity that has gone out of control.

The third level of symbolism – that of the larger historical Kenyan scene – calls for a special and prolonged comment. Please allow me to indulge. I am entering this country for the first time since the December elections that toppled the Moi dictatorship and for once, I am encountering people with a lot of hope. I am thrilled by it, but I am also reminding all of us to remain cautious and vigilant. This is because as we know, we have lived through euphoria before only to experience huge let downs. However, we do not want to feed on pessimism: we want to say that things will go right - that we will make them go right. Yes, for the first time after so many years, I am seeing and hearing people express confidence in their ability to

create positive change. So, I want to suggest that symbolically, we meet in Kenya at the dawn of a new day and depending on what action we take, we can make a difference that will affect tomorrow. We have met here to propel change and to make a difference. Let us not forget, however, that to be of lasting transformation, the change we make must be collective. This is the symbolism that we can draw from Kenya where we are meeting under a new political dispensation created through the collective will of the people. If we forget the collective nature of this victory and its significance, we will have betrayed history all over again. This will be yet another political disaster.

We have met here to find ways of working together collectively in order to address the countless problems facing us in Africa. As we look at these problems, we sometimes become discouraged and do not know where to begin; yet we know that we need to begin somewhere. I don't know if all of you suffer from this momentary panic, but I do.

The fourth level of symbolism for me is the celebration of people's potential in changing the oppressive reality facing them. In Kenya and other countries where windows of democracy have opened up, people have every right to bask in the sunshine ushered in by a new dawn, emerging as it does after a long night of terror. We have the right to enter the spaces we have created in order to enjoy the sunshine that we have been a part of the making and to affirm the fact that the sun's rays will stretch into the future. So, overwhelming as the task is, let us take comfort in the fact that daylight is on our side!

Having highlighted these levels of symbolism, let me now celebrate all those who have come to this soap summit as creators of one kind or another: artists, who use their imagination to fathom and create new worlds while believing in infinite possibilities; journalists, who have been so vigilant in naming the ills of neo-colonialism; activists, who have been the voice of our collective conscience especially under silencing; others from various professions who have given their skills to make a difference... Yes, I want to celebrate all of you who are here in the name of naming ourselves and our reality, and in the spirit of making things happen as we all struggle to intro-

duce sanity in a world gone mad. I salute you, fellow travelers, who have chosen to use action to fight pessimism, for we have witnessed the shedding of too many tears.

I truly celebrate the wealth of imagination represented here and just want to give an inspirational speech to say I believe we can change the oppressive reality before us as well as our people. Yes, we can do it. We must believe that as human beings, we have the capacity to transform our world. In celebrating you as cultural agents, I also celebrate our art and cultural heritages. I say, we have here a harvest of multifarious talents and we saw clear evidence of this earlier on in the morning during the opening session. It really was delightful and instructive listening to the members of the opening panel who covered so many issues with such stunning creativity that they have made my task a lot easier. All I need to do now is fire your enthusiasm rather than advise you on what to do. In fact, I am going to narrow my remarks to address the theme of "Transcending Pathology Created by Colonialism and Neo-colonialism in Order to Unleash Creativity." My argument is simple, until we recover from colonial and neo-colonial pathological hangovers, we cannot create meaningful soaps to address other health issues. Hopefully, the challenges I pose will provide a framework around which to brainstorm on how to move beyond borrowed solutions in order to emerge with our own inventions.

Let me now invite you to participate in the rest of my delivery, as I happen to be a child of orature and so believe in audience participation. In orature style, when I speak, I don't take the audience for granted. I like having them accompany me on our joint conversational journey. So I am going to give you a cue, indicating where you are supposed to come in. The one I am going to use employs a South African term, "abantu," which simply means "people." When I call upon you: "Abantu!" You are going to respond, "ĩĩ!" (Gĩkũyũ term for "yes") telling me you are there. Then I will ask you," Shall I go on?""Shall I proceed?" "Shall I speak?"... and/or other such variation. You will respond: "ĩĩ!" or "Yes!" However, when you say "No!" I will stop. So, any minute really that you feel tired, you know what to do. But please don't stop me too soon: let me speak for a few minutes at least.

"*Abantu!*"

"*ii!*"

"*Shall I begin?*"

"*ii*"

I want to begin by stressing that as we celebrate life and the possibilities before us, we are also situated amidst poverty, disease and other calamities. We convene here at a moment when there are so many wars – actual and metaphorical – raging in Africa. A lot of our children are dying, while others have been turned into child soldiers in unending ugly wars of hatred, bloodthirsty power mongering and wanton destruction of lives. In the words of Ambassador Olara Otunnu, the Undersecretary General of the United Nations, our children are being taught to kill while being killed before they have time to grow. This is a tragedy, especially when we think of the AIDS epidemic and other killer diseases such as malaria, cancer and so on that are wiping out our people. So, this is a critical moment for us as artists, culturalists and activists to ask: how can we address these issues? How can we use our imagination to bring creativity to these spaces where there is death and destruction?

"*Abantu!*"

"*ii!*"

"*Am I making sense?*"

"*ii!*"

I was nervous that someone would say "no" there because I am not really sure I am making sense.

With these serious challenges in view, I suggest that we do all in our power to move beyond symptoms and get to the root of the problems identified. Above all, we need to have a clear understanding of "where the rain began to beat us," to borrow the words of Chinua Achebe (1976). I repeat it is critical that we understand where, when and why our problems started. Important as this question is, it seems that when some of us raise it there are people who become nervous, asking, "Why do we have to dig up these past issues? Why don't we just forget?" This self-imposed amnesia is another very severe illness that we have suffered from since colonial times. We are afraid to recall what went wrong, partly because the

act of remembering forces us to step in and take action to remedy the offending situation. I want us to remember. I want to take you through some painful moments, not for sadistic reasons, but because they will jerk our memories to remember why we are having so many things going wrong scores of years following independence. How can Africa, a continent that had so much hope at independence, wreak so much helplessness? I remember the optimism we had when we came out of Makerere in the 1960s. We were so very full of hope. We were so sure we would make things happen. We were full of commitment. We were going to serve the continent as teachers, doctors, nurses, lawyers, architects, engineers, writers and so on. We must ask: "Where did the rain begin to beat us? What went wrong?"

For sure a lot of blame goes to our leaders, especially those who have ended up becoming dictators, for, at their hands we have witnessed untold terror and destruction, especially that of human resources. However, as ruthless and pathetic as African leaders have been, the people of Africa must assume collective responsibility for having been largely silent while these destroyers ravaged our countries and resources. Yes, it is a shame that at first only a few people dared to speak out against these crimes. If the entire continent had spoken out loud, do you think these dictators would have had enough jails in which to lock all of us up? That would not have been possible and probably change would have come a lot sooner. Look at the collective psychological trauma this inaction has resulted in! Our countries need therapy. It is indeed my sincere hope that the soaps we create will address these issues of psychological health. Our collective humanity has been brutalized by what has happened over time. The soaps will have the challenge of indicating ways of giving birth to new human beings with a vision and mission that seeks to humanize the entire world.

Having said that, I want to believe that there is a reason we have gone through so much pain and that hopefully, we have learnt a lot through our mistakes. In this regard, I must celebrate the people of Kenya and others from all over Africa for deciding to rise up in the end and say, "No! We are not going to allow terror to continue. We are bringing humiliation to a stop in order to move forward!"

"*Abantu!*"
"*ii*!"
"*Shall we proceed?*"
"*ii!*"

As we try to understand what went wrong, let us not under-estimate the impact of an internalized colonial ethos and how the psyche it created shaped the people that we find in ourselves today. But then, some of you will say to me that this is placing blame on colonial masters, turning them into convenient scapegoats. But let me tell you: to understand ourselves fully, we have to comprehend our past. If we don't understand colonialism and the way it worked in order to leave us in the neo-colonial mess that we find ourselves in, we are failing to understand a very important part of our history. Yet, only proper understanding will help us move forward meaning-fully into the future.

We are talking of behavior change at this summit. In my view, there is no way I can deal with this question without revisiting colonialism. For, if former colonial subjects are to employ behavior change theory to their lives, they must have the courage to go back to colonization and analyze the consequences of a colonial victim mentality.

This is the only way we can transform the legacy of abuse, self-doubt (even self-hatred), and an incurable pre-occupation with whiteness as a coveted state of being. Ladies and gentlemen, those of you coming from a colonial background may not want to hear this, but I want to suggest that we are still suffering from a colonial hangover that has been reinforced under neo-colonialism. We have grown to not only lose confidence in ourselves, but in our history and culture. Thus, as we seek to create change through soap operas, we need to revisit these abandoned sites – not in a spirit of nostal-gia – but in active search of culturally homegrown solutions to our specific, local problems. We need to love ourselves, understand our-selves and re-embrace our heritage. Why? Because when a person really understands himself or herself, when a person has the lan-guage and words to name herself/himself and her/his world, then s/he is in control. But once you don't have a language; once you don't have a past; when you pass a vote of no confidence in yourself,

you lose the ground on which to stand in order to be sufficiently grounded to transform your reality as necessary.

Let me give an illustration. In the last three days that I have been here, I have been watching television and 90 percent of the time the movies that are on the screen are from the West – mostly Britain and North America. I am asking myself: How is this so on a continent where creativity is in so much abundance that we should not know what to do with it? How do our people see themselves in the faces that are on these screens? How do the exhibited Hollywood scenes and the reality show characters of the Jerry Springer drama, for instance, reflect Africa's crying needs? What is going on? For me, there is an obvious problem here, especially for children who are always on the lookout for models. It is as if we are telling our children that they ought to look outside themselves, their societies and their worlds in their struggle to construct their identity.

People, there is a crisis here – a big crisis – and I am calling upon all of us to speed up the production of locally generated and oriented soaps in order to speak to Africa's needs. Where urgency is concerned, I am in agreement with the donors. We need to make those soaps happen today: we needed to have done so yesterday. On the other hand, however and this is critical, the work must not be done at the cost of cultural authenticity. We must be careful, even as we rush production, to ascertain that whatever is done is rooted in and mirrors the cultural understanding and self-reflection of our people. I am agreeing that there's urgency and the struggle is at a phase when we really need to speed up action, but not at a cost to our integrity.

"*Abantu!*"

"*ii!*"

"*Shall I proceed?*"

"*ii!*"

With your permission, I will revamp my theorization further and take you back to the question of the urgency in rooting out colonial mentality. I insist that to address Africa's ills we have to begin with attacking the psychological block that undermines our self-confidence, making us always want to look for answers from

the outside. Until we learn to trust the strength, the imagination, the will and the creativity within ourselves – to have abundant faith that we can make things happen, we will continue to helplessly gaze outwards. You see, as agents of change, we have to be creative; we have to move from the colonial mentality of self-mutilation, self-destruction and self-doubt – erase from our psyche the culture of self-contempt and even self-hatred, a malady that makes us imagine that whatever we have is inadequate and inferior to things Western. We have to work towards the rehabilitation of our mutilated, dismembered personal and collective self-imaging and come to trust that we have within ourselves the human potential for determining our lives. The inculcation of an inferiority complex among the colonized was a clear goal in colonial education. It happened in India, it happened here, it happened wherever colonials set foot and it continues to take place under neo-colonialism. We cannot afford to delay the process of creating soaps that will undo this psychological damage/mischief even as we campaign against other visible medical illnesses and health concerns.

There's a very revealing documentary entitled, *In the White Man's Image*, that narrates the tragic story of Native Americans and the way they were colonized through the elimination of their identity as well as culture. In the documentary there is a ruthless White educator, Captain Richard Pratt, who makes it his mission to not just educate Native American children but to actually change them, mentally and physically. There is a very chilling recurring line in which the colonizer constantly speaks of the need to "kill the Indian and save the man"– obviously meaning there is a need to erase "the Indian" in the children by turning them into whites. This process of "killing the Indian" is equivalent to exorcising the "native" out of colonized Africans. Within this context, the victims had to be given new names when they entered government or missionary schools under colonialism. In my case I ceased to be Njũrĩ or Mĩcere and became "Madeleine," acquiring a French name that I could not even pronounce then! So, at one point in my primary school life I was known as "Madeleine Richards." This would be my name at school and on returning home I would revert to my African name – pick up my identity. In this bizarre situation, some people ended up

having double personalities and developed a rather schizophrenic relationship with themselves, their homes, their culture and their identity. Serious stuff!

All of this partly explains why an identity crisis persists among our youth, including those who have never left their homes – yet experience a deep craving for wanting to be either American, or British, or anything that is not African. We have passed on the confusion to them under neo-colonialism. It always surprises me when I hear the older generation accusing the youth of losing their culture and identity. Rather than blame them, we should be laying the responsibility on the collective social ethos of self-devaluation that has emerged over historical times. I say, when we begin with a lack of self-knowledge, we are not in a position to become agents of change. The situation is not getting any better, much as we may pretend it is. As we speak, there is a project of re-colonization afoot, which comes as a part of the globalization package. We need to be fully aware of what the process is all about in real practical terms. Namely, that there is now a single power – America – supported by the international corporate world and dominating the rest of the globe, with poor nations at the bottom of the rubble. Let us not mince words: President Bush is out to conquer the rest of the world and to colonize weak states. I am cautioning that this culture of dominating others militarily, economically, politically and culturally is the philosophy behind globalization. We need to be keenly conscious of this.

Some people have been as bold as to openly advocate the re-colonization of Africa. There was a very revealing article in the *New York Times* Magazine of April 18, 1993, in which the writer, Paul Johnson, proposed that Africa was better off under its former masters and that it was high time ex-colonial powers returned to re-colonize the African continent. Now, nobody is disputing the fact that neo-colonial African leaders have turned the continent into a basket case. There is indeed a sense in which the dictatorships we have survived – not to mention the general mismanagement of our resources – have dragged Africa many years back. In Kirinyaga, for instance, where I come from, roads that were in excellent functioning order during the 1960s and 1970s are no longer passable. There

was a road between Kutus and Kībīrīguī on which I used to drive at about 40-50 m.p.h. in my little Volkswagen beetle traveling from Kabare High School to Nyeri, but now that road cannot even carry a donkey cart. This state of things is unacceptable. Yet, in the midst of all this, some African rulers have been known to boast of how much they own. You no doubt know the story of the late Mobutu Sese Seko who became furious and insulted when a journalist asked him if it was true that he was the tenth (or some such rank) richest man in the world while he was actually much richer than that. Mobutu nearly swallowed the poor journalist alive! Oh the nerve! Some thief is here, having impoverished his country and having grabbed everything that there is to grab and he is boasting about being a better thief than estimated! Friends, I am saying that there's a lot of work to be done because to a certain extent we have brought upon ourselves the contempt with which we are being treated. But, even with all of this granted, who is Mr. Johnson to decide to choose the future for Africa! How does what has happened under neo-colonialism make colonialism right given all the dehumanization and suffering it unleashed on African people?

The above reminds us that soap operas have a role to play in filling in the gaps that exist and in exposing the ills that Africa ails from today. If we do not do this, someone else will step in and fill the gap. In cultural terms, this is already happening. At the levels of television, film and media alone, for instance, re-colonization is a real threat.

Let me give you an example. Go to any part of the world be it in Africa, Latin America, Japan, the Caribbean, etc., and you will find that one of the clearest television stations is CNN. The whole world is being brought up on CNN. Now, I have nothing against CNN, or cross-cultural convergence of resources for that matter. In fact, I was watching CNN only this morning when I lost sleep! What I am saying is that when you go to a country and cannot access programs on the local station because CNN has the clearest beam, then there is a problem. What we are witnessing is the equation of globalization with mainstream 'Americanization' and this, in essence, constitutes global colonization. I am arguing that there is something dangerously wrong when the world falls under the superpowership

of one country. We need independent film and media to provide an alternative, especially for Africa's and the world's poor. This new imaging created by independent media must strive to gather together all cultures and all people – irrespective of race, class and gender – making them a part of global humanity.

There's a problem here and it is among the root causes that we need to address in our artistic products if we are going to make headway.

"*Abantu!*"

"*ĩĩ!*"

"*Are you tired?*"

"*No!*"

"*Don't say yes, just yet. I promise I am coming to an end!*"

So, what is the way forward? As we struggle to wean ourselves of the colonial and neo-colonial hangovers that I have talked about, we must simultaneously work on creating alternatives. Soap operas have a very special role to play in this task, as already intimated. Only such alternatives will bring about an alternative form of development – one that focuses on entire human populations rather than on a few privileged individuals. We must move beyond self and realize that without collective development, no given country can make the mark. In the prophetic words of J.M. Kariuki – a popular Kenyan politician assassinated in the 1970s: "We do not want a [country] with ten millionaires and twenty million beggars." Those of us who are socially privileged ought to seriously take heed of these words. Africa today has armies of poor people while a small elite wallows in obnoxious wealth. This will take us nowhere. Sometimes you wonder how most people live from day to day– how they survive.

Last night I went to bed very humbled and deeply pensive. I had sat next to a young man at dinner (I hope he is here), who told me his story of survival and human triumph. I believe his name is Sammy Gĩtau. He was born in Mathare Valley, where he grew up – largely in the streets – living on an empty stomach most days. I don't know how he survived, but today he is here as one of our participating artists and community activists. I was simply amazed by

his story and even more so, by the determination with which he had emerged out of a human pit where so many others of our children have gone down.

I am trying to say that there is something grossly wrong when we have armies of children in the streets; when so many are homeless and hungry; when sprawling ghettos become eye sores and yet we remain surrounded by so much wealth. There's clearly something wrong when we are plagued by so much illiteracy – having to deal with people who cannot decipher one iota on paper – while there are so many of us who are educated. It is in view of all this that I am persuaded there is no other way outside collective development I am positing that for those of us who are privileged, our privilege is also a responsibility. On this score, Mwalimu Njogu, I celebrate you for having organized this gathering to remind us that we owe the world a responsibility by putting us to work on doing something concrete to change the status quo.

"I am because you are and since you are, therefore I am." This is a rough quotation from John Mbiti's (1969) *African Philosophy and Religion* and teaching that we find in most African orature heritages. I subscribe to it – heavily! I tell you, don't you listen to anyone who suggests to you that this kind of thinking belongs to "primitive" and/or "communist" societies. Every human being should have this as a life motto.

Allow me to belabor the point and ask that we remember we did not make it to where we are alone; that in actual fact we are products and extensions of our communities and that, above all, we are products of the years of historical struggles waged by people before us. Sacrifices liberated a lot of the spaces that we occupy today. The soaps we create must, therefore, address the dangers of individualistic development. Our soaps must never get tired of naming the dangers of poverty and disease. Indeed, they must make a connection between poverty and insecurity; between impoverishment and disease, etc. They must ask harsh questions regarding the role of the World Bank, IMF and imperialist domination – all of which create an indebtedness that makes the poor of the world even poorer. Above all, acknowledging the importance of collective development, please I beg us all to leave behind existing divisions based on

all petty nonsense related to "tribalism," ethnicity and other socially created barriers such as gender inequity and discrimination against those with disability, etc. We must never ever forget the tragedy of the Rwanda genocide, of Burundi, the Democratic Republic of Congo, Sierra Leone, Kenya's Rift valley massacres and so on. While on this point, let me say that I can never understand how/why – with all our problems in Africa, including the scourge of killer diseases – we succumb to the madness of sharpening machetes, pangas, arrows, spears and loading guns for killing other people simply because some lunatic of a power hungry warlord convinced us they should die since they don't come from the same group as us!

Sometimes I have wondered, what happened to our psyche? Why have African lives been rendered so cheap... so easily dispensable? Look at this morning's newspaper and see what happened in Mathare Valley yesterday! Why would a landlord exploit unemployed youth to go and evict tenants by beating them, just to get them and others killed in the process? Where is this kind of individualized greed and thuggery going to take us? These are all serious questions that our soaps must pose. To borrow from Chinua Achebe, "the house is on fire!" I am referring to the analogy he gave in one of his essays regarding a man whose house was ablaze and as it was burning down, he saw a rat running away to escape the fire. And you know what the stupid man did? Instead of focusing on rescuing his belongings, he took a huge stick and began chasing after the escaping rat. I recount this story and have done so several times before to suggest, ladies and gentlemen, that Africa – our "house" – is on fire. Please do not let us go chasing rats that are intelligent enough to escape the fire. There are far too many "rats" that we keep chasing even as our house burns: petty "tribalism," ethnicity; political war games; idle consumerism; competitive parading of wealth exhibits and so on.

In this regard, let us vow to make the soaps we create focus on the core issues that affect the lives and health of our Africa's majorities most. In creating the soaps, we should engage the question of local languages and involve the masses in the creation of the pieces. Let the people speak for themselves by telling their own stories wherever possible. We cannot possibly replace their voices, however talented or skilful we may be artistically. I keep emphasizing that until we

network with the masses in the production of knowledge and other cultural products, intellectual output is going to remain the monopoly of the elites. In this respect, we should recognize the criticality of orature. In African Orature we have an incredibly rich heritage that we should truly be proud of. It has an abundant reservoir of stories, allegories, epics, songs, etc.; that will greatly enhance our creativity. I remember how at the height of political repression here in Kenya, one of the dramatists (I forget what his name was) used animal characters to populate his political satires. These characters represented real people on the Kenyan political scene – roaming the stage as hyenas, elephants, ogres and so on. Once, a senior government minister that I will not name lavishly praised this use of African culture, little knowing that he was one of the undesirable animal characters on the stage that day. We sniggered all the way from the National Theater to the Norfolk hotel where we enjoyed tea and jokes at his expense! Orature is a goldmine and a powerful artistic tool at our disposal whether we are operating from the rural areas or urban set ups. This was ably illustrated during the opening panel today.

The application of orature in creating soaps and other artistic products will serve a useful purpose in bringing out the interdependence between ethical and aesthetical concerns and this foregrounds the old time debate regarding "art for art's sake" and functional creativity. In orature conceptualization, there is no contradiction, for it is not a question of either/or, but rather a matter of complementariness. This is to say that in orature, while art is by and large utilitarian, its aesthetic appeal also matters. The orature heritage perceives art as an aspect of human productivity that has a functional purpose, but one that is also meant to express beauty while it entertains the audience. Thus, when we describe soaps as edutainment, we are at one with the orate tradition in which teaching, education and entertainment converge to define a desirable piece of art.

As we compose, script and produce our soap operas, let us not forget to incorporate the youth as a target audience. If we are not careful, the marginalization of youth in many of our undertakings is going to cost us heavily somewhere along the way. There is an illustrative story that reinforces the aspect of behavior change theory that posits that habits inculcated early in life are likely to have a

more lasting effect on a growing child. The story has it that a Catholic priest was asked by his Anglican counterpart:"How come the Roman Catholic has such a huge, loyal following?" The Catholic priest replied, "Aah! We catch them when they are young!" Please, let us catch them when they are young and if well done, the messages we pass through the soaps we create will stick, becoming life lessons. Returning to orature yet again, the heritage has genres that naturally attract the attention of young people, especially song and dance. Look at the phenomenal role the two have played all over Africa, especially in liberation struggles!

Only last December, the Kenyan political landscape was a theater using orature popular art forms to mobilize the people. There is a song that I became so addicted to after my nephew played it in the car for hours that I seem to be constantly singing it in America six months later. I am referring to "Yote Yawezekana"... "Everything is Possible"... without you know whom – no need to mention names! The notion of people embracing their self-empowerment and declaring that they are capable of creating any type of change without dictatorial blocks is most refreshing after so many years of silencing. Soaps should exploit the orature genres of dance and song as they naturally appeal to young people and tend to unleash their creativity while enlisting participation without too much of an effort.

In conclusion, let me echo the spirit of this song and say that in the work before us, having shed off colonial and neo-colonial hangovers and then fortified ourselves with self-knowledge and determination, "yote yawezekana!" So, next time you wake up feeling defeated and tempted to remain between those sheets, just throw off the blanket and tell yourself, "I am unbwogable!" (to evoke another popular election song in which the opposition was vouching, "we shall not be moved!") Let us harvest this field of fertile imagination all around us and get on with creating those overdue soaps and other popular art forms that we need for moving our work forward.

Let us remind ourselves time and again: we can do it! We will do it!

"*Abantu*"

"*ii!*"

I will stop now. Thank you very much.

Chapter 13
BURYING THE KASUKU SYNDROME: CONSTRUCTING INVENTIVE SITES OF KNOWLEDGE

Point of Entry: *Hodi! Hodi!* (Knock! Knock!)

Having come here to advocate the immediate burial of *"kasuku* culture," alias, "parrot culture," I had better initiate the process of grave-digging myself. As an African academician, poet, playwright, artist, cultural worker and activist, I have sought to do this in different ways. One such way has been using my intellectual work to affirm progressive indigenous African paradigms, including orature, which Pio Zirimu and Austin Bukenya (1987) once concisely defined as "verbal art." I will, therefore, use an African Orature style of delivery to hold this conversation with you. I cannot think of a more appropriate tool of competing with fatigue at the end of a long day, or of keeping a possible dozing audience alive, following such a challenging dinner.

My talk, or *palaver,* will be divided into movements or cycles, labeled *palaver* one to ten. Inside each of these full stream *palavers* will be meandering tributaries of smaller, but related *palavers.* If the meanderings interfere with your focus, therefore, just find ways of tolerating them. For instance, treat them as the musings of an elder-in-the-making, borrowing a leaf from the *wazee wakumbuka* (elders

recollect), an extremely popular *kipindi* (program) on KBC (Kenya Broadcasting Corporation) radio network sometime in the 1970s.

Palaver One: The Conversational Journey

In African Orature *palaver,* the speaker does not take members of her/his audience for granted. She/he seeks to maintain contact with them by constantly calling upon them in an attempt to ensure that they remain with him/her as companion travelers along the conversational journey. She/he does this by deliberately eliciting their participation, thus transcending the crisis of the "banker" in Paulo Freire's discourse on "banking education" as expounded in *Pedagogy of the Oppressed.* In this narrative, the "banking" educator, or lecturer, simply "deposits" information into her/his students, treating them as empty "receptacles" and never as "active participants." After the dumping process, the lecturer expects the students to memorize the "facts" and then accurately regurgitate the information when prompted to do so. I am sure we do not have such educators in our midst at this gathering! Whatever the case, I will not turn you into my "receptacles."

Travel with me, instead, as I take the African Orature path, in an attempt to interrogate the *kasuku* way, taught to us in the colonial and neo-colonial classrooms. The format of African Orature *palaver* is the antithesis of the "banking education" model. It utilizes a "call-response" delivery style that insists on a partnership between the speaker and her/his audience. This format is widely used among people of African origin globally, be it in social/religious gatherings, public speeches or group discourses.

In our *palaver,* the "call-response" will go something like this... I will call upon you as *abantu,* or as *wenzangu,* or even as plain "people!" You will respond, *yúû!/wúî*! You may also respond, *yebo* or *naam*! Use whichever comes more readily to you. After this I will "ask for the road," by posing any of the following questions: "Shall I continue?" "Shall I speak?" "Shall I proceed?" You will "give me the road" by replying, "Continue/go on!" "Speak/speak on!" "Proceed!" Again, just use whatever comes most naturally to you. The only favor I ask for is this: when I go beyond the twenty

minutes that the chairperson, Tade Aina, has allowed me and then ask, "Shall I continue?" You must enthusiastically respond, "Continue/go on!" Remember to make it extra loud as well.

Palaver Two: Burying Colonial Kasuku Consciousness

Once upon all times, there has always lived a bird known as *kasuku* or parrot. The creature is at once fascinating and at the same time pathetic. S/he is intriguing and fascinating because she excels in imitative skills – always able to reproduce the speaker's word, using the originator's exact pronunciation and even tone. Imitation and reproduction, or to use academic language, plagiarism, are perfected through sessions of attentive listening and repeating. However, the creature is also pathetic in the sense that s/he can never become the "owner" of the source word. Thus, we can only call her/him a fascinating mimic, but never an intellectual thinker. The point is simple: serious intellectuals must transcend mindless repetition, mimicry and plagiarism. In this regard, forgive me if I observe that colonial and neo-colonial educational systems have trained too many intellectual thieves, other areas of thievery aside. These are the types that Vidiadhar Naipaul needed to viciously satirize in his fictional work, *Mimic Men.*

I wish to be even more provocative and suggest that the said colonial and neo-colonial classrooms did not just produce a huge contingent of intellectuals cum con-artists, but unwitting pathological creatures, badly inflicted by a chronic streak of the *kasuku* syndrome. We have among us "hypnotized parrots," "willing/professional parrots," "reluctant/involuntary parrots" and lastly, "dissenting parrots." So, fellow parrots, of whichever inclination, let me call upon all of us to find a fast cure for this syndrome if we are to be agents of innovation in African higher education.

(*Call and Response*)

If this cure eludes us, we might need to call upon our ancestral spirits to kill the *kasuku* in us – not us, oh! – as our people in West

Africa would say. Following the resulting burial ceremony we will need to move on very rapidly with the business of creating our own authentic word. Here, again, I borrow from Paulo Freire. Accuse me of being a disciple, not a *kasuku,* and I will not deny it.

My fictional sister, Lawino, of Okot p'Bitek's *Song of Lawino and Song of Ocol* has a whole lot to say on *kasukuism.* She was so passionately contemptuous of those who suffered from the syndrome that she once accused her husband of possessing no "testicles" (her language not mine, oh!) According to her, Ocol's "articles" had been "smashed by huge books" in the colonial classroom. Lawino's sexist language notwithstanding, her accurate characterization of the *kasuku* syndrome-stricken intellectual was visionary. I am not surprised that Ocol abandoned her in preference of red-lipped Clementina, a colonized African woman *kasuku.* The critical point is, despite this strong condemnation, Lawino seems to have relented somewhat, leaving a small window of hope by appealing for the emergence of a new Ocol. So, to living and potential Ocols, I say: creativity and inventiveness are still possibilities. However, these goals are challenging ones to all of us as survivors carrying those vitals that were smashed in the colonial, and by extension, the neo-colonial classroom.

(*Call and Response*)

Fellow survivors, let me draw your attention to another exponent of the *kasuku* syndrome so that you can truly appreciate the urgency of burying it. In *The Wretched of the Earth*, Franz Fanon refers to *kasuku*-like intellectuals as "those walking lies," who had nothing to say of themselves outside what "master" had schooled them to mimic. Now, you and I have encountered these fakes, "walking in the air," as the saying goes; feeling so "hot" that they heat up the very air we breathe. Whether as Achebean "been-tos" or as domestic misfits from Ibadan, Nairobi, Cairo, Fort Hare, or whatever local university, those who became "walking lies" behaved the same way. They tried to outdo those whom they imitated at their own game, in the fashion of grand *kasukus.* Some of them even developed self-willed amnesia and could no longer remember their

villagers or fellow villagers. As Aimé Césaire has observed in *Discourse on Colonialism*, they became schizophrenic towards themselves and their people. Nay, they turned into zombies, losing the creator and inventor in them. But why do I speak in the past tense? These schizophrenics and zombies are still with us today and have multiplied under neo-colonialism. Yes, Carter Woodson's thesis on the *Miseducation of the Negro* still holds true in this 21st century.

(*Call and Response*)

Fortunately, we also know that there have been survivors and that they, along with the new visionaries, are going to become composers of the type of narrative that Carole Boyce-Davis would call an "uprising discourse." So, let us leave the court poets alone, singing praise poems inside or outside the gates of statehouses. Let us remember that there were always at least three types of intellectuals: dinosaur conservatives, chameleon liberals and dissident progressives. We, of the intellectual community, are a happy mix-grill and never a homogeneous collective. Whatever our designation, I see a lot of work ahead of us if we are to breathe new life into our institutions of higher learning. So, for those who would be authors of "uprising discourses," may the spirit of creativity possess our imaginative faculties and set them on fire, releasing unstoppable energy that bursts into flowering dreams and eternal visions.

(*Call and Response*)

As our dialogical journey touches *palaver* three, we specifically turn to the question of curriculum in the new university of our dream. There is no denying it: throughout history, knowledge has always been one of the most contested sites of human achievement. This is to say that the classroom and the curriculum are critical aspects of whatever visions we emerge within imagining the universities of our dreams.

Palaver Three: Deconstruction/Reconstruction of Knowledge

The construction of a compulsory course for deprogramming the mind of every university student must be a high priority, preferably during the first year of admission. Such a course should aim at interrogating the dimensions, dangers and cost of the *kasuku* syndrome, while seriously searching for alternative and lasting solutions. Whether titled, "Deconstruction and Reconstruction of Knowledge," or "Knowledge as Power," the aim of the course should be to bury, once and for all, the *kasuku syndrome* at the undergraduate level. Only after that will the learners' minds open up to pursue creative ventures, ultimately emerging with empowering paradigms. Once this kind of self-empowerment is achieved, it will turn our students into authentic agents capable of production and dissemination of knowledge. It will also hasten the end of the pertaining equation of knowledge, development and civilization with Western cultures, which is but a dangerous myth.

(*Call and Response*)

Palaver Four: Engendering Knowledge

Having deconstructed knowledge and embraced it as a universal human gift rather than a handover from the West, we will be duty-bound to engender it as well. For, throughout history, knowledge has come to be associated with males. Women who have dared to enter this world have encountered all types of resistance: physical and psychological intimidation; misrepresentation; stereotyping; discrimination; abuse and much more. I remember how in my mother's day, educated women, or rather, women who dared pursue an intellectual path, were depicted as "loose," *(malaya),* or as "wild." In my time, I can provide two revealing illustrations of stereotyping, both insulting, but, ironically, meant as benign by the unwitting perpetrators.

A male colleague who was acquainted with my writing and who had looked forward to meeting me at a conference, for the first time, walked up to me and greeted me. He then told me that he was sur-

prised to see what I looked like in person because from my ideas, he had expected to meet a "masculine" looking woman. At first I was lost for words and then, a devilish idea flashed through my mind. "Well," I quipped, "you were not wrong." He looked puzzled. I kept up the suspense. Then, with a wicked smile I said, "You see, I actually only shaved my beard this morning!" That took care of that one.

(*Call and Response*)

On another occasion, a male colleague and friend of mine came forward to congratulate me at the end of a speech I had given. Shaking my hand vigorously he told me, "You did us proud! You spoke like a man!" Just imagine. Inherent in this harmless sounding comment is the notion that men have a monopoly of intellectual power.

(*Call and Response*)

Therefore, in our innovative educational curriculum, we must introduce another course named, "Gender Education," or "Engendering Education," or whatever. It must be so introduced that all departments across the university incorporate it into their schedules. This will not do as an affair based in Women's Studies alone. Moreover, in our innovative paradigms, affirmative action must be extended to women students and other peripheralized groups. This will go some way towards providing equity in the face of years of systemic discrimination, exclusion and privileging of males.

At the administrative level, we must include more women in high-ranking positions, sufficiently well placed to advocate, as well as implement, this type of revolutionary change in the curriculum. I say, the administrative structures of our universities are too male-centered at the senior level, be it in the departments, the faculties, or the non-teaching sectors. Consequently, the curriculum remains very patriarchal. So, in our envisioned new universities, gender tokenism must cease. The pattern of a rare woman vice-chancellor here, a deputy vice-chancellor there and a Registrar some place else, will not do.

(*Call and Response*)

However, even as education and administrative powers cease to be perceived as prerogatives of males, in our dream universities women who enter these male terrains must be trained to rid themselves of patriarchal socialization. If this does not happen, we will have a scenario in which a male concedes monopolized space only to be replaced by another male-like occupier, who only happens to carry a woman's body.

(*Call and Response*)

Palaver Five: Indigenous Knowledge

Innovative higher education will need to confront another very damaging myth: the conceptualization of knowledge as Western (even white) and therefore, an importation to Africa. The internalization of this myth has had a devastatingly negative influence on our psyches. The irony is that in antiquity and medieval times, Africa was one of the most vibrant sites of knowledge. To understand how mistaken this notion is, just take time to read Cheikh Anta Diop, Ivan van Sertima, Martin Bernal, Richard Snowden and others. I want to suggest that to date Africa still offers very rich sites of knowledge. All they await is rediscovery, research, systematization and technological updating by innovative scholars.

In a meandering manner, what I am suggesting is the addition of another course on the core curriculum, entitled, "Indigenous Knowledges." If possible, all disciplines should be made to include it as a core, or to incorporate aspects of it. We need to urgently turn to our own world and rediscover, if not re-invent it.

As things stand now, jua kali practitioners, most of who hardly have any education to speak of, are emerging with more inventions than the "mimic men and women" being churned out of our universities. Perhaps it is time we brought these inventive artisans onto our campuses to conduct workshops and give us tips on creativity. Alternatively, what is wrong with apprenticing our students to

them? The Ford Foundation asked me to dream wild dreams. I am daring to dream them.

As for all those griots, gurus, musicians, artists, medicine persons and learned male/female elders in our communities, why can't we bring them up to the ivory tower more often than just once in a while? We mostly seem to go down to them, armed with tape record-ers and other intimidating pieces of equipment that mesmerize them into quickly surrendering their information to us. Believe me, many of us academicians and researchers are nothing less than "brain har-vesters." I am arguing that we must find ways of forming intellectual partnerships with our communities so that ordinary people become participants and generators in knowledge production.

(Call and Response)

Researching and writing a book on Field Marshal Mūthoni wa Kīrīma, a former Mau Mau freedom fighter, I have learnt so much that I am amazed at how much untapped knowledge is sitting out in the villages, towns and cities of our respective nations. I now know what Amilcar Cabral meant when he said that with every African elder that passes away we lose a walking library. Mau Mau freedom fighters had come up with incredible discoveries in an effort to survive in the forests of Kirinyaga and Nyandarua. They could break wood without making noise; walk without leaving tracks behind, light fire without matches; carry live charcoal in bags for weeks; pre-serve food to last months; tame wild animals; perform operations; make guns from pipes, etc. Today, all these skills could be refined and improved, using current technological know-how and I am sure, transformed into extraordinary inventions.

This reminds me: there used to be a man in Kenya, by the name of Gacamba, who was said to have made an airplane that could actually fly – well, let us say, at least take off! Whatever happened to Gacamba? What did our engineers do with his talent? Today in Rwanda and Burundi jua kali practitioners are making wooden bicycles that seem to perform wonders on the roads. In fact, they operate as *matatus* between markets, shopping venues and the hirers' destinations. The only problem is that they seem to use a

lot of human fuel and quite frankly, I am not sure that I would be courageous enough to take a ride on one of them, especially down a slope. Nonetheless, I stand in complete awe of this ingenious invention. What are we as intellectuals doing to match or improve on such efforts?

(*Call and Response*)

Our dream universities of the future must find ways of accessing and harnessing all these and other knowledges, with a view to advancing them. Ordinary Africans have become very inventive. They only require the backing of the intelligentsia in order to consummate and technologize their skills. If this knowledge remains untapped, or the skills frustrated, they are very likely to be misapplied. For instance, I understand that in Zambia, *wananchi* have found ways of "liberating" copper from telephone wires and that, consequently, the bulk of landlines are inoperational as we speak. Apparently, those who do not own cellular telephones are in trouble coping with distance communication.

Let me tell you something for nothing, as Sando, a Zimbabwean musician, would say. Unless we become inventors and come up with products that are uniquely African to take to the international conference tables, the rest of the world will never respect or take us seriously. In other words, we will remain consumers and copycats and lest we forget it, however well we copy, ours will always be a carbon copy – never the real thing.

An old adage counsels that need is the mother of invention. I want to think that all the pain that Africa is going through; all the crying needs that are forever screaming in our sore ears; all the deaths we are witnessing daily, mostly caused by poverty and, unfortunately, wanton war-mongering, etc., are for a reason. This reason had better be that sheer need will force us to probe deep into ourselves and learn to answer the vocation of all human beings: to struggle to reach the height of our potential. This can only happen when we dare to be "audacious and inventive" to borrow from Maya Angelou. I say: all the tragedies around us ought to make us wake

up. If we don't wake up this century and invent with a vengeance, we deserve to sleep forever – in pieces!

(Call and Response)

Palaver Six: Connecting with our Communities

This is a tributary of some of the forerunning streams of major *palavers* above. The simple issue is that our intellectual work should aim at resolving the practical problems facing our people and our societies. The cult of intellectuals, who are so removed from their people that they live on islands of seclusion and privilege, only driving into landmasses of dispossession to look at inhabitants through tinted glass windows, has to end. African intellectuals have to stop acting like "pouting children," to echo Okelo Oculi. They only go back to the villages to eat the last egg or hen from their mothers' and even grandmothers' chicken runs, even as hungry *kwashiorkor* smitten children look on with salivating mouths. Our dream universities will have to produce better graduates than these "pouting" adolescents: mature people who are ready to serve and sacrifice for their nations.

(Call and Response)

Palaver Seven: Focus on the Youth

There is a story, true or false, one never knows, of an Anglican bishop and a Roman Catholic cardinal. The former had a dwindling congregation, while the latter's church was bursting to the seams with worshippers. One day, after watching this development with a mixture of envy and perplexity, the Anglican gathered enough courage and approached his Catholic counterpart. "Cardinal," he said, "how do you manage to retain and attract so many followers?" The cardinal drew closer and in a conspiratorial whisper told the bishop, "Aaah! The secret is: we catch them when they are young!"

Inventive higher educational institutions must find means of "capturing" the youth early enough. All sorts of ventures can be dreamt up, ranging from institutionalization of mentorship

programs in schools; formation of "big sisters" and "big brothers" clubs whereby university students "adopt" high school pupils and groom them for high achievement, etc. In this connection, universities must dream up non-punitive youth service projects to replace most of the current ones that are based on a disciplinary or punitive model. Instead of drilling students, calling them names and trying to "break" them through harsh discipline and hard labor as happens, or has happened in many youth service programs, let us tap into their creativity. Let us send them out to the villages, towns and cities on literacy and "numeracy" campaigns. I am sure that a lot of philanthropic foundations would only be too happy to fund such campaigns.

Walter Rodney (1981) reminded us that the most precious resource is the human being. The youth of Africa constitute the bulk of Africa's population and our neo-colonial systems seem to have thrust them into a cruel world, mortgaging their lives before the young people have a chance to take their place in the world. Our innovative institutions of higher learning must find ways to restore the robbed dreams of Africa's youth.

(Call and Response)

Palaver Eight: Democratization of Corridors of Power

University classrooms and administrative structures must become more democratized, more gendered and more liberated from the "big boss" mentality. At one stage, especially in the mid-1980s, it was assumed that placing academicians in high administrative positions would bring the academic and administrative arms of academia closer. Unfortunately, although we seem to have succeeded in a few cases, we have failed miserably in terms of the majority. The administrative arm has tended to act as an agent of the state. I am familiar with the scenario of the proverbial piper's payer calling the tune, but surely, the university top brass are supposed to be more than mere "pipers!"

Even worse is the inaccessibility of the "big bosses" and their offices. The spaces they occupy are so forbidding and so intimidating that they have become frontiers of terror. I say, such an undemocratic environment is no soil in which to sow seeds of creativity and visionary innovativeness. People cannot think when their minds are frozen by fear and/or lives stifled by an emotionally/psychologically harrowing existence.

(Call and Response)

Palaver Nine: Networking, Collaboration and Exchange

Without networking, collaboration and exchange, we will remain islands of self-isolation and however innovative we think we are, we will never realize our full potential. We will be wasting resources that could stretch much further if we pooled them together. In responding to this challenge, we must not only focus on overseas connections and networks. Our primary targets should be our continental partners. It is paramount that we accelerate these.

(Call and Response)

Palaver Ten: Pending Palavers in Point Form

- Focus on distance education
- Promotion of cultural activities such as community theater to reach the people
- Confronting and preventing the nightmare of brain drainage
- Initiating and supporting efforts in economic, political and state democratization, as these are critical bases for either blocking or promoting innovations in higher education.

Point of Exit and Closure

Poem: "Intellectuals or Imposters?"
Refrain: Aha! Intellectuals or imposters?

When problems
 translate into
 deep seas
deep seas
daring
 philosophical diving
deep seas
daring
 skills in
 floating
 swimming
 surfacing
show me those
who emerge
 treading water
 walking the shores
 breathing courage
 and conviction
 scanning the horizon
a horizon extended
 unto eternity
an eternity
 of enquiry.
Show me those
who cast
 a penetrating eye
disentangling
 a maze of problems
 defying all solutions.

Show me these
and I will tell you
> whether they are
> intellectuals
> or imposters.

Show me those
> who walk the shore
> firming the earth
> on which
> we stand
> shaping up visions

visions that
clearly define
> who they are
> whom we are
> where we are
> when we are
> how we are
> how to be.

Yes, show me these
and I will tell you
> whether they are
> intellectuals
> or imposters.

Refrain

Show me those
who cross
> engulfing seas
> seas of confusion

those who build
> connecting bridges

bridges of understanding
those who traverse
dividing gorges
gorges of alienation.
Show me those
who leapfrog
with human grace
hurdles of
ego-tripping.
Friend, show me these
and I will tell you
whether they are
intellectuals
or imposters.

Refrain

Show me those
who break
icicles
of silence
those who untie
stammering tongues
those who teach
articulation
articulation of
the authentic word.
Show me these
and I will tell you
who are the intellectuals
and who are the imposters.

Refrain

Tell me too
tell me
> where they stand
> whether on the soil
> of liberating knowledge
> or upon the sands
> of unfounded learning.

Tell me
tell me whether
> they fan the furnace
> of living wisdom
> that generates the heat
> of probing dialogue
> and teasing ideas.

Tell me this
and I will tell you
> how I know them
> how I see them
> where I place them.

Refrain

Tell me
tell me
> whether they stand
> to the north
> to the south
> to the west
> or to the east

of the compass
> of our people's lives.

Tell me this
and I will tell you
> where they are

coming from
and where they may be
headed to.
Yes, tell me this
and I will tell you
whether they are
intellectuals
or imposters.

Refrain

Draw me
the circumference
of the circle
that surrounds them
Show me
where they have
positioned
themselves
whether they be
at the center
or on the periphery
of pro-people
human rights debate.
Draw me
this circle
and I will tell you
whether they truly stand
or decorate the fence
of abdicating neutrality.
Friend, tell me this
and I will tell you
whether they are

intellectuals
> or imposters.

Refrain

Capture me
capture me
> the podium
the podium
from which
> they deliver
> their treatises
> of academia
> whether they deposit
> engulfing piles
> of alienating information
> or micro-examine facts
> through the mirror
> of reflected
> and tested reality.

Yes, capture me
> the scene
and I will tell you
> whether they are
> intellectuals
> or imposters.

Refrain

Capture me
capture me
> this grandiose scene
> of academia
> with its dons

and their wisdom
Capture me
 the scene
and I will tell you
 whether the missiles
 of their ideas
 hit the target
 or bounce back
 on an overlooking
 blank stone wall
 of incomprehension
Friend, capture me
 the scene
and I will tell you
 whether they are
 intellectuals
 or imposters.

Refrain

Tell me
tell me
 whether they are
 perched
 statue-like
 on the high chairs
 of bureaucratic
stuffiness
 pushing heaps
 of reluctant paperwork
 heaps that solidify
 into immovable boulders
 sitting on forbidding
 mountains

of accumulated
red tape
Tell me this
and I will tell you
why they bake
themselves
in stuffy Anglo-American
and Franco-German suits
in the heat
of Africa's problems.
Yes, I will tell you
why the madams
choke themselves
with chains of gold
around sagging necks
while our children
writhe with the agony
of crippling hunger
and the diarrhea
of malnutrition.
Friend, tell me this
and I will tell you
whether they are
intellectuals
or imposters.

Tell me whether
they penetrate
the forests of intrigue
and the bushes of lies
planted by
stampeding elephants
and buffaloes
who mercilessly crush

our people's lives
under their hooves
making minced meat
of their lives
Yes, tell me whether
the reels of theories
they abstractly kite-fly
remain suspended in the sky
or make a landing
on people's earth
whether they sit
solitary confined
inside the cells
of incarcerating
academia
or whether they flower
like ripened plants
bearing the seeds
of education for living.
Yes, tell me this
and I will tell you
whether they are
intellectuals
or imposters.

Refrain

Tell me
tell me whether
their theories are
active volcanoes
erupting with
fertilizing lava
on which to plant

seeds that will
germinate
with self-knowledge
seeds that will
cross-fertilize
into collective being
Knowledge become
actioned theory
Knowledge become
living testimony
of our people's
affirmative history
liberated *herstory*
Actioned theory
inscribed as
a protest
manifesto
re-aligning our people's
averted humanity
Yes, tell me this
and I will tell you
whether they are
intellectuals
or imposters.

Refrain

Notes

Chapter 1

1. Frantz Fanon, *The Wretched of the Earth*, New York: Grove Press, 1963, p.7.
2. Frantz Fanon, *Black Skin White Masks*, New York: Grove Press, 1967.
3. Frantz, Fanon, *The Wretched of the Earth*, p. 7.
4. Okot p'Bitek, *Song of Lawino*, Nairobi: East African Publishing House, 1966.
5. Mũgo wa Gatheru, *Child of Two Worlds*, London: Heinemann, 1968.
6. Paulo Freire, *Pedagogy of the Oppressed*, New York: Continuum, 1992 Ed., p.150.
7. Frantz Fanon, *The Wretched of the Earth*, *op.cit.* p.152.
8. Chinweizu, *The West and the Rest of Us: White Predators, Black Slaves and the African Elite*, New York: Vintage, 1975, pp.355-356.
9. Paulo Freire, *Pedagogy of the Oppressed*, *op.cit.* p.126.
10. Ibid. p.127.
11. Conversation with a conservative, June 1994.
12. Chinua Achebe, *Things Fall Apart*, New York: Fawcett, 1969, p.24.

13. Walter Rodney, *Walter Rodney Speaks: The Making of an African Intellectual*, Trenton, N.J.: Africa World Press, 1990, pp.111-2.

14. Fanon, op.cit. pp.148-205.

15. Frantz Fanon, "Pitfalls of Nationalism," *The Wretched of the Earth*, ibid. p. 171.

16. *Kamukunji*, The original name of a place where political rallies used to be held during the struggle for Kenya's independence. The name was adopted by the University of Nairobi Students and simply used in reference to any of their political rallies, normally convened preceding a demonstration.

17. Kamīrīīthū theater project was a mass-based early experiment with community theater banned by the government which sent troops to raze the theater to the ground in 1978. The Theater Group in Kamīrīīthū Village, near Limuru, a town twenty or so miles from Nairobi, consisting of progressive intellectuals, artists, workers and villagers had revolutionized the rural community to a point where the government felt threatened. Ngũgĩ wa Thiong'o, the leading Kenyan writer, was a founder.

18. A part of a reconstructed police interrogation session.

Chapter 3

1. "Africa: the Facts," *UNICEF News Chart* (1984). Information derived from *Literacy Targets in the International Development Strategy* (New York: UNESCO, 1979).

2. "Africa: the Facts." Between 1970 and 1981 Tanzania reduced illiteracy from 70 percent to 21 percent.

3. Between independence (1980) and 1983, over 200,000 adults in Zimbabwe had enrolled in literacy classes, 71 percent of the students, women. By 1985, 350,000 adults were attending literacy classes and more than 3/4 of this figure were women.

4. Frantz Fanon, *Black Skin White Masks* (New York: Grove Press, 1968) 17-18.

5. Paulo Freire, *Pedagogy of the Oppressed* (London: Sheed & Ward Ltd., 1972) 49.

6. V.I. Lenin, "Party Organization and Party Literature," *On Socialist Ideology and Culture* (Moscow: Progress Publishers, 1962) 27-28.
7. Freire 120.
8. Freire 75.
9. Freire 76.
10. Freire 150.
11. Freire 136.
12. Freire 133.

Chapter 5

1. In 1993 I was invited, along with two other African colleagues, to participate on a panel of "distinguished African scholars" at a conference on African Studies and the undergraduate curriculum organized by a predominantly white university. My colleagues and I made critical comments that were not kindly received. Later, when the conference proceedings were under preparation for publication, one of the conference organizers telephoned me, insisting on including my contribution but gently suggesting that I omit my critique of the university's African Studies Program's academic integrity. I, of course, rejected the imposed conditions for being included in the publication. My probing elicited a long letter of explanation claiming that my contribution did not fit in with the rest of the papers. The ensuing publication has only one or two contributions by African scholars.

2. Amilcar Cabral uses this term to describe societies ruled by kings, queens and chiefs. Feudal systems, for instance, would be considered vertical in their organization.

3. Horizontal social formations had ruling councils as the governing bodies. Representatives on the councils were appointed by the people they represented; usually across age groups, clans and villages.

Chapter 6

1. I use this term deliberately in an effort to keep discourse open, especially with women who observe the practice. Obiora's paper has persuaded me that the use of the phrase "genital mutilation" alienates and criminalizes the very population with whom one is seeking to hold conversation. It also imposes an external definition on them, displacing their self-definition, which should be left intact, even if one does not agree with it.

2. L. Amede Obiora, *Bridges and Barricades: Rethinking Polemics and Intransigence in the Campaign Against Female Circumcision,* 47 CASE W. RES. L. REV. 275, 303 (1997) (quoting Audre Lorde, An *Open Letter to Mary Daly, in* SISTER OUTSIDER 67 (1996)).

3. Ibid. p. 292.

4 Ibid.

5. Alice Walker, *Possessing the Secret of Joy* (1992).

6. Alice Walker & Pratibha Parmar, *Warrior Marks* (1993).

7. Obiora, *supra* note 2, at 312.

8. Ibid.

9. See Chinua Achebe. *Things Fall Apart* (1959) (satirizing Enoch, the Umuofian missionary convert, as an "outsider who wept louder than the bereaved").

10. Obiora *supra* note 2, at 288.

11. Ibid. p. 322.

12. Rocking Rugby, *Daily Orange*, Sept. 16, 1996, at 1.

13. See Nawal El Saadawi. Address at the Writers' Workshop, Zimbabwe International Book Fair on Women and Books (July 29-Aug 3, 1985).

14. It has been reported that "there could be as many as 300 million chronically undernourished people on the continent by 2010," and most of these will be children. *Africa Recovery*, May-June 1996, at 7.

15. See Paulo Freire, *Pedagogy of the Oppressed* (1983) (originally published in 1972).

16. See Micere G. Mugo, *Exile and Creativity: A Prolonged Writer's Block, in The Word Behind Bars - The Paradox of Exile* (K. Anyidoho ed., 1997).

17. *The tsunga* performs the ritual circumcision of girls. See Obiora, supra note 2, at 324 9defining *tsunga*).

18. Audre Lorde, *An Open Letter to Mary Daly,* in *Sister Outsider* 69 (1996).

19. Walker, *supra* note 5.

20. Letter from agent of Alice Walker to Micere G. Mugo (June 18, 1992) (on file with author).

21. Obiora, *supra* note 2, at 324-25.

22. See Angela Davis, *Women in Egypt: A Personal View,* in *Women Culture and Politics* 117 (1990).

23. Ibid.

24. Ibid. p. 125.

25. Ibid. p. 121.

26. Ibid. p. 119.

27. Walker, *supra* note 5, at 6-7 (emphasis added).

28. Ibid. p. 204.

29. Ibid. p. 207.

30. See Walker supra note 5, at 204.

31. Ibid. p. 253.

32. Ibid. p. 146 (emphasis added).

33. Ibid. p. 219.

34. Ibid. p. 214.

35. Ibid. p. 136.

36. See Ibid. p. 134.

37. See Walker, supra note 5, at 7 (describing Tashi).

38. Ibid. p. 7, 262.

39. Ibid. p. 44.

40. Ibid. p. 45.

41. Ibid. p. 51.

42. Walker, supra note 5, at 63.

43. Ibid. p. 64.

44. Ibid. p. 74.
45. Ibid. p. 164.
46. Ibid. p. 208.
47. Walker, supra note 5, at 142 .
48. See Ibid. p. 143.
49. Ibid. p. 163.
50. See Ibid. p. 175 .
51. Obiora, supra note 2, at 323.
52. Walker, supra note 5, at ix.
53. Walker and Parmar, supra note 6, at 28.
54. See Ibid. p. 32 (emphasis added).
55. Ibid. p. 69 (emphasis added).
56. Ibid. p. 73.
57. Ibid. p. 71.
58. Walker and Parmar, supra note 6, at 47.
59. See Ibid. p. 348 (describing Walker's feelings about the interview with the circumciser).
60. Ibid. p. 43.
61. Ibid. p. 51.
62. Ibid. p. 71.
63. Walker and Parmar, supra note 6, at 47.
64. Ibid. p. 94.
65. Ibid. p. 95 (italics omitted).
66. Ibid. p. 49.
67. Ibid. (emphasis added).

Chapter 7

1. *Concise Oxford Dictionary*, New York: Oxford University Press, 1964, p. 231.
2. Niakoro, an old peasant character, in Ousmane Sembene's novel, *God's Bits of Wood*, refers to French as the language of "savages."

3. Amilcar Cabral, "National Liberation and Culture," in *Return to the Source: Selected Speeches of Amilcar Cabral,* edited by African Information Service (New York and London: Monthly Review Press, 1973), p. 41.

4. Ibid. p. 42.

5. Ibid., pp. 39-40.

6. Micere Githae Mugo, "The Battle of the Mind," in *UFAHAMU,* edited by Kyalo Mativo (Los Angeles: UCLA Press, 1984), p. 241.

7. Ibid., p. 242.

8. Paulo Freire, *Pedagogy of the Oppressed.* (New York: The Continuum Publishing Corporation, 1983), pp. 150-151.

9. N.B. "Dallas," "Dynasty" and "The Colbys" have remained on the Zimbabwean television screen for the last three years.

10. A sweetened grapefruit drink.

11. V.I. Lenin, "Socialism and Religion," in *On Socialist Ideology and Culture* (Moscow: Progress Publishers, 1965), pp. 24-43.

12. Amilcar Cabral, op. cit., p. 43.

Chapter 8

1. Mbiti, 1970.

2. See Cabral, 1973, "National Liberation and Culture," in *Return to the Source: Selected Speeches of Amilcar Cabral,* African Information Service (eds), New York: Monthly Review Press.

3. See Mugo, "The Role of African Intellectuals: the Reflections of a female scholar," in Mandaza, 1995.

4. Kenya is such an example.

5. Freire, 1983.

6. Selby, 1987, *Human Rights*, Cambridge: Cambridge University Press, quoted in Mugo, 1990.

7. The Catholic Institute for International Relations, *Rights to Survive – Human Rights Nicaragua*, London: Russell Press Ltd, quoted in Mugo, 1990.

8. Ibid: 7.

9. JASPA, 1982, "*Basic Needs in Danger – A Basic Needs Oriented Development Strategy for Tanzania,*" Addis Ababa: International Labor Office, quoted in Mugo, 1990: 8.

10. Rodney, 1972.

11. Ibid.

12. *African Charter on Human and People's Rights*, Banjul: OAU, 1981.

Bibliography

Achebe, Chinua

1959 *Things Fall Apart*. London: Heinemann.

1969 *Things Fall Apart*. New York: Fawcett.

1960 *No Longer at Ease*. London: Heinemann.

1966 *A Man of the People*. London: Heinemann.

Adams, Anne V and Mayes, Janis Alene

1998 *Mapping Intersections: African Literature and Africa's Development*. Trenton, N.J.: Africa World Press.

African Charter on Human and People's Rights. 1981. Banjul: OAU.

Aidoo, Ama Ata

1969 *Anowa*. London:Heinemann.

1970 *No Sweetness Here*. London: Heinemann.

1985 "To be a Woman Writer – An Overview and a Detail." Paper presented at the Writers' Workshop, Zimbabwe International Book Fair.

Aina, Tade Akin

1994 *Africa Development*, Vol. 19, No. 1. Dakar: CODESRIA.

Ajala, Adekunle

1973 *Pan Africanism: Evolution, Progress and Prospects*. New York: St. Martin's Press.

Al-Rahim, Tajuddin

1996 *Pan Africanism*. London: ZED Press.

Armah, Ayi Kwei
1979 *The Healers: A Historical Novel.* London: Heinemann.
Ba, Mariama
1980 *So Long a Letter.* London:Heinemann.
Boal, Agusto
1979 *Theater of the Oppressed.* London: Pluto Press.
Boyce-Davies, Carole
1994 *Black Women, Writing, and Identity: Migrations of the Subject.* London: Routledge.
Bradford, P.V. and Harvey Blume
1992 *Ota Benga: The Pygmy in the Zoo.* New York: St Martin's.
Brecht, Bertolt
1964 "The Popular and the Realistic." *Brecht on Theater*, ed. J. Willet, 107-115. New York: Hill and Wang.
Brown, Dee Alexander
1971 *Bury My Heart at Wounded Knee: An Indian History of the American West.* New York: Holt, Rinehart & Winston.
Bugul, Ken
1991 *The Abandoned Baobab.* New York: Lawrence Hill.
Bukenya, Austin and Pio Zirimu
1987 "Oracy as a Skill and as a Tool for African Development," paper originally presented at the Colloquium, FESTAC, 1977. Published in Okpaku, Opubor &Oloruntimehia, Eds. *The Arts and Civilizations of Black and African Peoples, Vol. 10.*
Busby, Margaret, ed.
1992 *Daughters of Africa.* New York. Pantheon Books.
Cabral, Amilcar
1973 "National Liberation and Culture." In *Return to the Source: Selected Speeches of Amilcar Cabral*, ed. African Information Service, 39-56. New York: Monthly Review Press.
1973 *Return to the Source: Selected Speeches of Amilcar Cabral.* New York: Monthly Review Press.

Campbell, Horace
1994 "Rebuilding the Pan African Movement;" Pan African
 Movement Looks at Tasks for the 21st Century;"
 Women Press for Equality in the Pan-African Move-
 ment;" Articles in *The Sunday Mail*, May 1, 8, 15.

Campbell, Roy-Makini
1994 Women's Participation in the 7th Pan African Con-
 gress." Paper presented at AAPS Forum, April 28.

Catholic Institute for International Relations
1987 *Rights to Survive: Human Rights in Nicaragua.*
 London: Russell Press.

Césaire, Aimé
1955 *Discourse on Colonialism.* Paris: Présence Africaine.

Chinweizu, Ibekwe
1975 *The West and the Rest of Us: White Predators, Black
 Slaves and the African Elite.* New York: Vintage.

Chrisman, Robert
1974 *Pan-Africanism.* Indianapolis: Bobbs-Merrill.

Christian, Barbara
1985 *Black Feminist Criticism: Perspectives on Black Women
 Writers.* New York: Pengamon Press.

Clark, J.P.
1966 *Ozidi.* London: Oxford University Press.

Concise Oxford Dictionary. 1964. New York: Oxford University Press.

Cooper, Carolyn
1994 " 'Resistance Science': Afrocentric Ideology in Vic
 Reid's *Nanny Town.*" In *Maroon Heritage*, ed. Kofi
 Agorsah, 109-118. Kingston: Canoe.

Crow, B., and M. Etherton
1980 "Popular Drama and Popular Analysis in Africa." In
 Tradition for Development, ed. Ross Kidd and Nat J.
 Collette, 57-94.

1982 "Popular Drama and Popular Analysis in Africa." In
 Tradition for Development: Indigenous Structures and

Folk Media in Non-Formal Education, ed. Ross Kidd and Nat J. Colletta, Berlin: International Education and International Council for Adult Education.

Dangarebga, Tsitsi

1988 *Nervous Conditions. London: Women's Press.*

Davidson, Basil

1964 *The African Past*, ed. Boston: Little, Brown.

1978 *Discovering Africa's Past*, ed. London, New York: Longman.

1983 *Modern Africa*, ed. London, New York: Longman.

1989 *Modern Africa: A Social and Political History*. London: Longman.

"Women in Egypt: A Personal View." In *Women, Culture and Politics*, ed. Angela Davies, New York: Random House.

Davis, Angela

1983 *Women, Race and Class*. New York: Vintage Books.

De Graft, J. C.

1976 "Roots in African Dance and Theater." In *African Literature Today*, no. 8, ed. E.D. Jones, 1-25. London: Heinemann.

Depelchin, Jacques

1992 *From Congo Free State to Zaire*. Dakar: CODESRIA.

Diop, C.A.

1963 *The African Origin of Civilization*. Paris: Présence Africaine.

1981 *Civilization and Barbarism*. Paris: Présence Africaine.

El Saadawi, Nawal

1975 *Woman at Point Zero*. Totowa, N.J.: ZED Books.

1985 Address at the Writers' Workshop, Zimbabwe International Book Fair on Women and Books, July 29-August 3.

Equiano, Olaudah

1987 [1814] "The Life of Gustavus Vassa" (Olaudah Equiano). In *The Classic Slave Narratives*, ed. H. L. Gates Jr., 1-182. New York: Mentos/Penguin.

Esedebe, Olisanwuche
 1982 *Pan-Africanism: The Idea and the Movement.* Washington, D.C.: Howard University Press.

Evans, Mari
 1984 *Black Women Writers.* New York: Doubleday.

Fanon, Frantz
 1963 *The Wretched of the Earth.* New York: Grove Press.
 1967 *Black Skin White Masks.* New York: Grove Press.

Finke, Laura A.
 1992 *Feminist Theory, Women's Writing.* Ithaca, N.Y.: Cornell University Press.

Finnegan, Ruth
 1970 *Oral Literature in Africa.* Oxford: Oxford University Press.

Freire, Paulo
 1972 *Cultural Action for Freedom.* Penguin: Harmondsworth.
 1983 *Pedagogy of the Oppressed.* New York: Continuum.

Gaidzanwa, Rudo
 1985 *Images of Women in Zimbabwean Literature.* Harare: College Press.

Giddings, Paula
 1985 *When and Where I Enter.* New York: Bantam Books.

Global Pan African Movement
 1994 *Resolutions: Seventh Pan African Congress.* Kampala: Pan African Publishers.

Graham-White, Anthony
 1974 *The Drama of Black Africa.* New York: Samuel French.

Head, Bessie
 1974 *A Question of Power.* New York: Harcourt Brace

Hernton, Calvin C.
 1987 *The Sexual Mountain and Black Women Writers.* New York: Doubleday.

Herskovits, Melville

1944 "Dramatic Expressions among Primitive Peoples." *Yale Review* 33:687.

In the White Man's Image. 1991. Alexandria, VA: PBS Video.

Jahn, Janheinz

1961 *Muntu: An Outline of Neo African Culture.* New York: Grove.

James, Adeola, ed.

1990 *In Their Own Voices: African Women Writers Talk.* London: James Currey.

JASPA

1982 *Basic Needs in Danger: A Basic Needs Oriented Development Strategy for Tanzania.* Addis Ababa: International Labor Office.

Johnson, Paul

1993 *New York Times* Magazine, April 18.

Jones, Eldred Durosimi, Eustace Palmer, and Majorie Jones, eds.

1987 *Women in African Literature Today.* Trenton, N.J.: Africa World Press; London : James Currey.

Kabira, Wanjiku Mukabi

1983 *The Oral Artist.* Nairobi: Heinemann.

Kamlongera, Christopher

1989 *Theater for Development in Africa with Case Studies from Malawi and Zambia.* Bonn: German Foundation for International Development.

Kenyatta, Jomo

1938 *Facing Mount Kenya.* London: Secker and Warburg.

Kidd, Ross, and M. Byram

1981 "Demystifying Pseudo-Freirian Non-Formal Education: A Case Description and Analysis of Laedza Batanani." Mimeo.

Kidd, Ross, and Nat J. Colletta, eds.

1980 *Tradition for Development: Indigenous Structures and Folk Media in Non-formal Education.* Bonn: German

Foundation for International Education and International Council for Adult Education.

Khapoya, Vincent B.

1994 *The African Experience: An Introduction.* Englewood Cliffs, N.J.: Prentice Hall.

Kuzwayo, Ellen

1980 *Call Me Woman.* San Francisco: Spinsters.

Longley, Ayodele J.

1973 *Pan Africanism and Nationalism in West Africa, 1900-1945: A Study in Ideology and Social Classes.* Oxford: Clarendon Press.

Lemelle, Sidney and Robin D.G. Kelley, eds.

1994 *Imagining Home: Class, Culture, and Nationalism in the African Diaspora.* London: Verso.

Lenin, Vladimir I

1965 "Socialism and Religion." In On *Socialist Ideology and Culture.* Moscow: Progress Publishers.

Lihamba, Amandina

1990 "Theater and Political Struggles in Africa." Paper presented at a Rockefeller Foundation Conference, Reflections on Development, August, Bellagio, Italy.

Lorde, Audre

1980 "The Transformation of Silence into Language and Action." *The Cancer Journals.* San Francisco: Spinsters.

Mackonnen, Ras

1973 *Pan Africanism from Within.* Nairobi: Oxford University Press.

Magubane, Makhosezwe B.

1987 *The Ties that Bind: African-American Consciousness of Africa.* Trenton, N.J.: Africa World Press.

Manning, P.

1990 *Slavery and African Life.* Cambridge: Cambridge University Press.

Martin William, and Michael West
 1995 "The Decline of the Africanists' Africa and the Rise of New Africas." *ISSUE* 23, no. 1:24-27.

Mbiti, John
 1970 *African Religions and Philosophy*. New York: Doubleday.
 1989 *African Religions and Philosophy*. London: Heinemann. Second Ed.

Mbuyinga, Elenga
 1982 *Pan Africanism or Neo Colonialism: The Bankruptcy of the OAU*. London: Zed Press.

McFadden, Patricia, ed.
 1996 *Southern African Feminist Review*, Vol. 2, No. 1. Harare: SAPES Books.

Mda, Zakes
 1993 *When People Play People*. Johannesburg: Oxford University Press.

Mlama, Penina Muhando
 1990 Interview with Adeola James. In *Their Own Voices: African Women Writers Talk*, ed. Adeola James, 75-91. London: James Currey.
 1991 *Culture and Development: The Popular Theater Approach in Africa*. Uppsala: Nordiska Afrikainstitutet.

Mugo, Micere Githae
 1984a *My Mother's Poem and Other Songs: Songs and Poems*. Nairobi: East African Educational Publishers.
 1984b "Women Writers." Paper presented at the New Writing Conference, Commonwealth Institute, London.
 1984c "The Battle of the Mind." In *UFAHAMU*, ed. Kyalo Mativo, Los Angeles: UCLA Press.
 1989 "Exile and Creativity." Paper presented at a Conference on Writers and Human Rights, Dakar: Centre African d'Animation et d'Exchanges Culturels, September 26-28.
 1991 *African Orature and Human Rights*. Monograph Series, No. 13, ISAS, Roma, Lesotho.

1991a *Orature and Human Rights*. Roma. Institute of Southern African Studies, National University of Lesotho.

1991b "Popular Theater and Human Rights." Paper Delivered at Conference, The Defense and Promotion of Human and Popular Democratic Rights in Africa, February 26-March 1, Maputo, Mozambique.

1993 "Culture and Imperialism in Africa," *Third World in Perspective*, Vol. 1, No. 2, Chicago, 85-97.

1994 *My Mother's Poem and Other Songs*. Nairobi: East African Educational Publishers.

2010 "The Role of African Intellectuals: Critical Reflections of a Female Scholar, University of Nairobi, 1973-82, and their Relevance to the US Academy." Chapter in *Academic Repression: The Assault on Free Speech in the Post 9/11 World*. Los Angeles: AK Press.

Mugo, wa Gatheru

1968 *Child of Two Worlds*. London: Heinemann.

Naipaul, Vidiadhar

1967 *Mimic Men*. London: Heinemann.

Ngugi wa Thiong'o

1986 *Decolonizing the Mind*. London: James Currey.

Ngugi wa Thiong'o and Micere Githae Mugo

1977 *The Trial of Dedan Kimathi* London: Heinemann.

Nkrumah, Kwame

1957 *The Autobiography of Kwame Nkrumah*. New York: International Publishers, 1989.

1961 *I Speak of Freedom*. New York: Praeger.

1963 *Africa Must Unite*. New York: PanafPress.

1973 *Towards Colonial Freedom*. New York: Panaf Press.

Odamtten, Vincent O.

1994 *The Art of Ama Ata Aidoo: Polytectics and Reading Against Neocolonialism*. Gainesville: University Press of Florida.

Ogundipe-Leslie, Molara

1990 Interview with Adeola James. In *In Their Own Voices: African Women Writers Talk*, ed. Adeola James, 65-73. London: James Currey.

Okot p'Bitek

1966 *Song of Lawino*. Nairobi. East African Publishing House.

Padmore, George

1956 *Pan Africanism or Communism: The Coming Struggle for Africa*. London: Dobson.

Pala, Achola, ed.

1995 *Connecting Across Cultures and Continents*. New York: UNIFEM.

Patterson, Orlando

1986 *The Children of Sisyphus*. London: Longman.

Qunta, C.

1987 *Women in Southern Africa*. New York. Schocken Inc.

Robertson, C. and I. Berger, eds.

1986 *Women and Class in Africa*. New York, London: Africana Publishing Company.

Rodney, Walter

1972 *How Europe Underdeveloped Africa*. London: Bogle L'Ouverture.

1982 *How Europe Underdeveloped Africa*. Washington, D.C.: Howard University Press Edition.

1990 *Walter Rodney Speaks*. Trenton, NJ: Africa World Press.

Rogers, J.A.

1961 *Africa's Gift to America. St. Peterburg, Fl: Helga Rogers*.

Sagawa, Jessie

1984 "The Role of Women in African Literature: Feminism and the African Novel." Undergraduate Honors Thesis, Department of English, Chancellor College, University of Malawi.

Selby, David

1987 *Human Rights*. Cambridge: Cambridge University Press.

Selwyn-Cudjoe, R., ed.

1990 *Caribbean Women Writers*. Wellesley, M.A.: Calaloux Publications.

Sembène, Ousmane
1970 *God's Bits of Wood*. Garden City, N.Y.: Anchor Books.

Snowden, Wenig Steffen
1978 *Africa in Antiquity: The Arts of Ancient Nubia and the Sudan*. New York: Brooklyn Museum.

Soyinka, Wole
1972 *The Man Died: Prison Notes of Wole Soyinka*. New York: Harper and Row.
1976 *Myth, Literature and the African World*. London: Cambridge University Press.

Taiwo, Oladele
1985 *Female Novelists of Modern Africa*. New York: St Martin's Press.

Terbborg-Penn, S.H. and Benton Rushing, eds.
1989 *Women in Africa and the Diaspora*. Washington, D.C.: Howard University Press.

Traore, Bakary
1972 *The Black African Theater and Its Social Functions*. Trans. Dapo Adelugba Ibadan: Ibadan University Press.

Turner, James
1993 "An Introduction." *David Walker's Appeal*. Baltimore: Black Classic Press Edition.

Walker, Alice
1992 *Possessing the Secret of Joy*. New York: Harcourt Brace.

Walker, Alice and Pratibha Parmar
1993 *Warrior Marks: Female Genital Mutilation and the Sexual Blinding of Women*. New York: Harcourt Brace.

Welbourne, Frederick B.
1961 *East African Rebels: A Study of Some Independent Churches*. London: SCM.

Wilkinson, Jane

1990 *Talking with African Writers*. London: James Currey.

Williams, C.

1961 *The Destruction of Black Civilization*. Chicago: Third World Press.

Woodson, Carter

1990 *Miseducation of the Negro*. Trenton, NJ: Africa World Press.

Zell, Hans, ed.

1983 *A New Reader's Guide to African Literature*. New York: African Publishing Company.

Zirimu and Bukenya

1987 "Oracy as a Skill and as a Tool for African Development," paper originally presented at the Colloquium, FESTAC, 1977. Published in Okpaku, Opubor &Oloruntimehia, Eds. *The Arts and Civilizations of Black and African Peoples, Vol.10*

Index